# Environmental Humanities on the Brink

# ENVIRONMENTAL HUMANITIES ON THE BRINK

## The Vanitas Hypothesis

## VINCENT BRUYERE

STANFORD UNIVERSITY PRESS
Stanford, California

Stanford University Press
Stanford, California

Printed in the United States of America on acid-free, archival-quality paper

Library of Congress Cataloging-in-Publication Data

Names: Bruyère, Vincent, author.
Title: Environmental humanities on the brink : the vanitas hypothesis /
    Vincent Bruyere.
Description: Stanford, California : Stanford University Press, 2023. |
    Includes bibliographical references and index.
Identifiers: LCCN 2022058234 (print) | LCCN 2022058235 (ebook) |
    ISBN 9781503630505 (cloth) | ISBN 9781503638631 (paper) |
    ISBN 9781503636798 (ebook)
Subjects: LCSH: Ecocriticism. | Vanitas (Art) | Humanities.
Classification: LCC PN98.E36 B78 2023 (print) | LCC PN98.E36 (ebook) |
    DDC 809/.933553--dc23/eng/20230302
LC record available at https://lccn.loc.gov/2022058234
LC ebook record available at https://lccn.loc.gov/2022058235

Cover design: Gabriele Wilson
Cover painting: Philippe de Champaigne, *Still-Life with a Skull*, vanitas
painting, 1671, oil on panel, 11" x 14.5"

# CONTENTS

CONTENTS

PROLOGUE

# Of Skulls and Shells

The Anthropocene stands for many things. Some are as tangible as the plastiglomerates identified in 2014 on the beaches of Hawaii as a geological marker composed of melted plastic, sediments, basaltic lava fragments, and organic debris.[1] And others, as intangible as a "scalar shift from the subject to the species [that] could make history a largely irrelevant pursuit."[2] For now—maybe not for long—the Anthropocene exists as a proposal to recognize the human species as a geological agent. It is at once a slice of geological time whose official existence rests in the hands of the subcommittee of Quaternary stratigraphy and an ongoing conversation about the contours of a present that one day will be legible as an age of mass extinction. Much of this conversation tends to revolve around neologisms: Thermocene, Capitalocene, Plantationocene, Phagocene, and so on. There seems to be no end to the list of "cenes" (from the Greek *kainos*, which designates something new, recent, unprecedented).[3] Each coinage contends with evidence that something of historical proportion is happening, while pointing in the direction of an emerging planetary archive to be reckoned with: global temperature charts, generalized social failure, crop monocultures, and sprawling landfills. It is at once a conversation that may be too political

1

for the International Commission on Stratigraphy and yet not political enough for those who express wariness toward the generalizing focus on Anthropos as species.

This book is part of a related conversation about the foundations and the future of humanistic inquiry in the context of what geochemist Paul Crutzen has called the "geology of mankind." The Anthropocene hypothesis offers a picture big enough to absorb and digest all the other pictures of the world, leaving nothing behind but a more or less sedimented deposit. That deposit may indeed be of interest to geologists of the future, who will find in it evidence that something of geological importance occurred at some point in time—or evidence to the contrary—but not so interesting to those of us stuck in the meantime, waiting for the grand flattening that will eventually turn millennia of civilizational record into compacted dust. The Vanitas hypothesis is my response to that state of affairs.

A vanitas image is the pictorial equivalent of an open landfill where heaps of meaningless and yet valuable things are laid to rest along with the worldly values attached to them for everyone to see. It is a mode of depositing value that turns displayed riches into a layer of stuff. Vanitas images downplay the attachment to the worldliness of the world by depicting, not necessarily the transience of life, as it is often said, but the emptiness and fragility of cluttered things turned into motifs (skulls, bubbles, tobacco, musical instruments, withering flowers, moldy books, etc.). Like the Anthropocene hypothesis in that regard, a vanitas image threatens the historical and visual record with indifference, but unlike geological projections it is designed to pay tribute to the day-to-day erasure of the world.

In the rigorist view, Rosalie Colie remarks, any image is a vanitas because the promises of images are empty as a matter of ontological principle. Some images are simply more intentional about their *vanitates* status.[4] In still-life paintings of the vanitas variety, the soft tissues that make up the world of portraiture and historical scenes have given way to dazzling displays of mineral remains that continue to exist independently from their past owners: seashells and pearl necklaces, glazed

ceramics and glassware, coins and clay pipes, the sand in an hourglass, and, of course, human skulls. This reversed correspondence between genres finds an echo in the historiographical tradition that situates the inception of still life in the margins of more ambitious compositions: as an arrangement of fruits, nuts, knife, and wine on a windowsill in Joos van Cleve's *Holy Family*, at the Metropolitan Museum (1512–13), or as a partially dismantled human skull painted on the back of the portrait of Margaretha von Mochau (formerly identified as Gertraude von Leutz) by Barthel Bruyn the Elder at the Kröller-Müller Museum (1524).[5] While the portrait side of Bruyn's painting faces the world and seeks out recognition, the hidden vanitas faces the blind surface of the wall like bony remains in the sealed shell of a sarcophagus. Because of the reversible logic of the panel the likeness of the sitter (on the recto) is an image of life always already inhabited by death on the verso.

Janus-faced and split-faced ivory pendants from early modern Germany offer a three-dimensional rendition of the same play between portraiture and vanitas.[6] One side of the pendant is still enfleshed, while the other is peeled away to reveal the skeletal structure underneath the facial shell of likeness. In these last two examples, vanitas is less an image—whether painted or carved—than a frame, that is, a mode of drawing lines between parts and wholes, recto and verso, face and skull, skull and shell. It designates the gesture of holding an image together while pointing at its fragile integrity. This means that the historical identity of the vanitas image is not necessarily in the repetition of a recognizable motif, skull, or shell but in the effort deployed by the image itself to both frame and query its avowed ontological slipperiness as a sign and a thing.

Today, environmental archaeologists entrust the ontological slipperiness that defines objects in their field to a notional distinction between artifact, "a relic of human manipulation of the material world," and ecofact, "a relic of other-than-human engagement with matter, climate, weather, biology."[7] In that sense, the skull in vanitas painting is both an artifact—an image of death—and an ecofact—the by-product of organic decay. The early modern allegorical tradition relies on a dif-

ferent set of oppositions. "In allegory," Walter Benjamin writes, "the observer is confronted with the *facies hippocratica* of history as a petrified, primordial landscape. History, in everything untimely, sorrowful, and miscarried that belongs to it from the beginning, is inscribed in a face—no, in a death's head."[8] The hesitation between "face" (*Antlitz*) and "death's head" (*Totenkopf*) should give us pause. "Skull" (*Schädel*) is perhaps too anatomical to be part of the picture being painted by the *Trauerspiel*. And yet, we are told that allegory (by opposition to the symbol) confronts us to "the *facies hippocratica* of history." In medicine, the Hippocratic face describes the livid appearance of terminal patients. It inscribes the slippery moment when what's left of the tissues that once composed a face lends some expression, as if by transparency, to an underlying skeletal structure, which would remain otherwise expressionless.

The anamorphic skull stretched out diagonally across the tiled floor in Holbein's *Ambassadors* (1533) has been the object of extended scrutiny. In this paradigmatic example, it is the stretching of a form rather than the stretching of the skin that lends expression to the skeletal structure concealed in the painting. Here the *Totenkopf* is expressed in a different optical register than the rest of the painting. The anamorphic skull stretched vertically across a prognostic chart by the gravitational pull of mortality statistics in François Colos's collage is certainly not as famous even though the article it illustrates has achieved the status of a classic in the literature on cancer survivorship.[9] In the right tail of the curve, a shielded warrior defies the negative odds materialized by the looming skull crowned with a plume of mannerist smoke. Although he is on his knees, the shielded figure stands for hope in the face of glib statistical prospects confronting him (half of the patients diagnosed with abdominal mesothelioma will die within eight months). Borrowing from the visual language of seventeenth-century vanitas, Colos's illustration reinstates an allegorical difference between life and death in a space where bodies are made interchangeable by statistical aggregation. If statistical aggregation is a mode of depositing bodies and abstractions, a vanitas is a strange visual algorithm that solicits the totality of

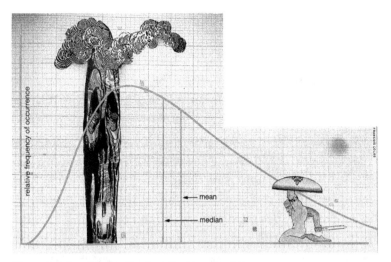

**Figure 1.** Colos, "The Median Isn't the Message," 41.

existence (*"everything* is vanity"; Ecclesiastes 12:8) while depositing all claims to it (everything *is* vanity).

In a lecture he delivered in 1940, art historian Erwin Panofsky explained, "Man's signs and structures are records because, or rather in so far as, they express ideas separated from, yet realized by, the process of signaling and building. These records have therefore the quality of emerging from the stream of time, and it is precisely in this respect that they are studied by the humanist."[10] Doubling down on the question of why we should be interested in the past, he offers a more suggestive answer laced with the language of vanitas and transience: "Because we are interested in reality. There is nothing less real than the present. An hour ago, this lecture belonged to the future. In four minutes, it will belong to the past. . . . To grasp reality we have to detach ourselves from the present." The humanities do this, he explains, not by "arresting what otherwise would slip away, but [by] enlivening what otherwise would remain dead."[11] To enliven means connecting monuments and documents with each other to form an "organic" system where its constitutive parts owe their existence to an idea of the whole as a category, and in turn the

very idea of the whole is made up of constitutive parts whose historical existence awaits qualification by a bigger picture to which students of the historical record can contribute to form and amend. The Anthropocene hypothesis is but a version of that "big picture," but it is one that for better or worse originates from outside what has been understood as the humanistic domain of operation. Better, when it encourages scholars to diversify their historicist portfolios. Or worse, each time it leaves humanistic inquiry vulnerable to unsympathetic takeovers.

The life of monuments and documents Panofsky has in mind is a conceit that grasps at a void by entertaining the fantasy that objects having emerged "from the stream of time" are entirely made by us and for us, the living, as if they were not meant to survive their makers, beholders, and interpreters. Organic life is the trope that for centuries has allowed humanists to lay claim to the historical existence of artifacts and to the distinction between animal and human remains (and in an expanded temporal field that Panofsky does not seem to consider, between historical and geological remains).[12] But it is a trope that is losing much of its metaphorical currency to the post-humanist rediscovery that "the notion of human exceptionalism was a lie and that in truth there is one life in which all the features that had once marked the human—knowledge, emotion, linguistic capacity, altruism, mind and community—are in fact present in all life."[13] Likewise, humanistic inquiry seems to be losing its edge in a context of ecocidal urgency.

Here is the dilemma facing environmental humanists. On the one hand, and as scholars, they take all the time they need to value the historical record while acknowledging, on the other, that time is running out. Most of the time, however, calls to act on this knowledge and to prioritize what's left to be done over what has already happened are another way to declare the irrelevance of humanistic logics of inquiry: the Anthropocene present is not a time to indulge in interpretive niceties. There is simply no time for the ambiguities of figurative language. It is high time for a quantitative turn toward facts and data. Anything else, anything less than a full commitment to the urgency of the situation is complicit with wanton ecocide and denial.

Take the following example. Pteropods are very common planktonic sea snails that occupy a key position in the ocean food chain. A lot is at stake in the fate of these sentinel organisms. Because of their sensitivity to ocean acidification and because of the carbon-sinking capacity of their fragile shells, they have the attention of marine biologists studying the effects of climate change. The stakes of their afterlives in visual culture have been the object of Stacy Alaimo's attention too. As a cultural theorist she sees in dissolving images of dissolving pteropods the promise of an immersive relation to environmental degradation and, thus, an alternative to the views from above that crowd Anthropocene visual culture. At some point in her argument, however, Alaimo steps aside to reconsider its investment in the power of an image to touch a public and alter its attitude toward ecotoxicity. Another thought crossed her mind: "The problem . . . is that contemplative or psychedelic practices have an association, in Western culture at least, with a navel-gazing, spiritual transcendence—the exact opposite of the sort of materially immersed subjectivity I think is necessary for environmentalism." In the end, an image of dissolve courting an incipient environmental consciousness is "useless in terms of social justice and climate justice."[14] In itself this episodic admission of inadequacy is not pointless. It is propositional.

We know from lyric poetry that the trope of inadequacy can be an expression of a disappointed desire. Alaimo's feeling for the uselessness of an exquisite image internalizes a widespread disinvestment in the value of humanistic inquiry. What if my investment in the visual promises of an image that could transform my relation to a world under erasure were as empty as the shell at its center? Why bother with climate justice if my engagement with the transformative value of the signifier leads nowhere and yields nothing? Why fund environmental humanities when toxic remediation or bioengineering could use more funding? The propositional and pedagogical dimension of that particular form of disappointment is what I designate by the Vanitas hypothesis.

Claims to historical continuity between baroque allegories of transience and marine biology are not what's up for debate in the previous example. The point is not to make the time-lapse image of pteropod

shells dissolving in acidic seawater more useful or less useless by calling it a vanitas, as if this were enough to substantiate the tenuous value of environmental claims issuing from humanistic inquiry. It is to recognize the volatility of the situation in which the claims of an image (or a text for that matter) to the world are understood to exist. Dutch still-life painting, in Norman Bryson's argument, flourished during a period of transition between two modes of accumulating and spending: from a model of dealing with surplus mostly governed by seasonality and one in which surplus wealth called for new regulatory mechanisms.[15] Still life is a site where historically the value and valuation of images, that is, the transfer of value, moral or otherwise, from things represented, whether humble or ostentatious, to the images that represent them—and vice versa—has been debated and experimented with. Calling a still life vanitas is to call out what's unwarranted in it and about it. It is to divest oneself from the moral failings of representation in general. But it is also a way to reinvest meaning in an image that loves the "so what?"[16] Still lifes are not really interested in telling a story and are entirely unafraid to do away with the human form along with the idea of a world revolving around the human form.

The Vanitas hypothesis is less about vanitas as object of inquiry located in a time and a place than about the feeling for a disappointing relation to images and other representations of the world. It is a feeling whose admission to pointlessness constitutes an ecocritical achievement in the Anthropocene present even though from the vantage point of a socially committed environmentalism the vanitas image is a bad object.[17] Yes, the glimpse that the Vanitas hypothesis affords at a world of reflexive pointlessness will seem at odds with the urgency of our Anthropocenic predicament. But that too—the feeling that there is too much to lose in this very moment of ecopolitical precarity—is an affective marker and, as such, a marker of the present, whether or not you want to call it the Anthropocene present.[18] The Anthropocene may be the geological age of humankind and an age of intensified environmental degradation, but from the perspective of the Vanitas hypothesis it might just as well be an age of indifference toward the life and death

of texts and images and, by extension, toward the value of humanistic inquiry.

Now, some say, is not a good time for theory. For the time being, experiments in pointlessness will have to wait or remain suspended until further notice. This sentiment and the retreat from a formalist commitment to the life of representations and from the study of non-referential language that it signifies amount to what Claire Colebrook has described as the triumph of nonnegotiable facts.[19] In this post-the-oretical state of affairs, the turn toward new realisms, such as Earth system realism and deep time realism, leaves ecocriticism very little to work with: "Science yields facts while the humanities trade in the effects and packaging of those facts."[20] And so environmental humanists trade facts for representations or representations for facts in an effort to make the study of representation more relevant, to catch up with the present in a move that belies the anachronism of literary studies in the research university.[21]

The ecocriticism that either resists or queries the straightforward-ness of these transactions to better dwell with wayward figures could be described as ecocriticism in a minor key. The Vanitas hypothesis plays along these lines by harnessing "the aesthetic energies of close reading" and seeking out the volatility of representations.[22] It accounts for the fact that texts, images, and, more broadly, artifacts do not exist in time outside the scenes, scripts, and scenarios that invest them with prospects of continuity and stability. The result is an ecocritical exper-iment in being stuck with a past that stays with us in its obsolescence, sometimes its toxicity. Stuck doesn't mean indifferent.

This unorthodox approach to ecocriticism is likely to be greeted with some resistance, in great part because of its concerted move away from the promise of representation and continuity that the idea of prece-dence affords (in the form of environmental memories, for instance, as I explain in Chapter 2). When artists, writers, and scholars in humanistic fields are invited to have a seat at the table where environmental con-cerns are raised, debated, and policed, it is usually on the assumption that they have what it takes either to amplify calls for action or foster

long-term thinking. Instead, this book invests in a future where early modern memories of the world deposited in allegorical engravings, still-life paintings, landscape paintings, chronicles, fairy tales, and lyrical fragments will continue to invite our attention, even when a scalar shift from the subject to the species will have made history an irrelevant project—to paraphrase Stephanie LeMenager. To be clear, the point is not to salvage these memories before they are all gone. It is to refine our understanding of what is entailed by their erasure in the Anthropocene present, including nondestructive forms of erasure that make a corpus of texts and image irrelevant, unrelatable, untimely, and out of step. It is precisely that feeling for quieter forms of destruction going unnoticed in the midst of the spectacular negative projections that saturates the Anthropocene present that the Vanitas hypothesis seeks to recapture.

From that statement, the reader will deduce that the Vanitas hypothesis is not a solution to ecopolitical impasse, only a source of non-indifference toward historical texts and objects that are neither entirely relevant to the representation of our planetary concerns nor entirely disposable. It is only an interpretive scenario in which the failure of an image to deliver on an impossible promise to undo, or simply correct itself, is not reason enough to rescind the initial investment in it and ditch representations for facts—even with the knowledge that facts are representations that have achieved a certain degree of stability.

In the realm of early modern vanitas images, the expression of contempt for the worldliness of the world doesn't have to be incompatible with a loving investment in the naturalistic reproduction of the very object of contempt. In seventeenth-century Europe, for instance, seashells are both exotic *naturalia* treasured by wealthy collectors and objects of moral contempt indicted by emblem books as yet another example of vain pursuits.[23] As such, valuable specimens are certainly not out of place in a tableau of discarded riches indicting the worldliness of the world and nacreous whorls.[24] But if seashells are in their pictorial element with vanitas painting, it is also because their spiraled intricacies solicit the kind of dazzling realism that only a still-life painting

can offer. Svetlana Alpers understands the mimetic achievements that characterize seventeenth-century Dutch painting as an aesthetic informed by scientific discourse and discoveries. For her—contra Roland Barthes's observations on Dutch painting and its world of wares—still lifes do not display objects "for use, or as a result of it, but for the attentive eye."[25] If the exquisite image of the shell stands for something, it is first for an attentiveness toward a world exposed to the same inquisitive gaze that cuts into fruits, cheeses, and bursting pies; looks into toppled cups; and cracks open walnuts to reveal the cerebral structure of the meat within the shell in a miniaturized forensic ritual of sorts.

There are visual circumstances in which the rotating views of the same object, or same class of objects (walnut, glasses, seashells, etc.), afford fuller access to the object represented, and others yield opposite outcomes. In five of the still lifes painted by Sebastian Stoskopff, the aggregate of glasses, some intact and others damaged, composes a crystalline bouquet, sometimes surrounded with shards of glass by way of fallen petals.[26] Stoskopff's glasses are artifacts aspiring to eco-factuality. His glasses are unmistakably glasses, and glasses of the finest craft, but they are arranged in such a way that they become almost floral. The number of cups that the composition manages to cram into a basket implies sociality. In a sense, there is no surface more social than a table laden with glasses. And yet the attention to transparency seems less convivial than elemental, or even phenomenological—very much in line with the constitution of a visual field where "wood is shaped, paper curled, stone is carved, pearls polished and strung, cloth is draped, . . . metal is imprinted . . . fashioned . . . sharpened, . . . turned . . . or molded."[27]

Stoskopff's rendition of transparency is an elegy to glass. However, unlike the glass elegy composed by Pierre de Ronsard in 1555, it has shed its lyrical trappings.[28] His bouquet of cups is no longer the instrument of gathering and quenched thirst but a burst of transparency that lets light and darkness through but resists Ronsard's insisting apostrophes ("O joly verre . . . Verre joly . . . Toi qui . . . Toi qui . . . Toi qui"). In Stoskopff's still life, the poet and the painters may have claim to the glass,

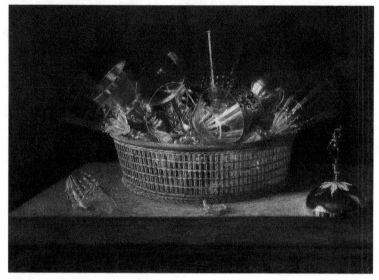

**Figure 2.** Sébastien Stoskopff, *Corbeilles de verres* (1644). Oil on canvas, 52 × 63 cm. Strasbourg, Musée de l'œuvre Notre Dame de Strasbourg. Photo Musées de Strasbourg: M. Bertola.

both the object and the substance, through its representation in verses and in painting, but their transparency is not theirs and will never be. So much then for the fantasy of a world entirely within reach and fully humanized. In "The World as Object" (1953), Barthes explains that still-life painting in the Low Countries belongs to a postmedieval world made of tangible things and made tangible by the things it depicts as either consumed or consumable.[29] The essay is essentially a meditation on what it meant for the Dutch painters to imagine themselves as if they were, in Descartes's dictum, "the lords and masters of nature" and as if painting were one of the "devices which would facilitate [their] enjoyment of the fruits of the earth and all the goods we find there."[30] In it, Barthes seems disinclined to engage with the omnipresence of vanitas motifs as if the focus on the ontological and stylistic emptiness of the objects populating still lifes was enough. He doesn't engage either with the seashell motif—with the exception of the less mysterious shucked

oysters. Is it because the usefulness of the shell eludes human interest? The shell provides an inside in which to take refuge, but the mineral interiority it offers will likely seem too baffling for modern subjectivity to feel at home in it, even when nautilus shells are carved and mounted to become a contrived sea chalice. It remains undomesticated.[31] In a visual field where everything can be accessed as a surface, the shell, whether it is made of wood, metal, glass, or calcium carbonate, is both an opened form and a form with an opening. Nested between coins and the coils of a pearl necklace, a pocket timepiece in Adriaen van Utrecht's *Vanitas Still Life with Flowers and Skull* opens like a clam.[32] The books displayed next to a skull and a precious seashell in Harmen Steenwyck's vanitas at the Museum De Lakenhal in Leiden become by contamination shell structures emptied of their legible content.

In Barthes's essay, Dutch painting occupies a liminal position. It is both inside historical time and on the precipice of something else that is yet to be named: it was once a new development in the history of representation ("where once the Virgin presided over ranks of angels, man stands now, his feet upon the thousand objects of everyday life, triumphantly surrounded by his functions") and at the same time a terminal projection in which humankind "know[s] no other fate than a gradual appropriation of matter. [There are] no limits to this humanization, and above all, no horizon."[33] On the other side of still-life history and in lieu of a temporal horizon, the horizontal untitled assemblages of plastic cups imagined by Tara Donovan (born in 1969) finds a past in Stoskopff's baskets of glasses. Plastic cups have a future. In fact, their social and single-use life is but a small segment of a much longer useless elemental life as trash and pollutants. Our thirst and our celebratory gatherings are not their destiny. They have an existence of their own as a temporal mass that clogs the future. Their unwanted endurance is such that, to a certain extent, they are the future in the present. Whether they hang from the ceiling like a foamy cloud or rise from the floor like a translucent topographical membrane, Donovan's installations are the allegorical counterparts of a plastic duration beyond sociality and conviviality. While still-life rendition of shells in seventeenth-century

painting is born from the asymmetry between the exoskeletal function of the seashell and its afterlives as a delightful *naturalia*, her aggregates of cups occupy the asymmetry between object and usage in a world where the endurance of suffocating stuff is less mineral than plastic— and toxic (more on that in Chapter 3).[34]

This dialogue between objects that art historical categories and literary periods have kept separate is at the heart of an argument that favors experiments in temporal cohabitation between diverging temporalities. It is a way for me to explore what lies beyond the presentism of environmental humanities and the controversial assignation of a geological present to the age of humankind. It is also my way of confronting the role assigned to the study of the early modern past at a time where the Anthropocene hypothesis urges us to assign a role to nonhistorical time in the study of the past and field pressing questions: What are the narrative forms and other forms of durations that are available to us to feel historical in the Anthropocene present? How do we let a disjunctive temporality that projects both the erasure and the legibility of the historical record into the study of the historical record without destroying by the same account all interpretive efforts? What does it mean to remember the claims of early modern depictions of the world in a world where glaciology and geochemistry also "remember" the world, although in other terms and by different means? How do we keep on reading and bear with the work of representation in the light of extinction?

Following in the steps of Aranye Fradenburg and Carla Freccero's search for an alternative ethics of history, what early modern stands for in this book is not indexed on the position of objects from the past in a time line where they tell the story of how we got where we think we are now (on the other side of modernity, in an impasse, on the cusp of something else, cautiously confident, or bitterly deflated) but a "zone wherein we can open ourselves to finitude, to new and rich relationalities."[35] The Vanitas hypothesis takes the risk of sourcing alternatives to indifference and erasure at the limit of the historical record, in places

where historiography meets projection modeling (Chapter 1), climate time (Chapter 2), toxicology (Chapter 3), biodegradability (Chapter 4), Earth system science (Chapter 5), and tissue engineering (Chapter 6).

Each chapter finds its bearings through a series of stretching exercises that explore on a trial basis what it means for the Anthropocene hypothesis to create both conditions of obsolescence and flourishing for humanistic inquiry. Each presents a repertoire of gestures and concepts that have for centuries underwritten the recording of the world (as still life, landscape, allegory, travelogue, etc.) to the test of having to account—and to fail to account—for the unraveling of the world in the Anthropocene present. In this method, the past I have in mind is less an untapped source of wisdom than a reactive agent that strategically downplays the posthumous legibility that the Anthropocene hypothesis promises on the other side of time and probes the idea that only geological time can accommodate the legibility that a geology of humankind demands from the world. The resulting reactions are observed through the lens of a motif in the Anthropocene vanitas that I paint: Canvas, Debris, Toxics, Paper, Ark, Meat, and Light.

Chapter 1 locates a desire for non-indifference toward the historical record in an attempt to think differently about the omniscience of projection models that let the future into the present while generating as their by-product a past that never was and thus cannot be remembered. Thus, difference will be recovered in the form of memories of the world. That is, as projections from the past with temporal ambitions of their own—starting with a seventeenth-century canvas painted by Cornelis Norbertus Gijsbrechts to give the illusion that the image is about to peel away from the frame underneath and eventually self-destroy. The projections gallery also includes Richard McGuire's graphic novel *Here*; Steven Pacala and Robert Socolow's stabilization wedges diagram paired with Alan Weisman's ecocritical fantasy *The World without Us* and Balthasar van der Ast's *Still Life of Flowers, Fruit, Shells, and Insects*; and Galle/Stradanus's *Allegory of America* paired with the Orbis hypothesis.

Chapter 2 focuses on the notion of environmental memory, which I

understand as a way of letting planetary time enter the historical record. Environmental memory hypothesizes that in its stillness landscape painting, for instance, bears witness to something it did not know it witnessed. If the belated negative knowledge that comes with this postulate can be retrieved as information by historians and ethnographers, it can also bring to the fore temporal relations and debris that will not be fully reabsorbed by environmental history but lend themselves to unanticipated interpretive articulations extending the reach of early modern landscapes—and icescapes—into the Anthropocene present.

Not all alternative ethics of history are life affirming. The emergent temporal relations Chapter 3 grapples with are mostly toxic. The toxicity it seeks to describe is at once chemical and affective, anecdotal and systemic, spectacular and hard to assess, forensic and fabulous, measurable in soils and bodies contaminated by a banned pesticide and deposited in their stories and the stories of other bodies before them. It is a toxicity whose future needs to be written by litigation and practices of environmental remediation, but whose past I reclaim in the early French Caribbean chronicles written by Jean-Baptiste Labat outside the purview of modern toxicology.

Vanitas painting has a thing for paper. It has an intuitive understanding of its medial properties as exoskeleton of knowledge, wealth, and sociality. Vanitas paper is at once a bearer of legible signs in the form of an opened folio, a notarized deed, a music sheet, or an almanac, and a foldable surface whose temporal existence is impenetrable to meaning—the rolled-up document in David Bailly's *Self-Portrait with Vanitas Symbols* (ca. 1651) has the same mineral density as the clay pipe with which it is visually rhyming. In other words, it is at once a matter of interpretation and conservation. Interpretation and conservation are usually kept separate so as to let interpretive practices invest objects and stories with full confidence that they will be available to interpretation at any given future point in time. Chapter 4 turns to texts by Jean de Léry and François Rabelais that may not be so confident in matters of continuity and durability and recovers their lack of confidence as a mode of engagement with a different relation to the historical record

and its medium. With this stretching exercise, I argue that it is not only possible but somewhat urgent in the Anthropocene present to consider what an old media—early print culture—has to say about a temporality of the trace that is not necessarily the one humanistic inquiry has traditionally envisioned in philological terms.

The ark of Chapter 5, *arca* in Latin, is at once a place of death in the form of a box large enough to bury a body—a coffin, for instance—and a place of refuge. It is also by creative contact with an oil painting by Isabella Kirkland in 2004, the shallow recess of a still-life painting dedicated to extinct species. The Ark motif solicits memories of fragility and thriving deposited in a fairy tale—Charles Perrault's version of "Puss in Boots" (1697)—in an attempt to read the geoengineering manifesto behind the Pleistocene Park project in Siberia as an experiment in storytelling. The point is neither to aggrandize a fairy tale nor to belittle the ambition of a geoscientist. Rather, it is to challenge what it means for scholars of the premodern past to engage with ecology and environmental discourse as something other than a gateway to modernity for stranded knowledge retrieved just in time to achieve relevance and save the future.

Chapter 6 proposes to stage one more encounter between a twenty-first-century project and early modern objects to paint a still life with in vitro meat. IVM, also known as lab-grown meat, is a prospective source of animal proteins that looks like meat, has the potential to taste like meat, and is healthier and cleaner than meat (because it leaves out the messy parts). IVM is meat in every respect but for its memory of animal death. It is consumable flesh reduced to its protein structure. For now, IVM exists mostly as an image and is consumed as an image, or, on the occasion of highly mediatized taste tests, as a prototype. It projects a future in which meat could be consumed without afterthoughts, consumed like an image but outside the history of its representation. The ambition of this last chapter is to trade IVM claims to futurity for memories of painted flesh offered to image theory in the form of trompe l'oeil painting and Netherlandish still lifes featuring meat and butchered animals next to living counterparts.

Finally, a brief candlelit Epilogue brings the book to a flickering end by soliciting memories of extinction deposited in crepuscular tableaus painted by French Renaissance poet Pierre de Ronsard. Again, the unity between this wide-ranging collection of verbal and visual objects is not located in the past where early modern sources and their claims to the world originate (and are destined by history to return eventually) but in the present in which they survive as cultural objects rather than as statements about Nature (and the nature of things, the toxic nature of certain relations, the temporal nature of a landscape, etc.). Remembering the world through them in the Anthropocene present is not an inconsequential gesture. It is a recognition that the forms and narrative and visual forms deployed by environmental activists, glaciologists, geoengineers, and tissue engineers to reinvest a world on the brink with a sense of continuity have created conditions in which to engage anew conventional modes of relating the world to its representations. It is these conditions that the formulation of a Vanitas hypothesis sets out to explore.

# CHAPTER
# ONE

# Canvas

## Gijsbrechts's Hypothesis

Why linger on an image when instead you could join the rebellion against extinction (XR)—a movement initiated in June 2018 by a group of British activists calling for the renewal of political structures through nonviolent civil disobedience? Fair enough. Still, it bears mentioning that the symbol adopted by XR borrows directly from the baroque allegorical tradition: "The circle signifies the planet, while the hourglass inside serves as a warning that time is rapidly running out for many species."[1] The hourglass and the orb—whether in the guise of soap bubbles, vases, or even whorled seashells—are familiar motifs in early modern vanitas painting. The only thing missing in the symbol adopted by the extinction rebellion to complete a fully fledged vanitas tableau is a human skull. That's one way to look at XR and a visual memory of eco-anxiety in the present. Another would be to consider images from the vanitas tradition in an eco-anxious light that is foreign to them. The *Vanitas Still Life* painted by Cornelis Norbertus Gijsbrechts, now in the Boston Museum of Fine Arts, offers a case in point when it comes to considering what is visually available to eco-anxiety in an image that knows nothing of it.

The top right-hand corner of Gijsbrechts's canvas is made to look as if it had started to peel away from the frame and fold over the rest of the painting in a striking trompe l'oeil that simultaneously reveals the pictorial nature of the vanitas display inside the stone niche with its tutelary

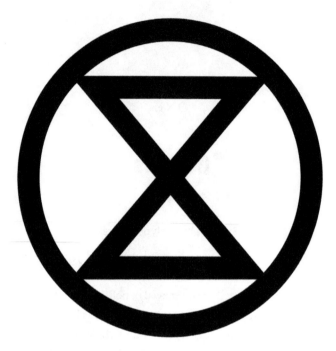

**Figure 3.** Extinction rebellion symbol.

skull and the "bones" of the tableau underneath the membrane of the image that shows signs of decay. The message is clear: everything is vain, even the medium. By internalizing, or perhaps, in an attempt to internalize its self-destroying precept, the vanitas image locates its pictorial claims in a state of partial adherence between the intact painting and the vision of its altered state, between the investment in the image and the failure of the image to deliver on its dour promise. In this scenario, the folding canvas acts like a projection. It stakes a dual state of receptivity to the pull of entropic forces that threaten the historical record with indifference but also to the affective force of the past—and its old trinkets.

Gijsbrechts's metapictorial stunts represent the culminating point of a period of intense experimentation with painting's claim to reality in Northern Europe.[2] With its unwavering focus on transience and its willingness to put the narrative properties of its medium to the test,

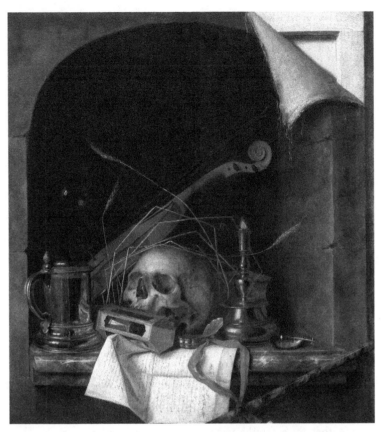

**Figure 4.** Cornelis Norbertus Gijsbrechts, *Vanitas Still Life* (1667–1668). Oil on canvas, 33 1/4 × 30 3/4 in. Museum of Fine Arts, Boston. Abbott Lawrence Fund. Photograph © 2023 Museum of Fine Arts, Boston.

Richard McGuire's three-hundred-page graphic novel *Here* (2014) returns us to that moment of experimentation. *Here* has received insightful critical and ecocritical attention for its daring treatment of deep time as both planetary and intimate, world building and minimalist, but I would argue that what is environmental and yet unrelatable about it never comes to light more starkly than in contact with Gijsbrechts's *Vanitas*.

McGuire's visuals bring a metapainting tradition to bear on a *scène de genre* set on a double page in the corner of a living room. In the

printed version of the graphic novel, the fold of the page coincides with the corner of the room to form a template in the etymological sense of the term *templum* in Latin. Before *templum* came to designate a consecrated built enclosure, it was understood as the mental casting of a gridded space along horizontal (east to west) and vertical lines (north to south), on Earth or in the sky where, for instance, the flight patterns of birds and the direction of lightning exist as signs to interpret.[3] It means that the corner of the room in *Here* is always there on the folded page and as a folded page, even before its construction in 1907 and after its anticipated destruction by water in 2111. Like the peeling canvas in Gijsbrechts's *Vanitas*, the room exists in a state of partial adherence with a nonlinear time line spanning eons, from 3,000,500,000 BCE to 22,175 CE. *Here* allows the reader to pretend "that our past, present, and future are connected." To be sure, they are not necessarily connected in anybody's mind and "by a certain continuity of human experience" but by the formalism of embedded time frames that both interiorizes the "collapse of the age-old humanist distinction between natural history and human history" and stretches the memory of the room to its limits.[4]

Animals (bird, bison, dinosaur, donkey, cat, cow, deer, hummingbird, wolf, a speculative marsupial) move in and out of the room and in and out of the page. People too. They have a life; they have a routine. They gather for a family portrait repeated at regular intervals. They answer the door, they chat, they fight, they play, they clean, they have parties where they put on a bear or a dinosaur costume. They have a viewing. They think out loud and tell jokes. They argue and seduce each other. They swim in the lake that was there centuries before the existence of the house and its corner room. They exist in a capacious meantime that doesn't occur to them most of the time—with some exceptions, as in 2213, when they visit the site the room occupied in the twentieth century. Or in 1999, when they learn from a TV program that one day in a distant future the sun will expand and absorb all the neighboring planets.

The landscape temporarily and partially obstructed by the presence of the corner room changes with time and marks time: the vibrant at-

mospherics of the Archean make way for a Cretaceous forest. Ice makes way for marshes, and receding marshes become a forest. In the Anthropocene, rising sea levels return the interior to water. Water recedes again sometime in the twenty-third century. The decor changes too. Wallpapers come and go along with upholstery. The nondescript landscape painting hanging above the fireplace is replaced with a mirror, a star-shaped clock, and eventually a flat-screen TV. An art poster reproducing Johannes Vermeer's *Girl Reading a Letter at an Open Window* comes to replace and repeat another Vermeer, *Woman Reading a Letter*, that hung on the left wall in 1943. The permeating presence of these two seventeenth-century domestic vignettes throughout the graphic novel is compelling. The epistolary motif in the paintings mirrors the generic dispositions of the graphic novel as an all-absorbing visual and verbal assemblage. The mirroring effect also obtains at a more formal level as soon as one realizes that Vermeer's paintings, just like *Here*, are made up of embedded rectangles—window embrasures, windowpanes, tabletops, chairbacks, a map on the wall, the lines created by the curtain rod—held together within a frame despite their belonging to different visual, material, and temporal realms.

On the wall adjacent to the Vermeer, on the other side of the fireplace, and at the other end of the same experiment with rectangular forms, an abstract painting reminiscent of Malevich or De Stijl adds another element to the inner genealogy of McGuire's graphic novel: the visual dominion of the modernist grid at the beginning of the twentieth century. In the words of Rosalind Krauss, the grid promised a return to the pictorial surface as the "indisputable zero-ground beyond which there is no further model, or referent, or text" but always failed to fully deliver on its promise. It failed because in the end, all that the grid did was create a state of partial adherence that

> summarizes all these texts: the gridded overlays on cartoons, for example, used for the mechanical transfer from drawing to fresco; or the perspective lattice meant to contain the perceptual transfer from three dimensions to two; or the matrix on which to chart harmonic

relationships, like proportion; or the millions of acts of enframing by which the picture was reaffirmed as a regular quadrilateral.[5]

In that sense, the flattening pretenses of the modernist grid in visual arts mirror the promises of the Anthropocene hypothesis to land a present beyond fiction and representation in the realm of nonnegotiable facts about the world as it starts, as it ends, and as it stands, as if the flattening power of geological time on that present was not already an expression of the power of certain images and scenarios to summon visions of an uninhabitable Earth.[6]

The grid may have failed in its modernist promises, but now, as far as the Vanitas hypothesis is concerned and because it has so relentlessly sought to evacuate history and what art history thought of nature as the horizon beyond the window, it is perhaps just the kind of formalism we need to live among the ruins left by the "collapse of the age-old humanist distinction between natural history and human history" and, why not, even find comfort in its state of partial adherence.

## Weisman's Hypothesis

Why bother with the early modern visual record if geology wins in the end? When, to quote Elizabeth Kolbert, "a hundred million years from now, all we considered to be the great works of Man, the sculptures, the libraries, the monuments, the museums, the cities, the factories will be compressed in a layer of sediments not much thicker than a cigarette paper"?[7] Logics of partial adherence suggest that it is because in the meantime, like vanitas paintings of a bygone era, flattening views from the geological nowhere "cannot escape being pictures."[8] In the end—as defined by the Anthropocene hypothesis—landscapes of extinction and previews of humanity in its fossil state exist as part of the civilizational record they simultaneously mourn and destroy at will in an attempt to model what it means to be both capable of planetary agency and still feel historical.

In a way the Vanitas hypothesis is about the status of humanistic in-

quiry in an ecology of knowledge driven by predictive models and other images of a future on the brink. Think hockey stick graphs, Hubbert peak theory, Pacala and Socolow's stabilization wedges, or the more recent planetary boundaries diagram. Or "suppose," as Alan Weisman writes in *The World without Us*, "that the worst has happened. Human extinction is a fait accompli. . . . Picture a world from which we all suddenly vanished. Tomorrow."[9] The point of such an apocalyptic prompt is not solely elegiac. It is to take stock of humanity's collective impact on the planet and to assess the differential speeds at which the present as we know it will be erased. From the perspective of ecopolitical mobilization, the prompt is more paralyzing than programmatic. Soon enough, Anahid Nersessian observes, the "vertigo of dread . . . dissolve[s] in the realization that we are not there yet."[10] There is still time to act, but when the time comes, it will be too late. Soon enough, the conjectural thought of a world without us quickly fades into fantasy— not because extinction scenarios are improbable but because we can relate to them only in the register of fantasy, as a version of the fantasy of surviving oneself as an unscathed spectator. If dread fails to move us, no matter how vertiginous the feeling, then let's try something different instead. Let's remember Weisman's invitation to picture a world without us in the pictorial register of Balthasar van der Ast's *Still Life of Flowers, Fruit, Shells, and Insects*.

Everything on the still-life table laid out by Van der Ast is marked by culture: a finely woven basket, perfectly formed fruits, a fabulously expensive tulip in a vase, a collection of exotic seashells, and the painting itself as an artful deposit of pigments and gestures. The products of human industry form the backdrop of the untold battle of the spider and the fly, the lethal raid of a lizard, the tragedy of the carnation bud that never bloomed, and, given enough time, the epic advances of mildew spreading through the grapes. The depiction vouches for accuracy, and yet the result set against a monochromatic stretch of painting that leaves only the slightest visible sense of a line of horizon is rather vague in what it is trying to achieve. Its pretenses remain unstated and perhaps elude conceptual thinking and language

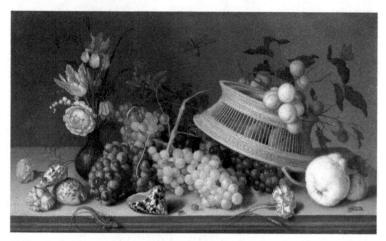

**Figure 5.** Balthasar van der Ast, *Still Life of Flowers, Fruit, Shells, and Insects* (ca. 1629). Oil on oak panel, 7 1/8 × 29 1/4 in. Birmingham Museum of Art.

altogether. Weisman's thought experiment brings us closer to a state of immutability that is apparent in the still life only as a miniaturized collapse of civilization. Getting closer to the painting means accepting its decentering terms. Van der Ast's image is a still life for the beholder but a landscape for the critters that have invaded the frame to take, or retake, possession of what was formerly a human domain of representation, after dark, after we have left the room, or Earth altogether. It's impossible to tell whether the world pictured in *Still Life of Flowers, Fruit, Shells, and Insects* has come to a halt or to an end. Besides, the world has already ended many times; it ends a little every day; many people the world over have been living after the end of their world for a long time now.

Clinging to the edge of the table, where the tableau meets the space from which the painting is viewed, a lizard hides from the bugs on top of the table. Mostly visible to us and despite the best intentions, we share in the reptile's predatory viewpoint of the scene that finds our presence unremarkable. The lizard figures as a point of reentry into the world that "some respected voices warn, could one day degenerate into something resembling a vacant lot, where crows and rats scuttle among

weeds, preying on each other."[11] It is not my suggestion that Weisman's words paint a broader picture in which Van der Ast's image can fulfill its destiny as one of many missing pieces in the open-ended jigsaw of history, art history, environmental and climate history. Rather, they speak to the posthistorical nature of still-life painting. Hanneke Grootenboer explains on this subject that the shallowness of *natures mortes* undermines both the promise of depth offered by representation in perspective and, modeled after the promise of perspective, the "yearning to see the artwork in its own time."[12] That's why one could say that the Anthropocene hypothesis is at home in the shallow recess of still-life painting. It gives to the unassuming image painted by Van der Ast a vertiginous sense of depth that is not, and need not be, structured by a line of horizon. It is as if his *Still Life of Flowers, Fruit, Shells, and Insects* had to wait for Weisman's prompt to deliver its full effect, not because it was a matter of prescience or precedence but because in that visual scenario, the ephemeral vertigo of dread prompted by a mass-extinction hypothesis achieved duration in the form of an actual image painted four hundred years ago. I understand this duration as a critical achievement, not because it secures the historical identity of a cultural object in planetary time but because it contends with the temporal contours that such an object draws and redraws in a climate of uncertainty regarding what the contours of the present are supposed to be or feel like.[13]

In risk theory uncertainty is the affective background against which some things come to exist while others fail to register. Uncertainty can be mobilized (in the form of preparedness exercise scenarios) or resisted (in the form of environmental activism). Uncertainty is not what lies on the outer limits of knowledge and action. It designates a new frontier where emerging governance models and projection models convert incalculable risk into actionable intelligence. The Vanitas hypothesis is my version of what Adriana Petryna calls horizoning work: a form of "intellectual labor that reconfigures possibilities for knowledge and action" in an age of faltering projections.[14] It is a version in which the untenability of prognostic models has a duration that allows us to stay with the thought of a world stranded between daily erasure and cata-

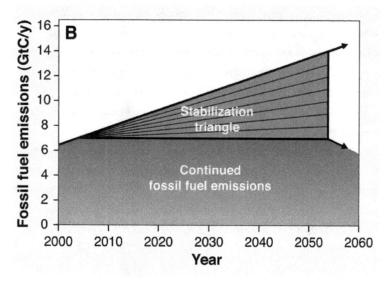

**Figure 6.** Pacala and Socolow, "Stabilization Wedges," 969. Reprinted with permission from AAAS.

strophic tipping points.[15] The Vanitas hypothesis doesn't mend perceptual tears in the fabric of the Anthropocene present by quietly returning objects from the past to a historical time made of concatenated phases, periods, and centuries. It seeks to understand the magnetizing effect of the idea of a geological age of humankind in a volatile present where predictive science rather than historical time has come to occupy the widening gap between anticipation and incalculability.

Take, for instance, the stillness that the stabilization wedges diagram devised by Pacala and Socolow sought to achieve. Their much-reproduced model visualizes a compromised temporal horizon projected on the $x$-axis of time, while the $y$-axis represents fossil fuel emission. The coordinates offer a series of paths set at different angles forming concatenated wedges. Each represents a series of known mitigation strategies whose cumulative effort aimed at restoring something that looks like a horizon—as opposed to an ascending curve. The upper path forming the widest wedge leads to a state of lessened climate stability that corresponds to the doubling of atmospheric $CO_2$ fifty years

down the road, starting in 2000, in the absence of mitigation scenarios. The lower path forming the narrowest wedge and the closest to a horizontal line corresponds to a scenario of intensive mitigation, in which the atmospheric $CO_2$ has remained constant. In 2011 and 2013 more wedges had to be added to the 2004 version of the diagram to catch up with a reality in which the initial projections were faltering.[16] Meaning that much more work was now needed to flatten the curve, that many more mitigation strategies would have to be implemented, and that projections and models do not exist outside time. The future never lasts forever. If at some point, Petryna comments, the diagram could pretend to offer a view through uncertain times, it has become by now "a parable, of sorts, about a further unmooring from safety and danger."[17] It was meant to be akin to a landscape view into the future. It is now the equivalent of a still life set against the blank stretch of an absence of horizon. With time, faltering projections too become conversation pieces.

The stillness pervading *The World without Us* has less to do with the realization that, according to the Preacher, "generations come and generations go, but the earth remains forever" (Ecclesiastes 1:4) than with the realization that, as Dipesh Chakrabarty explains, "to go along with Weisman's experiment, we have to insert ourselves into a future 'without us' in order to be able to visualize it."[18] This means that representing the past and envisioning the future now belong to two distinct domains of operation, each destructive of the other, but whose disjointed state has come to stand for the Anthropocene present. In line with the premises of the book, the next section looks into what it could mean for a historical object—a late sixteenth-century engraving by Theodoor Galle realized after a drawing by Johannes Stradanus—to exist in that disjointed state, or at least in relation to it.

## The Orbis Hypothesis

The engraving in question represents Amerigo Vespucci standing on the shores of the New World in front of a female figure who personifies America. Amerigo appears to her in full conquering garb: an astrolabe and a standard in his hands, a half-hidden sword at his side. America appears to him nearly naked, reclining in a hammock surrounded by exotic animals. Michel de Certeau adopts a rather unexpected perspective on this liminal scene. For him, the image is not a view from the past in the sense that it doesn't commemorate a moment in history. Rather, the engraving posits a contract between a technology of inscription that defines prospects of continuity in time and the future tense of history: "The conqueror will write the body of the other and trace there his own history. . . . She will be 'Latin' America."[19]

For environmental historians, the encounter between Europe and the Americas did not occur in allegorical terms. It corresponds to the clash of two ecosystems known as the Columbian exchange, resulting in the transfer of species, crops, bodies, and pathogens between two continents and a dramatic population collapse in the Americas between 1492 and 1650. In 2003 William Ruddiman was among the first paleoclimatologists to suggest a correlation between the Columbian exchange and planetary history. His model explains that the Amerindian genocide led to a considerable reduction of fire and land use, which in turn led to vegetation regrowth and, at a planetary and atmospheric level, to an increase in carbon uptake. In that scenario, the encounter between Europe and the Americas does not correspond to the naming of the land and its appropriation but to the identification of a decrease in the level of carbon dioxide ($CO_2$) in the atmosphere from 1500 to 1750 CE.[20] It doesn't eventuate into a scene that could be memorialized or allegorized but in a sequence of data points. The environmental history of the Americas is not written on the indigenous body, as in de Certeau's captioning of the Galle/Stradanus engraving, but in the oscillation between population collapse and vegetation regrowth.

In the Galle/Stradanus image, female nudity stands for a fantasy

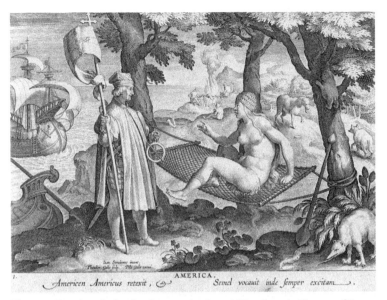

**Figure 7.** Theodoor Galle after Jan van der Straet (Stradanus), *Allegory of America*, from *New Inventions of Modern Times* (*Nova Reperta*, ca. 1600). Engraving, 10 5/8 × 7 7/8 in. Metropolitan Museum of Art, New York. The Elisha Whittelsey Collection, The Elisha Whittelsey Fund, 1949.

of conquest and vulnerability named America. Representing the New World in these terms is already a step toward possession, and destruction. Engraving is a proxy for a colonial project that prints away the world in which it assigns positions of life and death. On the other side of modernity, Ruddiman's diagram vaporizes death into traceable atmospheric variables, as if millions of bodies had found a burial ground in the planetary system rather than in the earth. What found its way into the ice cores is not the last breath of individuals but measurable levels of gas that yield variables and curves. Glaciological and geological deposits are nobody's death and nobody's grief.[21] In the grand flattening schemes of things, geology collapses the human record into a sedimentary layer and strata of indifference in a temporal field leveled by data extraction. The America of Stradanus enters history in a world where continuity in time unfolds in the form of written documents, record-

31

ings, notes, and images. In Ruddiman's diagram, continuity belongs to glaciology, the study of the ice record and the composition of the gases it contains, and palynology, the study of pollen deposits in sediments. The allegorical engraving and the diagram evolved separately and now belong to separate historiographical trajectories: the engraving is the stuff of (art) historians, and the diagram, the tool of paleoclimatology.[22]

The image representing Vespucci's christening of America is the first in a series of twenty prints known as the *Nova Reperta*. The series reads almost like the visual directory of an early modern present seen and captured through notable inventions and technological break-throughs, starting with the discovery of America and ending with the art of metal polishing and copperplate engraving that makes the whole sequence of images possible in the first place.[23] Ruddiman's diagram points toward a history that both predates writing and anticipates a future beyond written records, engravings, and diagrams. It projects us into a future disconnected from any experience of continuity in time, that is, a future beyond historicity, representation, and consciousness. But for now, in a present defined as a moment of transition from one form of continuity in time to another, and from one habitus of peri-odization to another, the diagram remains a representation of the past alongside Stradanus's allegory. Even though the decrease in the level of atmospheric carbon dioxide is legible only as a data point, its graph materiality is embedded in a topology of experience in the same way that remote sensing is embedded in a technological state of affairs and warfare. Even though the dent in the $CO_2$ curve is not a viewpoint that it would be possible to inhabit, it remains a representation and, as such, a site of emerging concerns and questions.

In 2015, two British geographers, Simon Lewis and Mark Maslin, entered the correlation between atmospheric and demographic varia-tions captured by Ruddiman's diagram into the debate over the strati-graphic definition of a new geological period succeeding (or replacing in some models) the Holocene.[24] While the Holocene starts with the end of the latest Ice Age, 11,500 years ago, there is no agreement regard-ing what marks the beginning of the Anthropocene. Lewis and Maslin

put forward two dates, 1610 and 1964, with a degree of chronological precision unusual for geological entities. The year 1610 corresponds to a seven to nine parts per million (ppm) dip in the level of atmospheric carbon dioxide, the lowest point between 1570 and 1620, which the authors identified as an atmospheric consequence of the Amerindian genocide. The other date corresponds to a peak in radioactivity following the detonation of the first nuclear weapon in 1945 and subsequent atmospheric testing, until the Partial Test Ban Treaty in 1963.

Lewis and Maslin's Orbis hypothesis—*orbis* being one of the many Latin words for "world"—is not unchallenged. For Matt Hooley, their proposal "makes Indigenous people and knowledge scientifically legible only in or as disappearance."[25] For Clive Hamilton, not only "nothing happened to the Earth System in 1610," but "the dip, in all likelihood, [is] the result of natural variability."[26] Yes, there was a massive population loss and there is an observable dent on a curve, but the correlation between the two does not make a scene. It does not constitute the place where continuity in planetary time is articulated. It is but a detail blown out to allegorical proportions by a proposal that has at heart to ground the formal definition of the Anthropocene as a geological time unit in the time lines of colonial expansion and genocide. And yet, what 1610 means to the planet according to the Orbis hypothesis has everything to do with the impact of this peripheral scene, lifted from a missionary report dispatched by Father Jean de Brébeuf from the village of Ihonatiria in Huron country in 1635:

> When we preach to them of one God, Creator of Heaven and earth, and of all things, and even when we talk to them of Hell and Paradise and of our other mysteries, the headstrong savages reply that this is good for our Country and not for theirs; that every Country has its own fashions. But having pointed out to them, by means of a little globe that we had brought, that there is only one world, they remain without reply.[27]

The Jesuit version of the Orbis hypothesis is the ultimate rhetorical move. The silencing and dispossessing power of the orb (the little globe)

is brought to bear on the concluding clause. "They remain without reply"—*Ils demeurent sans réplique* in the French original—marks the spot left by a counterhypothesis: This is not the world, only an image of it. This is where your version of the world ends and ours begins. Another translation of the clause, outfitted for the Anthropocene present, might read: "They dwell without replica."

The Galle/Stradanus engraving is a more or less direct expression of the Columbian exchange. And yet, it remains outside the locus of legibility that geology and glaciology posit in a world where everything leaves a measurable footprint, where every gesture, every decision and absence of decision have become accountable to the Anthropocene present. The nature of the link between the allegorical engraving and an atmospheric memory of the Columbian exchange retrieved by glaciologists studying ice-core samples from Antarctica is inscrutable. It is neither historical nor chemical, neither a representation nor a reaction. Despite their chronological proximity (ca. 1600 for the engraving and 1610 for the $CO_2$ dent), the allegory and the Orbis hypothesis belong to different temporal realms, each destructive of the other. And yet, the mannerist engraving survives in the 410.28 ppm present (a $CO_2$ concentration reached in 2017 for the first time in a very long time). Not only that, but it is still possible to read in Stradanus's engraving the plotline of what Europe had invested in the representation of Vespucci's gesture. And if so, to what end? What do the Anthropocene present and the story of its imperialist and genocidal origins mean to the understanding of the New World as allegorical and geopolitical invention—an invention that the *Nova Reperta* puts on par with print culture and the art of engraving?

Allow your eye to linger a little longer on the encounter between Amerigo and America and you will notice on the horizon, where their eyes meet, three naked figures gathered around a smoking fire—or *boucan*—where severed body parts are strewn about. This other scene wedged within the scene of encounter repeats the nudity of America

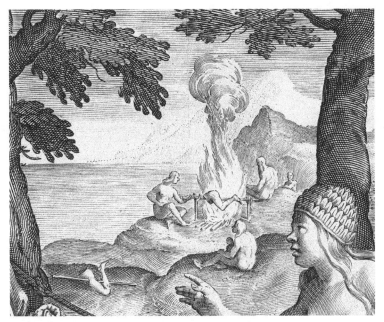

**Figure 8.** *Allegory of America.* Detail.

but infuses it with a predatory subtext. Something is boiling under-
neath the crosshatched surface of the landscape. To be sure, the en-
graved *boucan* is the unambiguous signifier of New World cannibalism
depicted by European travelers—Calvinist missionary Jean de Léry
writes in his *History of a Voyage to the Land of Brazil* (1578), "You could
hardly enter [Tupinamba] villages without seeing [*boucans*] not only
furnished with venison or fish, but also most often . . . you would find
them covered with thighs, arms, legs, and other big pieces of human
flesh from the prisoners of war whom they ordinarily kill and eat."[28] But
given its vaporous nature, the plume of smoke rising from the *boucan* is
also more than that.

    Smoke is a challenging form to engrave in the sense that engraved
smoke is but a smoke effect, the suggestion of something that cannot
be captured by curvilinear patterns, no matter how intricate the pat-
terns. The engraved smoke effect works only at a certain distance and

soon dissipates into an aggregate of concentric lines on closer inspection. I understand this untimely moment of optical dissipation where engraved lines do not add up to signify smoke anymore as a source of partial adherence that blows out the smoke plume rising from the *boucan* to the planetary dimensions suggested by the Orbis hypothesis. In that scenario, Lewis and Maslin's model does not put an end to the allegorical distribution of meaning in Stradanus's image. It recasts the distance between the engraving and the world that an allegory was meant to occupy into a visual continuum between mass death and billowing atmospherics.

## Coda: Negative Projections

An influential report commissioned for the UN Stockholm Conference of the Environment in 1972 explained that "the majority of the world's people are concerned with matters that affect only family or friends over a short period of time. Others look farther ahead in time or over a larger area—a city or a nation. Only a very few people have a global perspective that extends far into the future."[29] The first diagram, "Human Perspectives," visualizes that distribution of concerns between "the majority" and the "very few" across time (next week, next few years, lifetime, children's lifetime) and space (family, business/city/ neighborhood, race/nation, world) on a basic gridded plan. It is the first of many diagrams (or graphs) whose presence throughout the report is integral to the argument developed by the coauthors known collectively as the Club of Rome. If the "Human Perspectives" diagram seeks to give some substance to what it may have meant for them to be visionary, it also functions as a placeholder for a missing body politic defined by the sum of its actions, decisions, aspirations, and projects, past and present, held together in suspension by the magic of a cloud of data points.

Visually, the aggregate of dots is a close enough equivalent to the allegorical sovereign composed of over three hundred silhouettes greet-

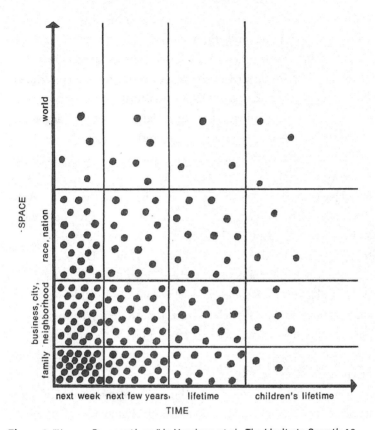

**Figure 9.** "Human Perspectives," in Meadows et al., *The Limits to Growth*, 19.

ing the reader who still dares to reopen *The Leviathan*. Of course, the diagram deals in data points distributed geometrically across realms of perception, not in silhouettes arranged by the hundreds to form the anatomy of a towering giant. And yet, the editorial voice in *The Limits to Growth* explains that the sparsely dotted region of the diagram is imbued with a sense of direction—where the head is ("Our concerns thus fall in the upper right-hand corner of the space-time graph"[30])—while the highest concentration of dots forms a baseline or a torso ("Most people's worries are concentrated in the lower left-hand corner

of the graph"[31]). In that scenario of partial adherence, between diagram and allegory, anthropocentrism sneaks back in the abstract picture to solicit our membership in Anthropos.

Around the same time that the Club of Rome adopted *The Limits to Growth*, a diagram-driven rhetoric of restraint and curtailment, Princeton physicist Gerard O'Neill was floating projects of space settlement in human-made structures large enough to accommodate infinite growth, with all the amenities of suburbanite living and none of its chemical and societal toxicity, all the prospects of a neo-settler society but none of the violence that plagued Earth's colonial past.[32] In 1975, he commissioned on behalf of the NASA Ames Research Center a series of artistic renditions to give both visual and narrative appeal to his vision. The sweeping views from inside the gigantic toroidal structures painted by Donald Davis and Frank Guidice revealed a manicured world enclosed in what in effect is a shell of glass and steel, outfitted with some of Earth's most cherished landscapes: the French Riviera, the Monterey Peninsula, and Tuscan hillsides. Reinvented for the purpose of the colonization of space, the landscape genre serves the function of a behavioral control mechanism in a stress-inducing environment.[33] It is meant to offer a much-needed retreat into a cultural memory of *oikos*—the inhabited world—while redrawing contours of inhabitability, as though the current relation to the given world was not primarily extractive and destructive. No matter how enticing these Technicolor renditions of a world conceived so space settlers would not have to register the finitude of the world they were about to leave behind, there is something terrifying in their courting of the future as a present without duration. The toroidal landscapes make plain for everyone to see how far-fetched the possibility was, and still is, to afford a future built on the societal and visual premises of the present.

Contemporary artist Naoya Hatakeyama, in contrast to Davis and Guidice's space-age picturesque, reclaims his landscape format from extraction by fixating destructive instants. Between 1986 and 1991 he photographed limestone quarries in a recognizable landscape format,

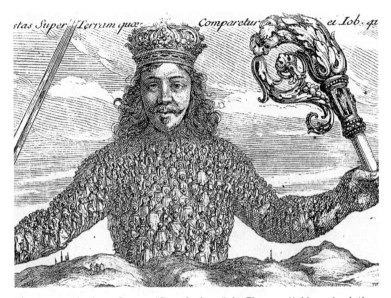

**Figure 10.** Abraham Bosse, "Frontispiece," in Thomas Hobbes, *Leviathan* (London: Andrew Crooke, 1651). Detail. Courtesy of the Holmes Collection, Rare Book and Special Collection Division, Library of Congress.

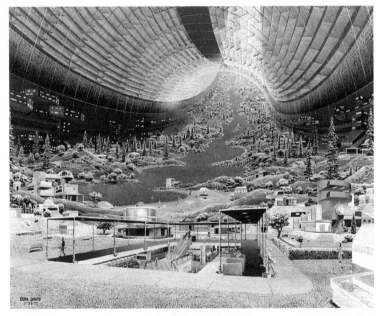

**Figure 11.** Donald Davis, *Toroidal Colonies Interior View* (1975). NASA ID Number AC75-2621. Photo credits: NASA Ames Research Center.

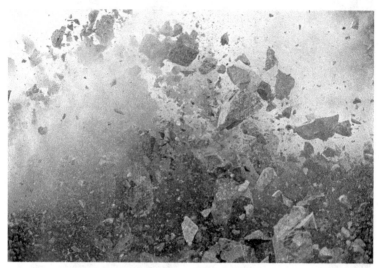

**Figure 12.** Naoya Hatakeyama, *Blast #12022* (2005). Chromogenic prints, 40 × 119 1/2 × 2 in. Courtesy of The Museum of Fine Arts, Houston. Museum purchase funded by the S. I. Morris Photography Endowment, 2008.531.A,B. © Hatakeyama Naoya, courtesy Taka Ishii Gallery. Photograph © The Museum of Fine Arts, Houston; Thomas R. DuBrock.

where rock formations stand still even if conspicuously carved, displaced, and remodeled by human activity. With its stunning images of projected rocks and debris in suspension, the series *Blast* (1995) constitutes a further development in Hatakeyama's photography. In each of the "blasts," the camera becomes a detonator and the detonator a camera. To see is to extract, and extraction, in turn, is just a more destructive form of vision. It is as if the blast—not unlike the possibility of a sudden mass-extinction event in the thought experiment that triggers Weisman's *The World without Us*—were a modality of what Jean-François Lyotard calls *dépaysement*, literally "un-landscaping," that is, the estrangement or disconcertment, without which there would be no landscapes, only places.[34]

Hatakeyma's photograph is an image of something under erasure that can be understood in light of classical theory of representation.

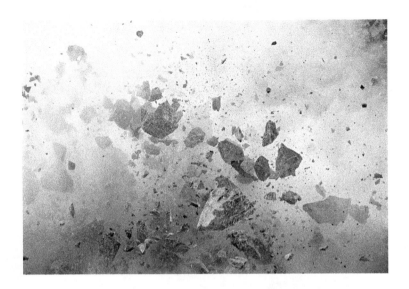

Like still-life painting before it reached generic independence as a stand-alone composition of objects, flowers, and edibles arranged on a plinth or a table, landscape painting, Victor Stoichita explains, was born in the margins of *istoria*—the narrative middle distance devoted to the realm of divine and human affairs. He describes this tiered layering of the painted world where still life appears within reach, history occupies the center, and landscape exists as a backdrop in the background on the other side of a window in terms of a "stratification of representation."[35] But why stratification? Why a geological metaphor? Why not simply "hierarchy"? Whatever was on Stoichita's mind at the time, it is this stratification of a relation to the world too that Hatakeyama's photography ended up blasting.

The expression "stratification of representation" is justified in retrospect by the fact that a blast is the visual (and mechanical) event that undoes the tiered template: still life, narrative history (*istoria*), and landscape. A blast rather than, say, a revolution, a reform, or a restructuration plan. It is also in that sense, in the sense that Hatakeyama's blasts are mineral and visual *projections*, that the tiered template still

life/*istoria*/landscape could exist for him as a memory of the world (rather than as an environmental memory). At a quasi-allegorical level, *Blast* also speaks to logics of partial adherence as a way to let the disjunctive temporality of the Anthropocene hypothesis into the image while maintaining its visual integrity along with the possibility of a perilous dialogue with a history of the landscape format.

# CHAPTER

# TWO

# Debris

Environmental memories form a subset of traces dispersed in the historical and ethnographical record that can be recovered as proxy information on "how human communities have responded in the past to extreme environmental events and variability."[1] In this scenario, the past is a repository of experiments—some more successful than others—and literary texts have things to say about soil erosion, biodiversity, and seasonal patterns once they have been stripped from rhetorical layers of tropes and motifs. The same logic applies to the visual record. To the concept of environmental memory, some art historians and historians of literature are likely to object that the relation between the world and its representations is primarily a matter of aesthetic conventions, according to which the environment remains in the background playing a supporting role or interfering with the main story, not a matter of environmental concerns.

Others, more sympathetic to the concept, may offer a historical backup. On the face of it, much of what is understood today in terms of environmental memory is a historical by-product of what Christopher Braider described as the "proliferation of new 'descriptive' forms and conventions explicitly related to the critical and scientific dimensions of

modern experience: . . . the landscape with its ties to maps and the science of cartography, . . . natural historical records of local flora and fauna; quasi-ethnographic sketches of the exotic dress, physique, customs, and milieu of alien people"—before adding by way of a proviso that "even as the world exposes itself to human scrutiny as never before, it also withholds itself as never before."[2] Another way to script that withholding effect is to refigure the notion of environmental memory as an interface between different versions of the world—the world for us and the world without us, the stilled creaturely world of Van der Ast's painting and the world geochemists describe in terms of the Earth system, the world available as picturesque landscape and the world a Finnish population biologist, Ikka Hanski, exhorts us to picture 30 percent smaller than it actually is so as to train ourselves to extract less from it.[3]

For the sake of the interdisciplinary exercise, some versions of the world are assumed to be more stable than others so that philologists, archaeologists, geographers, and climate scientists can work together and rise to the occasion, which means that in the end the interdisciplinary effort goes only one way and only so far, with very little room budgeted to run a reverse scenario in which the cultural archive whose content is under consideration gets to take the lead and ask questions. The Vanitas hypothesis responds differently to the ecocritical pressure to turn historical sources into resources. It offers neither lessons on how to survive mass extinction and major environmental disruptions nor retrospective diagnoses reconnecting a volcanic eruption with its observable consequences in texts and paintings so that the unity between event and impact can be made whole again and even serve as proof of concept when it comes to understanding "how abrupt shifts in climate affect human societies on global scales and decadal time frames."[4] Rummaging through landscape and icescape debris, this chapter is on the lookout for a more capacious relationship between the world and its representations, one that interrupts rather than rehearses environmental histories in order to trigger our capacity to reimagine, in the words of Déborah Danowski and Eduardo Viveiros de Castro, "a continuity *to-come* between the modern present and the non-modern past."[5]

## The Neuberger Hypothesis

In the 1960s, Penn State meteorologist Hans Neuberger conducted a systematic survey of twelve thousand paintings created between 1400 and 1967, with the premise that "in view of the powerful influence of the atmospheric environment on life on this planet in general, and on man in particular, it would be rather amazing if the artists could have remained oblivious to the weather surrounding them and merely invented whatever weather best suited their artistic purposes."[6] In six thousand of the paintings containing meteorological features, the study of the cloud coverage and morphology (such as low convective clouds) revealed an increase in cloudiness and a drop in the blueness of the skies.

The premise may align with the modern theory of painting developed by John Ruskin (1819–1900) and his description of painted clouds as meteorological entities that epitomize painting's modernity, but from the perspective of visual culture and art history, the argument is riddled with methodological problems. Neuberger does not seem to consider the possible increase in the production of paintings presenting "weather-related features" across art historical periods as a non-atmospheric variable that may have to do, for instance, with the emergence of the notion of landscape itself as an aesthetic category linked to the formation of modern nationalisms in Europe. He does not consider the fact that Renaissance painting lowered the line of the horizon, opening up the sky to the possibility of reflecting cloudiness, or that, in *The Ascension of Christ* (ca. 1460) by Andrea Mantegna, cloud formations are not objects from the atmospheric world.[7] They belong to the theatrical space of medieval plays where machines elevate saintly bodies above the stage and summon angels. There is nothing gaseous about them (but there is something nebular about the rock formations dotting Mantegna's compositions in the panels of *San Zeno*[8]). In another composition, a painted cloud will designate a vision, that is, a narrative and ontological break in an otherwise continuous surface. Or it will originate in an accident of painting—after all, nothing looks more like a cloud than a random stain.

Neuberger's statistical argument remains impervious to these objec-
tions because the logic of aggregation that made the inventory possible
has turned art history into a "blizzard" of images indifferent to their
past and toward the meaning deposited in them.[9] Neuberger was not
trying to show that clouds in painting are actual clouds but to deduce
a "collective experience of cloudiness and transparency of the air in
a given region during a given period."[10] His attitude toward pictorial
representation is a matter of belief in the capacity of painted images
to be referential, almost transparent—as opposed to being coded at all
levels (material, institutional, and conceptual). For him, the premise of
transparency can be tested against existing records in the period during
which meteorological observation is available. It can be encoded as
more or less cloudiness, more or less blueness. It can be averaged out to
entertain the hypothesis of a climatological unconscious of painting in
the Western tradition by melting centuries of art history in a statistical
pool wide enough to reflect planetary time.

British geographer Mike Hulme observes in his review of Wolfgang
Behringer's *A Cultural History of Climate* that, "because scientists make
the claim that past physical climates can be reconstructed, the past
begins to emerge in our imaginations as a past that is climate-shaped,"
adding: "It is harder to understand the prevailing social, cultural and
political milieu of the 16th century than it is to see that rivers were
flooded and glaciers enlarged."[11] Conversely, it is easier to gather evi-
dence of the Little Ice Age in the snowy landscape of Pieter Bruegel the
Elder's *Return of the Hunters* (ca. 1565) than it is to address the volatility
of representation in climate time.

Julie Cruikshank makes a similar point in *Do Glaciers Listen?* It is
easier to treat traditional ecological knowledge (TEK) about glaciers in
the region of the Saint Elias Mountains on the border between Alaska
and Canada as a source of data for climate models than as a possible
model to understand volatile relations of reciprocity between human
and nonhuman forces, between a place and its occupants. Cruikshank
explains that "orally narrated stories do indeed provide empirical ob-
servations about geophysical changes and their consequences," but they

are not "static remnants from the past." For the Tlingit elders she interviewed, stories of taunted glaciers destroying entire villages respond to developing situations and emerging threats. They take on "precise political meanings in terms of contemporary struggles."[12] Their status as narrative proxies for the glaciology of the region should not be separated from their significance as an index of the relations between settlers and indigenous populations.

More than a time-lapse structure, Neuberger's study leaves us with a time loop between climate history and art history. The climatological present internal to his project creates a situation in which changing climatic conditions explain changes in the realm of visual representations—for instance, the presence or absence of clouds in early modern landscape paintings in relation to the Little Ice Age or, more recently, the anecdotal evidence offered by the story of an Icelandic town that ran out of blue paint as artists tried to picture their newly iceless surroundings[13]—while changes in the realm of visual representations are indicative of changing climatic conditions. There is no easy way to come to terms with the fact that climate science does not simply occur within a given set of historical relations and as the result of an accumulated quantification effort but also rewrites these relations as it "cuts against the grain of ordinary human experience."[14] If glaciology and climatology cannot but color our relation to history (and art history), it remains that the verified correlation between the red-to-green ratio in J. M. W. Turner's sunsets and the known optical signature of volcanic aerosols in Northern Hemisphere middle latitudes does not say anything about what the hypothesis of a planetary unconscious at work in the history of representation means to painting as a medium.[15] Whether or not Turner's atmospherics have more to do with the Earth system than with the Industrial Revolution, or with environmental history than with the formulation of the laws of thermodynamics—as Michel Serres admitted to have thought initially—color-palette forensics fails to see that Turner's clouds inhabit several temporal realities simultaneously, starting with the temporality of painting.[16]

Renaissance theorist Filippo Brunelleschi modeled a version of that

atmospheric simultaneity in one of his experiments. Let a painted panel be held by an observer in one hand at eye level but with the painted side facing away, and a mirror be held with the other hand at arm's length, reflective side facing the painted side of the panel. A hole drilled in the center of the panel allows the observer to enter the closed circuit as a disembodied eye immersed in the spectacle of a painting. The panel represents an architectural view. In lieu of a painted sky, Brunelleschi uses subterfuge by covering "the corresponding part of the panel with a surface of dark silver in which the real air and heavens were reflected, and likewise any clouds that appeared there, propelled by the wind, when it happened to be blowing."[17] Clouds are thus simultaneously in the painting and yet outside the scope of the painting. They are both atmospheric reflections and foreign bodies—foreign to painting's theater of operations, precisely because they are atmospheric: bodies without surface conceived from within a pictorial world that is primarily organized by a geometry of dots, lines, and surfaces.

For the observer standing in the Anthropocene present, it is the photographic installations of contemporary Dutch artist Berndnaut Smilde rather than Neuberger's hypothesis that give a new meaning and dimension to Brunelleschi's experiment. The miniature clouds Smilde summons out of mist and smoke in the *Nimbus* series are physico-chemical reflections of their atmospheric counterparts in the atmospheric world. They are external to the empty architectural setting that contain them, as if "caught . . . in the wrong habitat."[18] But the bracketing effect of the experiment has less to do with architecture than with the ephemeral nature of the nebular apparitions. Smilde's "clouds disappear so quickly that they are mainly experienced through photographs."[19] Thus, they are more apostrophic than atmospheric, calling into question the minute rituals and aesthetic filters that allow us to leave the world at the door and to recover some of it in the notions of landscape, safety, or even climate control.[20]

Tellingly enough, in 2013 one of Smilde's perfectly timed and painstakingly lit photographs was used to illustrate a policy article on solar radiation management (also known as solar geoengineering). In

that moment of convergence between the techno-scientific prose of a world in need of repair and the surrealist poetry of a cloud out of place, Smilde's atmospheric sculptures designate geoengineering as a spectacle—"a spectacle that affirms the ability of the system to solve and ameliorate the crisis."[21] His nebular experiments are safely contained, and yet they cut across fields of inquiry and domains of operation. They challenge the nature of the spatial continuum that has been modeled after architecture, painting, and photography and the one that is being modeled in the age of geoengineering on the contested threshold of a new series of experiments conceived with the planet in mind. More on that in Chapter 5. In the meantime, more on the opaque nature of reflected clouds in painting.

### All the Time in the World

With their expansive skies and generous cloud formations, Nicolas Poussin's *Landscape with a Calm* and *Landscape during a Thunderstorm with Pyramus and Thisbe* would have been the perfect candidates for inclusion in Neuberger's study. Or would they? In the center of each landscape, a lake extends upon the earth the limit of the sky and thus the reach of its cloud formations—or in the words of seventeenth-century art critic André Félibien: "Nature herself . . . paints the sky and the earth on clear, calm water."[22] But there's a glitch. As the gaze comes to rest on the lakes in the painting, Poussin's landscapes signal an optical contradiction within the terms of their reflective scenarios.

In *Landscape with a Calm*, the cloud formation looming over the castle does not find its reflection in the lake. In *Pyramus and Thisbe*, the surface of the lake remains untroubled by the stormy conditions that prevail everywhere else in the painting. For Louis Marin, these anomalies miniaturize the contradictions between incompatible forms of cosmic, meteoric, elemental, and pictorial temporality. They commemorate the nonreciprocity of forces that at some point collided to compose a weatherscape impossible to grasp in the full and, at times, aberrant spectrum of its perceptual range. Marin writes:

**Figure 13.** Nicolas Poussin, *Landscape with a Calm* (1650–1651). Oil on canvas, 38 3/16 × 51 9/16 in. J. Paul Getty Museum, Los Angeles, 97.PA.60. Digital image courtesy of Getty's Open Content Program.

The meteoric time of Nature that [Poussin's] two paintings seem to present in the passage from *Landscape—A Storm* to *Landscape—A Calm* is, in fact, only the at once necessary and unforeseeable movement of the cyclical time of the cosmos, in which the plenitude of duration in which Beauty peacefully reveals herself to the contemplative eye is always potentially fractured in its very "now," by the "sudden" instant of the nocturnal background of Nature, a senseless explosion, in which every gaze and every theory are lost.[23]

T. J. Clark's take on "the mismatch between the real sky and its reflection" in Poussin's lakes is more guarded.[24] He urges caution. Marin wants the disturbance too much. For Clark it is only "momentary" and has nothing to do with the overall structure of the painting.[25]

In *The Sight of Death*, Poussin's painting is subject to the atmospheric changes recorded on the occasion of a residency at the Getty Research Institute in 2000, at a time when *Landscape with a Calm* and *Land-*

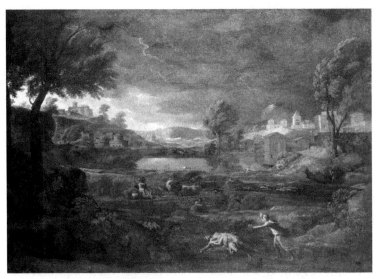

**Figure 14.** Nicolas Poussin, *Landscape during a Thunderstorm with Pyramus and Thisbe* (1651). Oil on canvas, 192.5 × 273.5 cm. Städel Museum, Frankfurt am Main.

*scape with a Snake* happened to be next to each other in the same room. Entry after entry, day in, day out, Clark composed a 250-page meditation on "paintings' sensitivity to circumstances" and "the fact of their living (and dying) in the light of day."[26] The impetus behind Clark's art writing experiment is not piety (or impiety) toward the past but an absence of consensus regarding the contours of the present dissolved and recomposed by lighting conditions in good and bad weather, in "a gray drizzly morning," or under artificial light.[27] It is as if "the immobile present of theory," in which the subject of representation, to cite Marin, "has *all the time* to assume and gather up the infinite space of Nature into a single satisfying whole,"[28] had been replaced by the temperaments of a coastal microclimate in Southern California:

> The light in the small room was extraordinarily beautiful—most often unmixed daylight coming through a louvered ceiling. (Readers not familiar with the climate of Los Angeles basin should think

away the cliché of unvarying surfside glare. The Getty is perched on a hill at the edge of that part of the city where the Pacific is dominant, bringing daily fogs and high hazes and morning glooms and sudden, improbable glittering afternoons.)[29]

The relation of painting to time Clark envisions is primarily ambient, that is, exposed to the fluctuation of natural and artificial light. In the process, the historical self-sufficiency of the painting implodes and with it the fiction of a theoretical subject. The layers of detail and the accumulation of observations do not easily add up to fill up the frames that contain the landscapes. They do not add up to recompose in the end a fully knowable object of study.

Marin's engagement with the reflexive anomalies of *Landscape with a Calm* and *Pyramus and Thisbe* does not require the two paintings to be in the same room on the occasion of a fateful temporary exhibit. Their sequence is theoretical rather than environmental insofar as the landscapes are not subject to the vagaries of light, display, and conservation. His description proceeds with the assurance of continuity and memory—for there is all the time in the world to negotiate sublimity within the realm of classical representation. Clark's description, by contrast, is rekindled by the atmospheric variations of each viewing. It is both a work in progress and a study in serendipity. What *The Sight of Death* negotiates for us is less a problem of representation than a question of resolution—as in high or low resolution—with the understanding that "description can act as a technology of amplification, flooding the delineated frame of the present with luminous grain of detail."[30] It is an understanding that Ada Smailbegović gained precisely through the study of nineteenth-century weather journals, wherein the weather is not a force or a state to be represented at the limit of painting but the force that commands a certain attention to a painting, a variable in an ethos of patience toward representation.

In the end, Clark's relation to Poussin's paintings is vulnerable to less-than-ideal conditions of observation and conservation. That relation can be easily compromised in the same way that the painting could

be damaged to a point where no reflexive anomalies would remain to be spotted in them. That thought may have crossed Neuberger's mind when he hypothesized that "the higher frequency of dark paintings in the first epoch [of the Little Ice Age] may, in part, be a result of the aging of the paint from the earlier centuries, the yellowing of the varnishes, and the deposit of dirt on the canvases."[31] Again, from Neuberger's perspective, the reflective incidents at the core of Poussin's two landscapes are nothing that a quantitative approach to art history could not reabsorb with utter indifference to their metapictorial properties. But couldn't we also say that the contradictory temporalities foregrounded by Marin happen to model in miniature the aberrant perceptual premises of a climate time at odds with immediate sensory expectations?

Unlike the spectator that Poussin's landscapes wished into existence, the Anthropocene present doesn't have all the time in the world "to assume and gather up the infinite space of Nature into a single satisfying whole." Planetary clocks are ticking. Tipping points are on the horizon. The Earth system thresholds that define a safe operating space for humanity are being crossed. The nitrogen and phosphorus cycles are one of these overstepped boundaries according to a 2009 article, which to date has garnered more than ten thousand citations.[32] Runoff from the excessive use of industrial fertilizers that pollute waterways and coastal zones results in anoxic events destroying marine life. They are responsible for algal blooms in bodies of water that, in the language of Félibien, no longer let Nature paint anything in them. In that all-too-familiar scenario, it is as if the broken mimetic contract between lakes and skies in Poussin's landscapes always already belonged to the ecological present in which they survived. But here too, as with the convergence between Weisman's thought experiment and Van der Ast's still life discussed in Chapter 1, the relation between the early modern past and the Anthropocene present is not a matter of retrospective prescience. It does not mean Poussin's landscapes are entirely worthless from an ecocritical perspective. They too tell a story about what it means to remember the world that the Anthropocene hypothesis leaves us to inhabit on impossible temporal terms.

## Melting Time

Simultaneity is the time of painting: everything on the canvas happens at once and is given at once on a bounded surface, even when a narrative sequence is suggested. The world is at a still; it is a still. Things are different in practice. The eye does not register all of the image at once. It takes time to take everything in. For Marin, *Landscape with a Calm* has all the time in the world to exist under theory's gaze because "what is offered to [the] sight is totalized in a spatial order without remainder or lack."[33] In a world where any moment is a moment that adds up to the disappearance of glaciers, the Extreme Ice Survey initiative founded by James Balog in 2007 had to invest in a very different version of what it means to see, predicated on the capture of vanishing forms. With the help of weatherproofed cameras programmed to shoot every hour during daylight, Balog and his team collected hundreds of thousands of images and reassembled them into striking time-lapse sequences destined to reclaim climate change from the abstraction of computational modeling. At this very juncture between vision and perception, Jeff Orlowski's documentary *Chasing Ice* (2012) comes to play an essential role in Balog's project by keeping a narrative tally of the technical and human cost involved in his pursuit of perceptual evidence.

It is with *Chasing Ice* in mind that I return to the first written observation of an Alpine glacier, the Rhonegletscher, in Sebastian Münster's *Cosmographia*: "On August 4, 1546, as I was riding toward Furka, I came to an immense mass of ice. . . . To anyone looking at it, it was a terrifying spectacle, its horror enhanced by one or two blocks the size of a house which had detached themselves from the main mass."[34] Münster's vision is not a primal scene with respect to what it is that he actually witnessed—a terrifying amount of ice, or the birth of a river— but with respect to the fact that the scene became glaciological only later on, when there is not much left of the initial scene to be seen and once the terror subsided to make room for a discourse on melting time.

Glaciology was born as a discourse on the past recorded in an idiom foreign to most historians. Ice-core samples cut through hundreds of

thousands of years at a time to reveal a past whose relation to the present had to be invented for the purpose of glaciology as a breathless memory of ancient atmospheres deposited in cloudy layers of air bubbles, dust, and pollen particles. It is a past that becomes volatile again when, in Serres's evocative terms, "chemical analysis . . . makes legible, as in an open book . . . the diverse climatic moments of eras whose dates and memory we had often lost."[35] But Serres is also here to remind us of other potential trajectories: of an atmospheric past vaporized into vibrant colorations caused by the diffraction of solar light through dusty clouds and volcanic aerosols—as in the aftermath of the eruption of Mount Tambora in 1815—and eventually deposited in some of Turner's most iconic paintings.

The disjuncture between historical and glaciological time has only been exacerbated by the development of cosmogenic nuclide dating, a method that manages to reconstitute patterns of glaciers' advance and retreat in the absence of initial eyewitness accounts. Cosmogenic nuclides are rare isotopes, such as beryllium-10, that accumulate in rocks exposed to high-energy cosmic rays on Earth's surface. Chronological measurements are made possible by calibrating the accumulation rates that vary with the degree of exposure—as when the bedrock underneath thick layers of ice during glacial maxima are less exposed to cosmic rays than during periods of glacial retreats.[36] Cosmogenic nuclide dating is in essence an experiment in nonhuman photography that goes to show that melting ice is not a historical substance in itself.[37] It becomes historical only when it reaches a certain dimensionality, when it becomes filmable, when it can be perceived in human time as a time lapse. Even the most dramatic images of calving and receding glaciers need a frame in order to mean something. Otherwise, all we are left with is the terrifying—monstrous in its own Anthropocenic terms— glimpse of a world out of scale, fragmented into hundreds of thousands of stills.

In his seminal venture into climate history with *Times of Feast, Times of Famine*, Emmanuel Le Roy Ladurie initiated a time-lapse sequence of his own device. He writes: "I undertook Münster's journey

in 1962 and again in 1966. The present glacial tongue is very thin, its height, and perhaps its width too, much less than those suggested by the sixteenth-century author."[38] The Anthropocene hypothesis has accustomed us to this type of time editing that juxtaposes slides taken at different intervals to both capture and caption durations that would not be experienced otherwise. Time lapses gesture toward the passage of time but without subjecting anybody to it. They reabsorb the pressure to turn historical sources into resources and deliver precedents in the form of environmental memories.

Münster's description of a terrifying spectacle and talk of horror place us in a historical context where monsters are not unfamiliar creatures to encounter in early modern travelogues and monstrosity a category capacious enough to include natural disasters, such as earthquakes and volcanic eruptions, that are also described as "horrible" by sixteenth-century physician Ambroise Paré.[39] Christopher Heuer explains that the first visual rendition of an iceberg in print culture was also marked by monstrosity and described by Thomas Ellis in his *True Report of the Third and Last Voyage into Meta Incognita* (1578) as a "great and monstrous peece of yce." What is monstrous about the spectacular emergence of the iceberg in print culture has as much to do with its sheer size as with its inscription in the visual field as an engraved plate consisting of a sequence of four rotating views ("1. At the first sight . . . 2. In coming neare unto it . . . 3. Approaching right against it . . . 4. In departing from it"),[40] each attempting to capture and caption a moment in the shapeshifting revolution of an unidentified object on the horizon.

Seventeenth-century descriptions of monstrous Alpine glaciers signal the emergence of a world awakened to terrifying, almost malicious entities that destroy entire villages in their path. Dispatched to Chamonix to witness and document the disappearance of land lost to ice, Nicolas de Crans recounts in 1616: "Above and adjoining the village, there is a great and horrible glacier of great and incalculable volume which can promise nothing but the destruction of the houses and lands which still remain."[41] Even in the nineteenth century, Louis Agassiz will describe Alpine glaciers as the terra incognita of modernity, with

pages that read like excerpts from a conjectural travelogue to a trans-lucent world in hues of green and blue made of tunnels and cavities too treacherous and fragile to explore.[42] Perhaps it is the reason that there is no illustration to be found in his *Studies on Glaciers*.

Le Roy Ladurie's rediscovery of pre-glaciological creatures from the Little Ice Age brings the historian on the threshold of "a strange land-scape, almost unknown, that until now only few historians have had the opportunity to observe for very long."[43] It is as if the frozen forces shaping and reshaping the contours of the settled world had opened a pathway toward a nonhuman-centered historiography. Le Roy Ladurie confides in the preface to the French edition: "I temporarily left the sector of humankind [*le secteur d'humanité*] that constitutes the usual subject of my research. Using this temporary effect of scotomization as a point of departure, I became, for a while, the disinterested histo-rian of a pure nature and the observer of a future [*devenir*] from which the human had ceased to be the center."[44] From *skotos*, in Greek, the darkness of blindness or the darkness of death, scotomization desig-nates a darkening in the field of vision; whereas in psychoanalysis and behavioral psychology the term refers to a visual form of denial, in the hands of Le Roy Ladurie the darkening is primarily methodological. It represents a necessary step in preparation for a perilous journey through uncharted historiographical territories. The darkening is only tempo-rary. In fact, everything in his venture seems provisional. It is just a phase, for he knows that one would risk too much by stepping aside from human-centered historiography for too long.

## Coda: Time's Up

Environmental memories are not exactly remembered. They are ex-tracted as part of collective endeavors that mobilize archaeology, phi-lology, and geotagging to remind a corpus of texts of the reality that lies dormant beneath layers of embellishment and fiction. The recalling reimagines the purposefulness of philological skills in response to in-terdisciplinary calls to actionable knowledge. It creates opportunities

to revisit historical and ethnographical sources that would be considered entirely peripheral otherwise. The optical asymmetries in Poussin's landscapes are not environmental memories, and neither is the plume of smoke in Stradanus's allegory of America, nor the mineralization of life in vanitas painting. They don't have terraforming lessons to teach on how to settle the Anthropocene present. But it's for the best because they are meant to start another kind of conversation. The Anthropocene present is not just the site of emerging relations to the world understood as Earth system. It is also the site of emerging relations to conventions of relating the world to its representations (as Earth system rather than as a mythical turtle, a sphere, a playground, as the world one wants, or as the world one is stuck with)—bearing in mind that some world pictures are more picture than others. Some achieve the status of models and projections, and others, the status of ethnographic objects.[45]

From an anthropological perspective, however, our entire cultural apparatus is an environmental memory in the sense that, according to Clifford Geertz, the Ice Age pushed us "to abandon the regularity and precision of detailed genetic control over our conduct for the flexibility and adaptability of a more generalized, though of course no less real, genetic control over it." He continues: "To supply the additional information necessary to be able to act, we were forced, in turn, to rely more and more heavily on cultural sources."[46] Another version of the same story coming from geochemistry has garnered a lot of attention over the past ten years outside the confines of geochemistry. It reads as follows: "The Anthropocene could be said to have started in the latter part of the eighteenth century, when analyses of air trapped in polar ice showed the beginning of growing global concentrations of carbon dioxide and methane. This date also happens to coincide with James Watt's design of the steam engine in 1784."[47] Looked at it one way, culture is a by-product of climate change; in the other way, climate change is a by-product of culture.

The perplexing relation of humanistic inquiry to planetary time takes on a different dimension once we understand with LeMenager that "the Anthropocene, conceived as a geologic epoch, is a coping strategy of

sorts, externalizing not the world so much as time, such that we can forget the moment-by-moment loss of the world by naming its passing on a geologic scale."[48] The Vanitas hypothesis develops that disjunction further. It speaks to the condition of being stuck between the world glaciology and geology capture through projection models and the one Poussin, among others, captured in the form of landscape paintings. Stuck but, again, not indifferent to the challenge of having to navigate the dissociation between "the moment-by-moment loss of the world" and a desire to remain invested in the valuation of the human record.

So what ought to come first: culture or climate, painting or the planet? The answer may be less obvious than at first blush, when one considers the time-lapse sequence devised by two atmospheric and climate scientists to determine the submersion level for the city of Venice prior to the first official records by lining up eighteenth-century city views painted by Canaletto and his assistants with modern-day photographs of the same views.[49] Using the green algae deposits visible on monument fronts in the paintings as proxy indicators of the sea level at the time of the painting, they reported the measurements in the photographs to quantify the rise of the water in the city. In the process, however, something else occurred that is beyond the purview of a submersion time lapse: they turned painting into the more stable referent of a sinking geography. In this particular instance, painting comes first and yet planetary time takes precedence, emptying the eighteenth-century paintings of their temporal content—by which I mean their belonging to a historical present to which they contributed to assign its contours. All you have left are slides. And who knows, one day Canaletto's views may very well hang on the walls of a climate-change museum, in the sea-level-rise room. Another room will be filled with the enigmatic cloud studies painted by John Constable during the summer of 1821.[50] Then, in a different wing, a companion exhibit—the Anthropocene equivalent of a *Salon des Refusés*—will host late Holocene paintings whose observational dedication to the passing of the world was deemed insufficient or inadequate.

# Toxics

## A Non-motif

In the realm of historiography, the past does not engender the present. Rather, the present is what regenerates itself by detaching itself from the past it produces as history. Like history, toxicity ties generations together, but it squanders more than it grows. Or else, toxic time grows bodies tired but no less sensitive to history's hurts. Quite the contrary. The hypersensitivity of toxic bodies does not leave historiography intact in its assumptions about life, death, and the transmission of affects. Julia Adeney Thomas even suggests that environmental toxicity challenges history's reliance, as a discipline, on a chemically unadulterated figure of the human.[1]

As part of her argument, she comments on a photograph by Shisei Kuwabara, in which methylmercury poisoning causing the symptom of Minamata disease appears to have morphed a human hand into something reminiscent of the furled ferns photographed by Karl Blossfeldt in *Originary Forms of Art* (1928).[2] The evidence of methylmercury toxicity in Kuwabara's image is shattering. It constitutes the visible tip of an otherwise invisible reality that "operates at scales and paces inaccessible to photographic registration."[3] His image of the furled hand also reg-

isters as an Anthropocene memory of the world insofar as the Anthropocene is also an age of toxicity and toxicity a vector of slow violence.[4]

The analogy between the deformed hand and Blossfeldt's ferns is not evidentiary in the sense that it is legible neither as a symptom on the body of Minamata's victims nor as a toxicological object of inquiry per se. It belongs to a different history of toxicity, one in which methylmercury has contaminated a body of images. Thus, the furling of the hand is the locus of a missing motif in the vanitas visual repertoire. The memory of Blossfeldt's photograph in Kuwabara's is not a *memento mori*—it doesn't express the insistence of finitude in a vanitas image—but a *memento toxici*: a reminder that "there is life even in toxicity's wake."[5]

## Toxic Legacies

For those trained to imagine that with just the right amount of detachment they would get to experience the past as an object of knowledge without risking the negative effects usually associated with the protracted exposure to dust and death, the toxic legacies that also define life in the Anthropocene leave us no other choice but to venture out, risk analogies between life-forms, and seek other models that will not shield the study of the past from the ethical concerns shaping commitments to a damaged present. In this chapter, the site of engagement and vigilance is neither photography nor ecocinema but fragments from a Caribbean history of violence.

In her ethnography of toxic exposure in contemporary Martinique, Vanessa Agard-Jones tracks the presence of a carcinogenic pesticide used on banana plantations—chlordecone (or kepone)—as it resurfaces in an ongoing conversation about what it means to live in a place that records the highest rate of prostate cancer in the world. Here toxicity is a form of vernacular because chlordecone poisons Martinique—a territorial by-product of the plantation economy—rather than another part of the French national territory.[6] Chlordecone toxicity is also vernacular, as opposed to vaporized, insofar as it speaks to the

endurance of colonial violence in the Caribbean. Agard-Jones explains that, through the stories people tell about their fear of losing control over their body and the work and the thought they put into regaining control over what gets "in their system," chlordecone toxicity affords "an important opportunity to think more flexibly about bodies, about what they are made of, and about what their biology might mean."[7] In that regard, "biology," Barbara Duden reminds us, also means "what its two components say: to 'speak' about βίος (bios), which is 'an individually lived life-time,' corresponding to the Latin *curriculum vitae*. . . . In antiquity the term *biologos* was used for the dramatic performer."[8] But one version of "biology" does not necessarily explain the other. The past does not flow into the present any more than the present contains the past. Likewise, flexibility does not necessarily mean continuity in time either, even if it creates openings between past, present, and the near future. It needs to be qualified, in the same way that toxicity has to be assessed and made legible, whether by chemical or biographical means.

Toxic stories about contaminated creole gardens, clusters of cancer among retired banana workers, and observed patterns of extremely precocious puberty in Martinique and Guadeloupe exist in relation to a narrative horizon as one of the modalities under which ordinariness accedes to representation. Michel Foucault explains that "for a long time, in western society, the life of the everyday could only accede to discourse when traversed and transfigured by the fabulous,"[9] only when fabulous-enough human events were to be offered up to memory as exemplary fables. He continues: "Since the seventeenth century, the West has witnessed the birth of a whole 'fable' of the obscure life from which the fabulous found itself proscribed."[10] It is a different offering, oriented toward fiction rather than fables. By this account, while the world of fabulous exemplarity "can only function in an indecision between true and false," the world of fictional representation invests its narrative energy in forensic forms and protocols of truth telling: "to seek what is the most difficult to perceive, the most concealed, the most discomforting to show."[11] The multiplication of toxicological vernaculars in the form of memoirs of multiple chemical sensitivity (MCS),

fictions of ecosickness, chemo-ethnography, and even through Shisei's photography continues to expand the historical horizon of the forensic universe of discourse, in which lives are subjected to biographical capture and toxic violence.[12]

The toxic past does not necessarily explain the contaminated present. It lingers and registers at a somatic level, measurable or not. It can be monitored and remediated, at least to a certain degree, but toxicity is not always remembered as life when toxicity pertains to relations we didn't know we had (with a place, with a cleaning product, with a fruit, with a habit, with a past). What may happen, however, is that in order "to think more flexibly about bodies [and] what they are made of," one may have to remember the meaning of toxicity in the early Caribbean. Toxicity in this chapter is a form of attention, not just a degree of concentration or a matter of dosage and overdose. Yes, toxicity has to be assessed and made legible. It is always mediated, measured, and sensed. But like Raymond Williams's "structures of feelings," toxicity "do[es] not have to await definition, classification, or rationalization before [it] exert[s] palpable pressures."[13] It is this very capaciousness of toxic time that I put to the task to investigate an eighteenth-century chronicle of life in the Caribbean written from the perspective of a missionary-turned-planter, Jean-Baptiste Labat, whose frightful name still haunts the Antilles as a threat aimed at naughty children.[14]

## Toxicity *avant la lettre*

Almost three centuries before the chlordecone scandal broke in Martinique, revealing that the French government had condoned the use of a dangerous pesticide on its territorial possessions in the Caribbean well after it was banned everywhere else, Labat's *Nouveau Voyage* (1722) revealed the Caribbean environment to another form of ambient toxicity. In the mangrove, things are not toxic in themselves but insofar as they are part of a continuum, from the tree to its fruit, from the fruit to the fish, from the fish to whatever comes next in the food chain. Labat writes:

[The barracuda] is a tasty fish. Its flesh is white, firm, and quite fatty. Its flavor is reminiscent of the pickerel, but it should not be eaten without precautions because it tends to poison itself and to poison those who eat its vitiated flesh. Because it is extremely voracious, this fish rapaciously eats anything it comes across underwater or floating on the surface. Very often, it eats Portuguese men-of-war [*Physalia physalis*] and manchineel apples [*Hippomane mancinella*]. These are violent and caustic poisons. The barracuda does not die from eating them but its flesh absorbs their venom and kills those who consume it as if they had eaten these nasty apples, or these Portuguese men-of-war.[15]

In this passage, toxicity describes a set of negative relations between things in contact, inert or alert, alive or not, rapacious or floating passively. In another passage, toxicity designates a broader range of substance conversions across vegetal, animal, and human realms:

[A slave] had been found guilty of the death of more than thirty of his companions he had poisoned. [A priest] reported that he was using the sap of a plant that one can find on the eastern shores of the islands. I do not need to describe this plant. The slave was carefully grooming his fingernails so as to keep one longer than the others. When he wanted to poison someone, he would scratch the bark of the said plant with this fingernail until it was full of the thick sap oozing from it. Back home with this poisonous load he would invite his next victim to drink some brandy. He would be the first to drink, then he would pour some to his victim from the same bottle and in the same halved calabash he had used but by handling it in such a way that his nail would dip into the brandy and empty the venom it contained. It would never take more than two hours for the one who had drunk the poison to go into a horrible fit of convulsions that would promptly end his life.[16]

Even if the toxic plant goes undescribed and remains unnamed, its toxicity manages to seep through the text, concurrently anatomized by the vivid image of a poisonous fingernail and weaponized by ill intentions. In that regard, this toxic anecdote is part of a much bigger picture that

Labat doesn't know how to paint. His anecdotal take on toxicity allows him to occupy a middle distance between landscape and still life, between the muddied background where trees ooze toxic sap and bear lethal fruits and the unassuming domestic composition in the foreground, with a halved calabash and a bottle set on a table. It allows him to carry on despite the stripping of the plantation world upon which his surveying eyes came to rest and press, along with the rest of his body.[17]

Labat's toxic spectacular is hard to process. It raises the stakes of description almost to a forensic point that affords his keenest readers the dubious narrative pleasure of catching perpetrators in the act and witnessing bodies turned inside out, but never gets to the bottom of it. The following passage describes the wrenching effect of the remedy used to purge a poisoned slave:

> The medicine induced an extraordinary sweat accompanied by vomiting spasms, so violent that the victim seemed to be about to regurgitate his bowels through his mouth. During one of these spasms, he regurgitated a living animal the size of a thumb, and whose body presented three distinct sections. It had small claws like those of a rat. The head could only be distinguished from the rest of the body by the motion of the neck. This animal had two small eyes and a mouth armed with teeth. It had a set of two wings on the back made of the same matter as the wings of a bat and shaped likewise. The rest of the body was sparsely covered with short hard reddish hair. After he had expelled this insect, the patient discharged a lot of blood and of a bluish substance. . . . A moment after this animal had come out, it started to move its wings. It felt on the floor from the top of the table where it had been left, while attempting to fly, but it was too weak to do more than flapping. We placed it inside a bottle filled with alcohol in order to preserve it.[18]

Here toxicity is the stuff of demonology and possession, not of gas spectrometry and body burden testing. There is no easy answer to the question of what is preserved in the bottle of alcohol and how both the specimen and the anecdote itself should be handled. No matter how

questionable or simply tenuous its claims to toxicity now appear in ret-
rospect, the missionary's text fulfills a diffuse demand for boundaries
and containment. Clearly, if the most graphic and visceral passages of
*Nouveau Voyage* retain some form of currency in a contaminated pres-
ent, it is less for their evidentiary value than for the vivid pictures they
paint. Their cheap thrills speak to the chilling reality of a climate of
violence Labat has contributed to create around him.

His chronicles are available as a point of origin but not as
a source of certainty. The ambivalent and ambient toxicity seeping
through the text undermines the assurance one may seek in it. *Nouveau
Voyage* is but a point of entry into the zone delimited by bodies that the
plantation system brought into contact. The very nature of their con-
tact is an object of both intense scrutiny and desire: at once a target—
when it comes to miscegenation and the laws monitoring forbidden
passions—and a trope—when it comes to fantasies of the promiscuous
sugar islands.[19] It means that the toxicity pervading Labat's chronicles
pertains to causal and chemical relations that do not sit tightly within
the confines of modern toxicology. It blurs species boundaries, causes
death, and engenders nightmarish creatures in unsuspecting bodies. It
is as much a chemical or reactive property of bodies in contact as it is
a climate of fear and aggression that left archival traces in the form of
decrees regulating the circulation of toxic substances, mandating the
autopsies of suspicious corpses, and preventing slaves from practicing
medicine.[20]

There is an extensive, highly specific, and fairly cohesive premod-
ern literature on poisons (*venenum*) and their properties.[21] However,
my argument throughout the chapter is less vested in containing early
modern toxicity in its past—that is, to make sense of Labat's toxico-
logical imaginary through the toxicological categories that may have
been available to him on the assumption that toxicology is what made
sense of his encounter with toxicity in the West Indies—than in re-
claiming the anecdotical fact that, in the world Labat describes and
settles, toxicity enacts a continuum between things and persons, ob-
jects and bodies at a time when, precisely, the availability of a certain

class of bodies as things was codified by law. It reflects the ambient violence that registered elsewhere in a text like the *Code Noir* (1685) but also in the chilling lines he devotes to torture in *Nouveau Voyage*: "I ordered for the sorcerer to be put in chains after he had been washed with a chili paste [*pimentade*], that a briny preparation in which one has mashed chili peppers and small lemons. The pain it causes on a skin flayed by a whip is horrible, but it is a sure remedy against the gangrene which would not fail to come to the wounds."[22] The early Caribbean *pharmakon* does not always kill or cure depending on the dosage. It also maims. Its toxicity registers the continuum that exists between the unsuspecting flesh seared by the caustic sap of the manchineel tree and the flesh seared by salt, lemon, peppers, and whips. But early Caribbean toxicity is also there, in Labat's text, as one steps into it, feels its causticity, and recoils before it.

If historical knowledge strives toward containment on the assumption that the historical coherence of a period warrants the explanatory force of the past, toxic legacies reconnect past, present, and future in unexpected ways. In this other passage, Labat leaves nothing to the imagination, as if the descriptive excess was there to compensate for the chronicles' overall lack of insight:

> I gave a lot of thought to what could contribute to my recovery before deciding to request some tincture of scammony [*Convolvulus scammonia*]. In my condition, I should have feared the violence of this medicine, but I took it without consulting anybody, thus playing double or nothing. This medicine worked wonderfully. I discharged such a prodigious quantity of water that in less than four hours my swelling had vanished. It looked like I was left only with the skin of my belly attached to the spine. Beyond all likelihood, I was so strengthened after such an impressive excretion that I went around for quite a while without feeling any weakness. But the best and the most surprising part in the expediency of this medicine was that I expulsed two worms the width of a thumb. One of them was sixteen inches long, and the other a little bit less. They had flat clover-shaped heads, like snakes. Their bodies were entirely covered with russet

hairs and they were so vigorous that they were still crawling in the
room six hours after I expelled them. . . . I have always thought
that those two extraordinary worms were the result of some sort of
poisoning, either from a poison that someone gave me to cause my
death, or a poison that I had ingested by eating fruits or tasting roots
in the woods.[23]

The spectacular toxicity birthing monstrous internal parasites through-
out *Nouveau Voyage* can be added to the corpus of obstetric nightmares
and tales of devouring progeny that have a particular resonance in the
Caribbean experience of transmission, dislocated genealogies, and sur-
vival.[24] This other memory of violence finds new bearings in what two
Martinican whistleblowers have described as a genocide by sterilization
in the making because of the reproductive health issues associated with
chlordecone poisoning.[25]

A parallel with another text from another colonial outpost situated
thousands of miles north of the West Indies might bring clarity to the
dubious virtues of entertaining, even for a brief moment, such a precip-
itous foreshadowing between the early modern past and Anthropocene
present. Jesuit missionary Paul LeJeune writes in his 1636 *Relation*:

Monsieur Gand, in his talk to the Savages . . . remonstrated with
them, saying that if death was so common among them they must
ascribe it to these drinks, which they did not know how to use with
moderation. "Why dost thou not write to thy great King," said they,
"to have him forbid them from bringing over these drinks that kill
us?" And when they were answered that our Frenchmen needed
them upon the sea, and in the intense cold of their country, "Arrange
it, then, so that they alone drink them." An attempt will be made,
as I hope, to keep this business under control; but these Barbarians
are troublesome to the last degree. Another one, breaking into the
conversation, took up the defense of wine and brandy. "No," said he,
"it is not these drinks that take away our lives, but your writings;
for since you have described our country, our rivers, our lands, and
our woods, we are all dying, which did not happen until you came

here." We began to laugh upon hearing these new causes of their maladies. I told them that we described the whole world, that we described our own country, that of the Hurons, of the Hiroquois, in short, the whole earth; and yet they did not die elsewhere as they did in their country. It must be, then, that their deaths came from elsewhere. They agreed to this.[26]

The passage is complicated by the fact that pestilence could have been understood and described by premodern theories of toxicity and that, in turn, modern toxicology has something to say about substance abuse and alcohol poisoning. In this particular instance, toxicity is the locus of a dialogue in the missionary text or, rather, of a non-dialogue since the figure of the native speaks only to be silenced or ridiculed. Today, the silenced hypothesis bracketed by LeJeune's account seems almost prescient in its recognition of a carrier effect and contagion pathways. But we know from the work of Jonathan Goldberg on the episode of the "invisible bullets" of Thomas Harriot in *A Brief and True Report of the New Found Land of Virginia* (1588) that even with the support of environmental historians who have documented the role played by infectious diseases in the decimation of New World populations, epidemiological prescience remains a fantasy of historical truth.[27] The anonymous intervention—"we are all dying, which did not happen until you came here"—does not speak an epidemiological truth. It locates a nexus between observation and conjecture, between what's visible and what's invisible. This nexus is presently occupied by epidemiological models and projections, but it also intensifies the prescriptive power of the missionary account by attributing a lethal or otherwise biohazardous form of agency to writing.[28] As they break into the missionary account, the remaining words of dissent both preserved and dismissed by LeJeune envelop the scene in a conjectural mist that puts the historical record on epidemiological and toxicological standby.

## Toxicoda

Jacques Grévin's 1568 treaty on venoms is mostly a forgotten book and, perhaps, an entirely forgettable mark in the development of modern toxicology. That being said, I am drawn toward a passage in which the author redefined the parameters of toxic exposure:

> It appears that sorcerers turned to plants and drugs to add efficacy to their words. . . . For what sort of malignancy would allow words to damage either someone's spirits, disposition, or even flesh? Words in themselves cannot do anything since they are nothing else but a vocal stream portioned out [*qu'elles ne sont autre chose que voix propor-tionnellement battues*] by the tongue, the palate, the teeth, & the lips. Therefore, words cannot make an impression on the body, even as the air touches it. For as soon as words are proffered, what remains of them is nothing more than the matter they are made of, which is no different than the air we commonly breathe.[29]

The passage is ambivalent. Even though he denies toxic agency to speech to undo the enduring association between poisoning and witch-craft, Grévin still conceives of the body as being on the receiving end of language. On the live edges of discourse at the juncture between expression and impression, the targeted body is impervious to verbal injuries but not to anatomical description that itemizes it into tongue, palate, teeth, and lips. It is permeable enough to language to be shaped into an object of debate and inquiry but not to the point of causing personal injury.

The point of this toxicoda is not to revive an old debate over the nature of verbal toxicity in the idiom of modern toxicology. It is to take notice of a memory of toxicity that shows more flexibility than history of toxicology in its attention to the fact that what is said about the body has the power to shape sentient bodies. According to Barthes we have several bodies: "the body of anatomists and physiologists, the one science sees or discusses. . . . We also have a body of bliss consisting solely of erotic relations, utterly distinct from the first body: it is another con-

tour, another nomination."[30] What about that other body made of spit, slur, and scolding? If love fashions bodies, so does hate. When words hurt, it is not the anatomical body they affect. Verbal toxicity redraws the contours of the body it targets with no less efficacy than the anatomist's blade. Teresa Brennan has her own way of telling the story of the verbalization of somatic relations. She explains that there was a time when the transmission of affects was recognized by scientific authorities because somatic channels necessary to it were still open.[31] Philosophical modernity happened more or less in sync with anatomical modernity to redraw these contours and shut down channels that holistic medicine is now trying to recover by pointing at a whole that is longed for, sensed, maybe self-evident to some but not easily evidenced.

The "I'm tired" project has another way of telling the story of verbal and affective toxicity. Started in June 2015 by two UK-based artists, Paula Akpan and Harriet Evans, the "I'm tired" project seeks "to highlight the significance and lasting impact of everyday micro-aggressions, assumptions and stereotypes."[32] The project consists of a series of anonymized portraits of bodies that have absorbed much verbal toxicity but can take only so much of it: "I'm tired of pretending I'm over my miscarriage," "I'm tired of being the angry black woman," "I'm tired of being told . . ." The repetitive and formulaic dimension of the project, born online and curated via Facebook—like much of the verbal toxicity the project recaptures in the first place—is reminiscent of the meme mechanism with its ephemeral scenarios of participation designed, phrased, and circulated to be soon replaced by another captioned image begetting the next version of itself in an open-ended sequence.

The models enrolled in Akpan and Evans's project are tired but not yet exhausted.[33] Put differently, they are still capable of forming a project, if only by virtue of their membership in Akpan and Evans's series. But for how long? They don't have all the time in the world.[34] The most compelling dimension of the series is perhaps its use of a present ("I'm tired") anchored in repetition. The photographic sequence both mimics and displaces the iterative nature of microaggressions with its temporality of harm done at a speed that does not register in the vocabulary

of injury. The multiplication of the visual shots mirrors the many verbal shots that warrant a feeling of fatigue in the sitters. The question of how to assign value to the present on the live edge of discourse does not depend on recapturing or catching up with the moment of inception, which is already comprised in the very logic of accumulation and accretion. Words percolate and images add up, depositing the sensitivity of bodies to language into an impossible time-lapse sequence of what it means to bear the burden of verbal toxicity, while shifting in the process the toxicological meaning of body burden testing.

Of course, the debate over the microaggression research program (MRP) has nothing to do with the chemical reality of toxins, except perhaps in a different historical context where toxicity was not yet contained within toxicology. The debate is not about whether language can harm, humiliate, or constitute a form of assault. It is about how psychological science constructs adequate evidence.[35] Akpan and Evans's models wear the long-term cumulative effects of toxic discourse on their back but not as clinical symptoms or as biomarkers. It does not mean that their project has nothing to contribute to the conversation about the contours of a damaging present. Its embodied memory of insult and injury alerts the Anthropocene present to another modality of what it means to refuse to settle for indifference toward the day-to-day erasure of the world.

CHAPTER
FOUR

# Paper

### Philology on the Red List

In this book big asks find small answers. The question of how human-istic inquiry is supposed to constitute itself as responsive to the emer-gence of a planetary archive that signals the dawn of a geological age of humankind, while remaining critical of a posthumous promise of legibility that negates memories of life in the Anthropocenic mean-time, brings into relief sliding moments situated within the sphere of historiography but at a breaking point in the temporal fabric of the world: a peeling canvas and other unsettled projections (Chapter 1), melting or otherwise troubled landscapes (Chapter 2), toxic legacies in the Caribbean (Chapter 3). Chapter 4 finds its impetus in a philological moment of crisis.

What happens when a distinguished scholar of early modern French literature addresses his colleagues and fellow *seizièmistes*—that is, specialists of sixteenth-century French literature—as members of an "endangered species"?[1] Choosing a period remains a rite of passage in professional fields that train medievalists, early modernists, roman-ticists, modernists, and so on and so forth. Periods cement the belief in a certain kind of continuity in time to allow the present to envision

the future of the past as it unfolds in a sequence of centuries, dynasties, or aesthetic movements. Periodization assigns tasks, delimits scopes, streamlines professional expectations, qualifies expertise, tames anachronistic pleasures, and disciplines unseasoned attachments to objects of inquiry.[2]

The spirited quip registers and defuses a sense of crisis shared across literary studies in the idiom of conservancy and environmental collapse, knowing well that no matter how devastating the prospects of a die-off, nobody is likely to die with *seizièmisme*. The threat of extinction here is primarily a structure of feeling shared by a group that has invested in a corpus of texts the prospects of its continuity in the world. What appears to be under threat is the logic of dedication and affiliation that binds bodies to a corpus of texts. Sixteenth-century texts will survive the odds of such an extinction event, even if it is as deposited information turned into a searchable archive rather than as a lively tradition. What is being mourned in the idiom of species collapse is the possibility to live off one's dedication to verbal remains. After all, this is what humanists do: they value the human record in itself, not by "arresting what otherwise would slip away," Panofsky writes, but by "enlivening what otherwise would remain dead."[3] In an age of data extraction, where the historical record is mined rather than enlivened, searchability replaces linear perspective as the foundation of historical distance and the measure of historicity.[4] The past is imagined as searchable in the same way that it can be imagined as "fractured, desiring, layered with the possibilities of its futures as well as its memories."[5] Or from the perspective of Pantagruel's prefatory summons, imagined as biodegradable: available as a memorized text that could be recited upon request, fully reabsorbed by the next generation of learned bodies, or fully erased by an extinction event.

Endangered *seizièmistes* will be familiar with Rabelais's opening salvo:

Most illustrious and most valorous champions, noblemen and others, who gladly devote yourselves to all things nice and honorable, not

long ago you saw, read, and came to know the *Great and Inestimable Chronicles of the Enormous Giant Gargantua.* . . . And it will be my will that everyone should leave their own job, take no heed of their trade, and forget about their own affairs, to see to these entirely, without their mind being involved elsewhere, until they knew them by heart, so that if the art of printing ceased or in case all books perish, in the time to come they might be taught accurately to their children and pass them as if from hand to hand to their successors and survivors like some religious cabala.[6]

In this passage, the early modern text imagines itself at once fragile and all consuming. It thrives from anticipating its medial afterlives in a postapocalyptic future where it will have survived by parasitizing surrogate bodies and their lip-syncing progeny. In François Truffaut's 1966 movie adaptation of Ray Bradbury's *Fahrenheit 451*, a forbidden copy of *Gargantua and Pantagruel* survived the holocaust of print culture but only long enough to be tossed on the floor, doused with kerosene, and set ablaze, not by the arsonist police tasked to clean up the world from books but by a self-immolating reader. Rabelais's legacy goes up in flames along with the clandestine library and its resolute librarian. In the meantime, in the margins of a society that has ceased to tolerate literary ambivalence, other dissidents are devoting their existence to memorizing endangered texts for safekeeping while waiting for literacy to return in the ruins of a world that is about to end. The film ends with the vision of living books reciting and passing on to the next generation their adopted text in the snow in a literal rendition of *Pantagruel*'s prefatory summons.

The coevolutionary tingle of the trade-off between the book and the body in *Pantagruel*'s fabulous herding call is impossible to resist. Two distinct reproductive logics harness each other in a fluttering of voices that leaves in its trail a progeny of surrogate bodies lip-syncing printed memories that are at once fully theirs and entirely foreign to them, "located *beyond living*" and yet "*lively*, devoted to life, composed in relationships with living populations, the apparatus that maintains it, and the future it seeks to enliven"—or so an eavesdropping biologist may be

**Figure 15.** Surviving copy of *Gargantua and Pantagruel* (next to *Joan of Arc*) doused with kerosene. François Truffaut, dir., *Fahrenheit 451* (Universal City, CA: Universal Studios, 2003).

tempted to say.[7] And while it is certainly true that postgenomic biology is as foreign to the world of Rabelais as it can be, or that, appealing to the concept of species extinction fails to account for the historical investment of the Renaissance in reproductive futurism, didn't *Pantagruel*'s fantasy of docile bodies mobilized by the vulnerability of the written word wish new relations between flesh and data into existence as a response to the perceived volatility of its historical present?[8]

The reference to postgenomic life designates a volatile present whose volatility often remains in the realm of abstraction, neither experienced nor felt. But it is never so volatile that it does not end up reshaping our modes of accounting for the unraveling of the world. It was only a matter of time until Rabelais's wetware experiment on a captive population self-condemned to repeat the words and born from that repetition would find its way into the Anthropocene present as a memory of the end of history gesturing toward the vision of a civilizational record where, to quote Caitlin DeSilvey, "all structures and artifacts have biological as well as social lives, and all ecosystems have deeply cultural properties as well as natural ones."[9] There is nothing utopian about that. It is the situation conservation practitioners find

themselves in when tending to the thatched roof of listed buildings covered with *Leptodontium gemmascens*, a type of moss recognized as a vulnerable species in the United Kingdom.[10] As far as *Leptodontium gemmascens* is concerned, the rumor of the Anthropocene "collapse of the age-old humanist distinction between natural history and human history" is a lived-in reality (to go back to Chakrabarty's key essay cited in Chapter 1)—less collapse than a continuum between the roof as structure in need of repair and as medium of growth for what is at once a parasite to remove and a living patina to preserve as a time-stamp and a form of biodiversity.[11]

There is still a good chance that even after the collapse of the *seizièmiste* population designated academic areas will subsist where it is still possible for a handful of specimens to roam free and even thrive. But the challenge I set for myself with the Vanitas hypothesis does not consist in reclaiming a shrinking philological habitat. Rather, it is to reimagine what non-indifference toward the historical record and the practices invested in its maintenance could look like in the Anthropocene present—whether it is by recovering what devotion to the signifier may have meant in the Holocene or by "releas[ing] . . . some of the things we care about into other systems of significance."[12]

No matter how comedic the passing specter of a print apocalypse is in Rabelais—like so many passages in the rest of his satirical bildungsroman, the prefatory summons is most certainly spoken in jest—it also strikes an anxious chord. As comedy often does. It is my contention that *Pantagruel*'s herding call is worth remembering in the Anthropocene present, not because it was written with the Earth system or the geological fate of the human species in mind but because of the peculiar expression it lends to pervasive concerns over human agency and civilizational continuity. In it, continuity is unassignable—and so is agency. Is it on the side of life with its cycles of reproduction and death? Or is it on the side of the book that generations enliven and carry through time? And building on Geertz's coevolutionary premises about climate and culture mentioned in Chapter 2, where does the book end and the body begin?

In the broader terms contributed by Alexander Nagel and Christopher Wood in their compelling study of the sphere of European artistic production in the fifteenth and sixteenth centuries: Is continuity on the side of the memory of a contact preserved by a relic or a body that does not have an equivalent, only proxies? Or is it on the side of duplication, repetition, and the disposability of the medium, where loss can always be offset by the making of a copy? Is continuity ensured by shielding certain objects (including built structures) from historical time by repairing or enshrining them so they appear timeless no matter how historical they are? Or is it to be found through authorship, signature, and timestamps? Rabelais's print apocalypse offers us a glimpse at what lies beyond the opposition between subject and object, sentience and insentience—and in the wake of the Anthropocene collapse of categorial divides between natural and social science, beyond species thinking and the renaturalization of global warming as "the outcome of the knowledge of how to light a fire, or some other property of the human species acquired in some distant stage of its evolution."[13] It returns the formulation of the Anthropocene hypothesis to a sociogenic point of inception in the civilizational record where books and bodies beckon each other.[14]

## The Purloined Letters of Brazil

Léry left France in 1556 to join a Calvinist colony in Brazil. He returned a year later with a manuscript written with an ink made of brazilwood, or *pau brasil* in Portuguese. *Caesalpinia echinate* is now considered to be an endangered tree, but in the sixteenth century it was exported in large quantities to Europe to produce a vivid red dye. Brazilwood is a substance with remarkable properties in *History of a Voyage*. It bleeds ("The water rose so high that it covered the brazilwood in the cargo, and ran out through the conduits as red as oxblood"[15]) and moonlights as a last-resort food ("But on the sea, during the voyage of which I speak, we were reduced to such extremity that we had nothing left but brazilwood, which has less moisture than any other; several, however,

pressed to the limit, for lack of anything else began to gnaw on it"[16]). It exists in multiple states: solid, liquid, and residual. Léry recounts: "One day one of our company decided to bleach our shirts, and, without suspecting anything, put brazilwood ash in with the laundering lye; instead of whitening them, he made them so red that although they were washed and soaped afterward, there was no means of getting rid of that tincture, so that we had to wear them that way."[17] Not only did the laundry incident leave both an anecdotal stain along with stained garments but also stained garments one has to live (and write) with. A sense of temporal depth accompanies the unexpected flaring of color beyond the ashes in the laundry incident. It is not expressed in the future tense but as an illegible, yet sensuous, continuity across matter.

One can only assume that most of the manuscript's original content survived into the first printed edition in 1578. What did not survive returns in the preface as memory of a show and tell:

> Early on, after I came back to France, I would show people my memoirs, most of them written with brazilwood ink [*escrits d'ancre de Bresil*], and in America itself, containing the notable things that I observed during my voyage, and I would give spoken accounts to those who wanted to know yet more; but I had not intended to go any further with them than that. However, some of those with whom I often spoke maintained that, rather than let so many things worthy of memory remain buried, I should set them down in writing at more length, and in a more orderly fashion. Upon their entreaties and solicitations, in the year 1563 I wrote a rather full report of them.[18]

The brazilwood ink manuscript is an object that gathers. It is less a book to read than an exotic relic to behold. The object itself is gone, but its memory lingers like an imperceptible drop of red in a sea of monochromatic letters destined to be read rather than seen—if indeed, to read, "is to see the ink not as ink."[19] Still, the typographical slippage between the *e* of *encre* (ink) and the *a* of the homophonous *ancre* (anchor) in *escrits d'ancre de Bresil* launches another journey through the text, where the failing anchor (*ancre*) that momentarily delays the expedition echoes

the *ancre* (ink) that holds Léry's memories anchored in sensuous haze of the color brazil: "[The captains] gave the command to weigh anchor [*ancre*], and we thought to put to sea that evening. However, the cable of the ship I was in broke, and the anchor could only be hauled with great difficulty; thus we were not ready until the following day."[20] The slippage holds open, if only for a nonmeasurable instant, the possibility for the manuscript to haunt its printed successor in illegible ways, or for Léry's printed memories to reabsorb some of the reliquary pressure to function as evidence that, unlike others, he actually went to Brazil and indeed saw firsthand what he claims to have seen there.

Claude Lévi-Strauss is well aware of the reliquary status of Léry's printed memories that he too had to shed as memories that were not his. He confided in an interview: "Reading Léry help me escape my century and get back in touch with what I would call a 'sur-reality' [*sur-réalité*]—which is not the one the surrealists talk about, but a reality even more real than the one I witnessed. Léry has seen things that are priceless because it was the first time that they were seen and that it was four hundred years ago."[21] *History of a Voyage* contains the memories Lévi-Strauss can only wish to have had and shared with Léry himself. It is at once a disposable object whose informational value can be replicated and transmitted in a different format, and whose loss could be offset by the making of a copy, and a relic, the irreplaceable memory of a contact once deposited into a document vulnerable to the vagaries of history.[22] Léry explains in the opening pages of the travelogue that the manuscript he had entrusted to a friend ended up being confiscated in Lyon. He believed the manuscript to be lost until it was recovered serendipitously years later. In the meantime, Léry had managed to reconstitute most of his text and make another copy, which he lost a second time after being forced to take refuge in Sancerre to escape religious persecution. Other manuscripts were not so lucky.

In the tenth chapter of his other book, *The Memorable History of the Town of Sancerre* (1574), written during the Fourth War of Religion, Léry minutely recounts the incremental descent of a besieged city into an estranged reality. As food grows scarce, Sancerre's inhabitants

remap the borders between the eatable and the non-eatable. They turn to horsemeat when the city runs out of beef, and then to dogs and cats, mice and rats, and then to weeds, poisonous or not. A step further down, they cook objects that were once flesh before and became flesh again by virtue of their newly found identity as food. Boiled and accommodated with suet and spices, leathers and parchments, especially vellum, are repurposed in improvised tripe recipes:

> Those who are hungry take stock of everything: when the supplies of leathers and pelts started to sink and dwindle, the shrewdest and most ingenious among them started to sample and try out parchment skin with good results. Suddenly parchment skin was in such demand that not only blank ones were eaten but so were letters, bonds, and books, printed, as well as handwritten. They were eating without a second thought ancient manuscripts that were between one hundred and one hundred-and-twenty-years-old.[23]

With each incremental step taken toward pushing further the frontiers of inedibility comes, on the heels of resignation, a new sense of precarious normalcy. A revised scale of values emerges as Sancerre's famished inhabitants accustom themselves to what lies farther and farther away from what's familiar and revisit in the process the defamiliarized contours of the flavorful: horsemeat turns out to be better than beef. And after a while, fried leather becomes a delicacy. Léry's description of the famine in Sancerre delineates a potential zone for the never-seen-before to be witnessed. He announces at the beginning of the chapter that he will describe "things that are no less true than they are admirable, unheard of and never seen before in any nation known to memory and chronicles."[24] He certainly keeps his promises by painting the stomach-turning tableau of a family discovered preparing the body of their dead toddler in a stew.

Another tableau stands out in the *Memorable History of the Siege of Sancerre*, not because it is more horrifying than the scene of baby cannibalism but because of its unsettled status. The scene in question is simultaneously made to be seen, read, and eaten. Among the boiled

books turned into stew, Léry notes: "I also saw some being eaten where printed and handwritten characters were still visible, and where one could read the parts served in dishes ready to be eaten."[25] Here again, as in the opening page of *History of a Voyage*, the legible text sinks under another layer of memories in the guise of a storied surface in the process of being erased by a starving reader, who may have noticed the sunken letters but not carefully enough to transcribe them. As with the brazilwood inked memoirs, details float to the surface of consciousness between print and handwriting, trace and erasure, legibility and invisibility.

In order to function as a medium of transmission, *History of a Voyage* had to internalize what Léry kept on losing in the form of more Brazilian memories buried on the threshold of the printed travelogue:

> During that year or so when I lived in that country, I took such care in observing all of them, great and small, that even now it seems to me that I have them before my eyes, and I will forever have the idea and image of them in my mind. But their gestures and expressions are so completely different from ours, that it is difficult, I confess, to represent them well by writing or by pictures. To have the pleasure of it, then, you will have to go see and visit them in their own country.[26]

Not everything will be brought back. Not everything can be committed to writing. Not everything can be engraved either. In this passage, the opening withdrawal of the purloined letters of brazilwood replays itself to compose a ghost plate. It is less a missing image in the series of superb engravings that illustrate *History of a Voyage* than a negative image or, better yet, an etched surface lost to the engraving process rather than to history. The ethnographical status of the engraved plates that give an idea of the Brazilians' "gestures and expressions" and that we can actually work with and describe (and even reproduce), is complicated by the fact that these images mean very little to fieldwork-oriented ethnography today.

The scenes from the Tupinamba world gracing Léry's travelogue do not function as a repository of information about the world they were

entrusted to represent but not necessarily to record. The difference is key. De Certeau writes: "These plates . . . punctuate [the written discourse] with 'monuments,' whose essential value is in their belonging to the order of the visible. . . . They allow the belief that one can see the beginnings once again. . . . They allow us to 'see' or to 'glimpse' the beginnings of history."[27] The function of the plates in Léry's travelogue errs on the side of the reliquary. They do not represent information but visions. They are no less artifact than the artifacts they depict (bows, arcs, ornaments, hammock, monsters, exotic fruits)—no less artifact than a shrine that stands for the formlessness of its content hidden from sight by a shell of gold and gems. And insofar as "what [proto-ethnographical plates] represent has never been 'seen,'" they are no less fabricated than computer-generated images.[28]

The Calvinist missionary lived to tell, holding on to his notes written in brazilwood ink. And yet, the body that survived alongside the manuscript did not quite make it through. The voyage changed the travelers. Léry writes that when he and his companions "arrived at Nantes it was as if all our senses had been entirely overthrown; for about a week we were so hard of hearing, and our vision was so obscured, that we thought we were becoming deaf and blind." Bodies are not so much reborn than expecting, poised on the verge of becoming something else: "Not only did we have fantastic cravings, such as women with child are commonly said to have (were it not for fear of wearying the readers, I could cite strange examples), but some among us also had such a distaste for wine that it was more than a month before they could bear to smell it, let alone taste it."[29] Profoundly marked by the hardships of the trip, the body that returned from Brazil is returned to its infancy, deprived of the rich and seductive sensorial responsivity to the New World that sets apart *History of a Voyage*. It is as if the returned body had to assume in its altered state the reliquary status that the book can no longer assume in its printed form.

In another passage, it is up to the reader to reabsorb these reliquary pressures and enshrine the memory of a contact with the Americas, as when Léry pauses his description of Tupinamba brewing techniques to

solicit a bodily response: "I have no doubt that some of those who have heard what I have said concerning the chewing and twisting around of the roots and millet in the mouths of the savage women when they concoct their caouin, will have been nauseated, and will have spit."[30] It would appear that the travelogue did not shed its reliquary status all at once with the publication of the book, in part because what such shedding will have meant is not necessarily available as a memory of Brazil. The process took time, measurable as the four centuries that separate the first draft of Léry's travelogue from Lévi-Strauss's inaugural lecture at the Collège de France in January 1960: "It was perhaps in the nature of our science to appear simultaneously as an effort to make up for lost time and as a mediation on a discrepancy to which some of its fundamental characteristics should be attributed."[31] Perhaps it was in the nature of a science born from the temporal discrepancy it has sought to reabsorb to source one of its primal scenes in a travelogue punctuated with temporal hiccups and melancholic moments. For Léry, this time is measurable as the number of years that separate his return from the publication of the manuscript, but it also registers through nonlinear relations within the text as the interminable work of sorting out what he can from what he can't bring back, what he can and can't live without.

## Coda: Anachronism and Biodegradability

The Anthropocene hypothesis has created conditions that mandate renewed attention to the temporal mode of existence of artifacts beyond their position on historical time lines. If all objects exist in time, they don't all exist in time in the same way and under the same modalities. Some are more impervious to historical claims than others, more time sensitive, more reflexive about their temporal existence and self-conscious of their recording power. A new class of objects has emerged in the Anthropocene present that invested its non-indifference toward the historical record in prospects of self-erasure.

The notion of biodegradability surfaced in the field of industrial microbiology in the 1960s where it came to designate the physi-

co-chemical properties of certain organic compounds that do not leave traceable markers behind. Biodegradability is a symptom of itself. It is an artificial word dealing with artificiality at a time when fast-paced cycles of production, consumption, and replacement generate enormous amounts of toxicity and refuse. For words are things too, more or less organic, more or less compounded, more or less pliable, and more or less durable in their capacity to refer to the world. In his meditation on the whereabouts of the term, Jacques Derrida notes that biodegradability "overloads language with a supplement of artifice":

> It adds a prosthesis to it, a synthetic object, a modern and unstable graft of Greek and Latin in order to designate primarily that which is opposed to the structure of certain products of modern industry, products that are themselves artificial and synthetic, from plastic bags to nuclear waste. . . . Because it does not belong to the organic compost of a single natural language, this strange thing may be seen to float on the surface of culture like the wastes whose survival rivals that of the masterpieces of our culture and the monuments that we promise to eternity.[32]

Insofar as biodegradability troubles our ability to discern between artifact and ecofact, and distinguish the surviving relic from the decaying process, the endurance of trash from the endurance of masterpieces, it functions as an Anthropocenic response to anachronism.

The idea of anachronism consolidated during the Renaissance to acknowledge and deal with the lingering properties of objects that "come into being bearing the marks of their historical moment" as both datable—that is, subject to authentication and falsification—and somewhat alienating in their duration beyond the life of their immediate beholder.[33] In the Anthropocene present, the concept of biodegradability does not just provide an operational logic to postindustrial societies to deprogram the chain reaction ignited by the act of making and deposit the temporal volatility surrounding the material existence of objects. It makes time in the sense that it is a paradoxical mode of staking claims to continuity and agency by undermining all claims to them—in dis-

tant line with the vanitas tradition. It is a mode of handling the asymmetrical relations between life spans and afterlives, between objects and ownership. It is another way to desire the future without having to live with the past.

But what does this desire mean to a history of print culture if, indeed, "printed discourse reproduces what seem to be 'living' moments of a delivery of meaning from one interlocutor to another"?[34] Conley muses: "As we 'listen' to the spoken words through the printed page, we nonetheless discover that our response is tentative, imaginary, seeming forever to be light-years from the context in which the writing originated."[35] And so, the living moment passes, reabsorbed within its own rhetorical effect exposing the printed artifact and its surrogate status. The moment that passed is released as its own duration, expansive enough to dissolve everything that touched it but also expansive enough for new temporal formations to emerge.

# CHAPTER
# FIVE

# Ark

## Noah's Grave

For Erwin Panofsky humanists are basically historians. They value the historical record in itself and attend to its graininess. In that regard, if Kantian humanities are defined by a qualified response to traces (in the sense of *"the records left by man"*[1]), it is tempting to frame environmental humanities as a response to the pressure of facts and, more specifically, of the kinds of facts that make up the substance of bad news. Extinction, for instance, is not always the paralyzing thought of the end of all things lost to a maelstrom of logical contradictions, where the thought of the end of all thoughts is still a thought and the image of the end of all images is still an image. It is also something that shows up in newsfeeds as yet another piece of information in a steady stream of stories jostling for a dedicated spot on what ought to be on our collective mind, leaving us reeling or indifferent, or something in between.

In early 2001, Advanced Cell Technology, Inc. announced simultaneously the birth of the first cloned endangered animal—Noah, a baby bull gaur—and the beginning of a new era in zoological conservation. The bioengineering process necessary to conceive Noah is known as somatic cell nuclear transfer. It consists of implanting the genetic infor-

mation contained in the skin cells of a dead male gaur in the enucleated egg of a dead domestic cow. The embryo was brought to term and delivered by a surrogate domestic cow at Trans Ova Genetics Advancement Center in Sioux Center, Iowa. The newborn calf, however, survived only forty-eight hours before succumbing to a bacterial infection.[2] Another bitter drop in an ocean of Anthropocene stories.

Scholars in the field of extinction studies teach us that the bioengineered birth of an animal considered to be extinct does not make it less extinct by virtue of being alive, and genetic resurrection is not viable if a de-extinct animal does not display the key behavioral traits usually cued in by the interaction with other members of the same species. They tell us that the loss of biodiversity will not be offset by cryopreservation of genetic material if there is nowhere left to accommodate species and herd life after de-extinction saved the day. They also explain that "one of the deadly ironies of developing interspecies nuclear transfer has been that, when cloned endangered animals have been born seemingly against all odds, basic husbandry problems have frequently brought about the untimely death of these animals. The question of how to care for the cloned animal has all too often been marginalized in technology development."[3] But it seems unfair, almost careless, to trade the collapsed news of Noah's birth and death for a cautionary tale. Instead, I return to the wager of this book, to query the status of humanistic inquiry in an ecology of knowledge and affects driven by the thought of extinction. If there is such a thing as extinction studies to start with, it is because the concept of extinction remains in excess of its operative logics within paleontology, population genetics, and field biology, where it originates. It is also because extinction has created new categories of loss and new forms of grief for which a language had to be invented. In that spirit, let the anachronism of Noah's brief existence designate a form of temporal and affective volatility in the present, something in the wake of which to reconsider the narrative resources afforded by a fairy tale—Charles Perrault's "Puss in Boots"—when it comes to building bridges between domains of knowledge whose fragmented state gets in the way of telling the story of the Anthropocene.

### Perrault's Ark

A miller died a miller's death with so little to pass on to his three sons that the scene of transmission is left off the official record. Writing would take too much of a toll on the very narrative existence of one of Mother Goose's most destitute creatures. We are told that upon the miller's death, "portions were quickly [*bientôt*] divided; neither the notary nor the attorney general was called in—they would have quickly [*bientôt*] swallowed up the whole piddling patrimony."[4] To wit, a notarial presence at the scene would have cost us the entire story. For with nothing left to pass on, there wouldn't be a story to tell. Moving outside legal, archival, and authorial structures enforced by notaries, attorneys, and signatures, the tale of "The Master Cat" opens an intermediary space within transmission codes. It deploys itself around the impending strike of the second *bientôt* as the narrative equivalent of these ecological buffer zones, where "species wiped out elsewhere continued to thrive."[5] Our time, Anna Tsing explains, is marked by the disappearance of these spaces of resurgence. If the Holocene was a time when untimeliness was possible because it was more affordable, or at least less brutally experienced, the Anthropocene corresponds to the loss of counterfactuals—the loss of odd things at odd ends that are more likely not to find the serendipitous niche they need to flourish anymore, or the loss of frugal beings that thrive on very little but whose existence on the wane is so easily diminished by the slightest downturn—even more so than to a new geological epoch.

Another memory of untimeliness called motherhood built itself around another postponed *bientôt* in Jean-Jacques Rousseau's treaty on education: "What loving care is required to preserve a united family! And there should be no question of virtue in all this, it must be a labour of love [*enfin tout cela ne doit pas être des vertus, mais des goûts*] without which the human species would soon go extinct [*bientôt éteinte*]."[6] Here *goût* is a sensorial principle of attunement.[7] It is the opposite of indifference and has the potential to make all the difference in the world in a world of shaky counterfactuals. The kind of difference that a few drops

of water can make over time in an arid landscape.[8] In this scenario, prospects of human extinction are not evolutionary in scope. They do not correspond to a disastrous event of planetary proportions. They designate the recessive reality of indifference. Incidentally, there is no maternal presence to be found in Perrault's tale unless we trust that it is Mother Goose herself that tells us that the miller's eldest son gets the mill, the second receives the donkey, while the youngest inherits the cat along with the vision of a certain death: "'My brothers,' he said, 'can make an honest living if they join forces; as for me, once I've eaten my cat, and made a muff from his skin, I must then die of hunger.'"[9] If the two older brothers receive the means to earn a living, the little one is left to survive for a little while with the little he has received.

Enter the speaking cat. What he has to offer in such dire circumstances is not his life—which he never had to start with since he too was transmitted, along with the mill and the donkey—but to cash in the youngest death check and buy himself some time. Cashing in death is what the cat does best: "The master of the cat . . . had seen the cat many times perform such clever maneuvers to catch rats and mice— when he hung by his feet or when he hid himself in the flour and played dead, for example—that he did not give up hope on the cat's ability to relieve his misery."[10] The youngest of the sons cannot but agree to give up the not-enough he received in exchange for a one-way ticket out of the primogeniture cul-de-sac. On these premises, he transmits his impending death to his cat to enjoy in the end a fabulous return on investment.

Fairy tales may be escapist in the sense that they trade in happy or otherwise cautionary endings, but it is only to the extent that they have cornered an at-risk youth into finding a way to flourish in the cracks of the kinship system that sought to write them out of the story. In the absence of a viable transmission scenario, transformation takes the lead in the story of the Master Cat so as to reverse-engineer the thought of extinction—as when, in the Anthropocenic world of whooping crane conservancy, humans put on a silhouette-canceling suit to prepare fledging birds from a captive-breeding program for migration.[11]

Step one: The cat presents the king with rabbits and birds he killed, on behalf of his master, whom he fancies to name "the Marquis of Carabas." As the king receives his gift, the nameless orphan receives a title along with some amount of royal gratitude. Step two: The shapeless boy is reborn into the body of a marquis outfitted by the king himself following a staged episode of drowning and rescue. Step three: A marquis needs a domain, which he receives directly from the mouths of peasants coerced by the cat into lying to the king. And what an estate! "It is a field that never fails to yield a plentiful harvest every year."[12] Step four: A marquis needs a castle that the cat wins over by defeating a shape-shifting ogre. Challenged to change into something as small as a mouse, the complacent ogre is easily devoured by the cat. The promise of a lineage formalized by the alliance with the king's daughter is the fifth and last step that completes the transformation cycle.

There is throughout Perrault's tale something almost alchemical in the process of turning signs into things, and abstraction into actions—starting with the image of death in the boy's mind. There is also something sociological *avant la lettre* in the analytics deployed by the cat. As the cat's trickery fleshes out a full-fledged marquis, the method itself unravels a feudal order, in which kinship oversees the distribution of power and the reproduction (and destruction) of bodies. The Marquis of Carabas, no less than any other marquis, received his privilege from the accumulation of violence and verbal alliances. From rags to riches, from the initial famished words to the final feast in the dead ogre's castle, nothing has changed in the institutional structure of power even as a deathling, with nothing to his name, not even a name, is reborn a sovereign. If nothing else, there is even more power attached to the Carabas name following the alliance with the king and the annexation of the ogre's estate. It is as if "The Master Cat" were dreaming of social mobility without being willing to overthrow rituals of feudal kinship and its allegiance to transmitted positions of power. No matter how masterful the cat is in his understanding of signs and codes of social recognition, he remains under the boy's authority even as he makes equity with his initial mortgage.

The cat and his master survive the ordeal of a world where death is an event that occurs within the food chain: a father dies exposing his meager patrimony to predatory clerks; the youngest of his boys is likely to die of starvation; the mill's cat in charge of keeping the mice population in check is on its way to becoming the boy's last meal; the devouring ogre ends up being devoured; and finally a drunk king gives away his daughter to an identity thief. From the anonymous boy who contemplated his own death nothing remains but his cat, who himself became, in the last instance, "a great lord and never again ran after mice, except to entertain himself [*pour se divertir*]."[13] As the tale ends and lands awkwardly on two moral afterthoughts, its closing statement designates a new relationship to food and death. It opens on a space of play where predators can prey without preying and where fabulous creatures, like the rodents the cat does not eat, or like the son the dying miller left for dead at the beginning of the tale, are neither dead nor alive but somewhere in between, trapped in a narrative box for the purpose of an experiment in surviving a moment of crisis in the reproduction of life.

There are other instances of such an experiment in *Mother Goose*, when Le Petit Poucet (The Little Thumblette in Jones's translation) along with his six older brothers is left by his parents to die in the woods after a bad crop year. In "Peau d'Âne," one of Perrault's *Contes en vers* (1694), the wealth of "the greatest king there ever was on earth/above ground [*sur la terre*]" depends on the digestive track of a remarkable donkey that, instead of producing manure, transforms biomass into gold coins—as if its metabolic system were directly plugged into the mineral riches of the sub-surface (*sous la terre*)—not unlike the large Brazilian trees concentrating high levels of uranium because of the size of their root system and the volume of nutrients they filter.[14] The king's one and only child puts herself through exile and transformation, not because there is not enough to eat, or inherit, but to force the decoupling between her and her dead mother and thus force her father out of his incestuous passion. The princess meets the king's impossible love with impossible sartorial requests. But her father stops at nothing, managing

each time to deliver the impossibly sumptuous dress, as if it were easier for him to conceive of incest than to resign himself to the "extinction [of his royal lineage] or a son-in-law's accession to the throne."[15] When there is nothing left to ask, not even the fur of the alchemical donkey, the princess finds refuge under its pelt and eschews her human fate under the cover of animality.[16] Those readers hunting down folkloristic traces of an Indo-European past will see in the humanimal conquest of power leftovers of a shamanic motif.[17] Fairy tales are often asked to serve as the deposit of a past that exists on the border of consciousness. I am more interested in the futurity they solicit and the emerging narrative system in which they sometimes land.

## Puss in Boots Goes to Pleistocene Park

By the time Perrault had recorded his version of "The Master Cat," there was no full-frame grassland ecosystem left in Europe. The world of grain and the storytelling that came with it—Perrault's "Master Cat," with its references to harvest and milling, being one of these stories—had already replaced a world of grass dominated by large herbivores whose quiet epic Russian geoscientist Sergey Zimov retold for us in the "Wild Field Manifesto" (2014):

> For hundreds of millions of years, terrestrial ecosystems were an arena of struggle between plants and herbivores. To avoid being eaten, plants protected themselves with thorns, tall heights, bitterness, acids, and sharp smells. Many developed numerous poisons: Solanaceae developed nicotine; poppy developed morphine; and willow developed aspirin. But, 20 million years ago, life on the planet changed. Grasses and quickly-growing pasture herbs appeared. They did not spend resources on thorns and poisons; their main strategy was rapid growth. All of them were tasty, nutritious, and not afraid of being eaten.[18]

In Zimov's retelling, the story of grass is embedded in the metabolic spectacle of life and death.[19] Changes in plant survival strategies—from

toxic individualism to selfless sacrificial dissemination—open up narrative options bridging the infinite distance between a fable of deep time ("For hundreds of millions of years") and a time before the apparition of fables. The "Wild Field Manifesto" offers the spectacle of a past that came to an end twelve thousand years ago with the rise of agrarian societies and the shift toward a new equilibrium between energy needs and territory.[20] In metabolic terms, this past designates a ratio between square kilometers of grassland and pounds of grazing flesh. In the context of Pleistocene Park, it is a past endowed with geoengineering properties.

Zimov imagined Pleistocene Park as a response to stories of a future on the brink. The idea behind this large-scale project is to reconstitute a lost grassland ecosystem whose carbon-sinking properties would stop, or at least slow down, global warming mechanisms. In Pleistocene Park, animals do most of the geoengineering work by virtue of being alive and alive in large numbers on vast expanses of otherwise unproductive land situated in the Russian Arctic (Republic of Yakutia). In theory, their continuous grazing, digesting, and trampling would contribute to insulate the permafrost, thus staving off the thawing process that is currently underway, threatening to release into the atmosphere enormous amounts of carbon and methane precariously trapped in the frozen soil. Even more speculatively, the impact of wildlife's newfound density on a corner of the planet would lengthen indefinitely the period of climatic transition we currently live in, or lived in until recently. The geoengineering rationale behind Pleistocene Park offers a literal take on Fradenburg's idea that "our most inspired attempts to replicate the past cannot help but change the world. We change the world when we put the past back into it."[21] If this equation constitutes an ethical challenge for historiography, Anthropocene science seizes it as an ecopolitical opportunity.

One of the missing pieces in Zimov's geoengineering project is a fabulous animal. It is not fabulous because it speaks (and fakes), like Perrault's cat, but because it is currently extinct. In a 2017 reportage for the *Atlantic*, Ross Andersen portrays Pleistocene Park as a familial

enterprise involving two generations of tricksters: Sergey, the father, and Nikita his son. Nikita Zimov narrates some of the biotechnological steps and hurdles that separate the present of extinction from the future mammoths' return in a genetically engineered form. But should gene editing succeed in retrofitting the Asian elephant genome, still remains the narrative gap of the birth. He explains that "the embryos will have to be nurtured in an engineered environment, most likely a tiny sac of uterine cells at first, and then a closet-size tank where the fetus can grow into a fully formed, 200-pound calf."[22] The biotech manipulations required by the speculative engineering of a mammoth exist in a suspended state and as part of a narrative contract that is roughly equivalent to the one drafted by Puss in Boots for his motherless master to enter into and be reborn a marquis: "If you will but give me a bag, and have a pair of boots made for me, that I may scamper through the dirt and the brambles, then you shall see that you are not so poorly off with me as you imagine."[23] Or in Nikita's version: "Give me 100 mammoths and come back in a few years."[24] In Perrault's story, the bag and the boots are two pieces of foraging equipment that form a nexus of narrative promises, where things are made available and held in relation with each other.[25] The empty bag (*sac*) is to be filled with the dead animals that the cat sets aside for the king on behalf of his master. The bag, unlike the cat, is barely a possession in anyone's possession. It stands for the mutual agreement between the storytelling animal and his human master at the end of his rope and the looseness of a contractual form built on carefully orchestrated delays. Pleistocene Park takes up residency in the interval between speculative advances in reproductive veterinary sciences and a history of fables. It exists as a pouch of prehistoric past holding together a volatile present made of precarious atmospheric relations and territorial compromises, a pouch whose narrative opening corresponds to the indefinitely delayed birth of a planetary future on life support.

Pleistocene Park is the site of an open-ended experiment in storytelling set in a climate of uncertainty regarding what our narrative options are when it comes to engaging with the world-altering prospects

of global warming. The provocative pairing between, on the one hand, a fairy tale in which a boy extends his cat's life long enough so that an agile feline can give him in return the narrative life he never had in the first place and, on the other, a geoengineering project imagined by a man who has vouched to give birth to mammoths, simultaneously disinvests the fairy tale from the conjectural traces of an Indo-European past that some readers would like to find in it, to reinvest some of its narrative energy in the Anthropocene present. The provocation is both deliberate and exorbitant. It is exorbitant in the sense that it "demands to attend both to the deep rumblings of a dynamic earth and to the complex temporalities of inheritance—cultural, corporeal, ecological."[26] It is deliberate as a reading experiment meant to query the narrative dimension of Zimov's "Wild Field Manifesto" rather than its territorial limits and real-world limitations but also to mirror, rather than deflate, the no-less-fabulous endeavors conducted around us in the name of reviving extinct species and keeping a sinking world order afloat.

Obviously Pleistocene Park is not a fairy tale. Mother Goose, conversely, does not offer models to mitigate a planetary crisis. Storytelling will not support increasing population pressure on the soil. The mastery of Perrault's cat does not apply itself to a milieu but to a counterworld conquered over the realm of necessity and negative futurity (*il faudra que je meurs*).[27] There is only the most tenuous formal analogy to be found in the fact that both scenarios register and attend to a scene of perilous transmission, or in the fact that both seek to bring motherless abstractions—a marquis and a herd of woolly mammoths—into existence. But isn't it enough of an overlap in the exorbitant scheme of things? Enough to ask whether some of the oddities in the pairing of "Puss in Boots" and Pleistocene Park will resorb themselves at some point in the future, that is, after Zimov's geoengineering project will have managed to reclaim a roaming space for the post–Ice Age wilderness that may have left its imprint, as an environmental memory, in the predatory violence suffusing Perrault's fairy tales?

It would be mad and dangerous too to confuse fairy tales and sci-

ence because there is no arguing against a fairy tale. But to be fair, shouldn't we expect the thought of extinction to drive us mad? Or to avoid such a loaded term, to induce *"a profound mutation in our relation to the world."*[28] As if there were not already some madness to the geo-engineering method—or anticipating the next and final chapter—as if biotech ventures with their informational view on species life reduced to a genetic code that science can both break and mend did not belong *de plein droit* to the realm of fairy tales. The point here is not to move unilaterally from fables to facts, or from fiction to flesh, but to bear with the fact that sometimes fables can be more tenacious than facts, and that sometimes fiction is all you have to bear with the world's appetites.

## Coda: *Gone*

Extinction studies exist within an ecology of knowledge and affects as a site of unlearning for the historicist automatisms and narrative assumptions that allow us to envision the future of the past in the idiom of history. The thought of extinction speaks to the challenge of conducting humanistic inquiry as a whole because of its tendency to corner the Anthropocene present into thinking that all there is left to do in the absence of historical prospects of continuity in time is to take a leap of faith into the technological remaking of life and death.[29] Contemporary painter Isabella Kirkland greets the thought of extinction with the technical skills cultivated by seventeenth-century Dutch still-life masters as a promise of mastery over a world of fleeting beauty that achieves duration in an image.

*Gone* (2004), one of the six oil paintings in her *Taxa* series, portrays sixty-three animal and vegetal specimens against an impenetrable dark background. Some are seemingly alive—the flowers and the birds perched on them; some conspicuously dead—shells, skulls, antlers, and wet specimens in preserving liquid; and others, such as the eggs, in intermediary states. The towering bouquet is reminiscent of Ambrosius Bosschaert's flower painting. The perched birds could be a nod to Balthasar van der Ast's *Still Life with Fruit on a Delft Plate, Seashells,*

*Insects, Flowers in a Wanli Vase and Two Parrots* (ca. 1620, private collection), and the fishes served on a silver platter a tribute to Pieter Claesz's humble breakfast spreads. While the skulls, the seashells, and even the orb of the eggs scatter vanitas motifs throughout the composition, the preserved specimens in jars repatriate within the oil-painting tradition Damien Hirsch's reboot of the memento mori genre in the 1990s with his spectacular tiger shark floating in a tank of formaldehyde (*The Physical Impossibility of Death in the Mind of Someone Living*, 1991, London, Tate Modern).

Kirkland frames her tribute to Dutch still-life painting as an expression of her commitment to accuracy; to the use of durable materials that withstand the test of time, retain and even accrue value; and to the study of historical sources and taxidermies in museums. But if there is a timeless quality to the genre, there is also something uncanny about its naturalism with regard to the ecological and systemic understanding of life that subtends the concept of species extinction. The flora and fauna in still-life paintings exist in a void, as curious pieces in a Wunderkabinet, not as part of an ecosystem. This suspended existence outside environmental time is what, in turn, makes still-life painting so apropos when it comes to picturing the terminal consequences of habitat destruction and ecological degradation.

However, for seventeenth-century Dutch master and art critic Gérard de Lairesse, still-life painting is a preposterous and shallow genre because flowers are meant to be smelled, not painted.[30] A still life lacks depth not only because it tends to occupy niches, larders, narrow windowsills, and kitchen tables set against an impenetrable background, but also because there is nothing in it to offset its onerous mimetic cost.[31] That nothingness speaks to the vanitas effect at the heart of still-life painting understood as a display of things that do not respond to our demand for stories and instead address us from the shallow grave where they have been laid to rest. Kirkland's website proposes a keyed version of the *Taxa* paintings, as if to counter still life's tendency to elude explanation. Her version of depth is not allegorical—as De Lairesse would have wished—but informational and ecological.

In keyed versions of the paintings available online each specimen is numbered and identified. In *Gone*, entry number 52 for the Stephens Island wren (*Xenicus lyalli*) even tells a story:

> In 1894 on Stephens Island, off the northern tip of New Zealand's south island, the lighthouse keeper's cat caught an unusual bird. An amateur ornithologist, the lighthouse keeper sent the specimen back to England, where it was recognized as a new genus and species. Sadly, in the following year, that same cat caught every last one of the small, nearly flightless, ground-nesting birds.[32]

This entry reads like an epitaph and, for those who have cheered for Puss in Boots, like a cautionary reminder that domestic cats are also merciless agents of ecological destruction. *Gone* is an invitation to mourn and more. More by direct visual associations with the Revive and Restore project, a de-extinction initiative led by the Long Now Foundation.[33] Kirkland's claims to the still-life tradition confront the lifelessness of image that no technique of representation will either revive or restore and query the nature of what is being revived and restored by de-extinction programs. What is it exactly that the dazzling technicity of bioengineering intends to rouse from genetic graveyards?

Before becoming *nature morte* in French, a still-life painting (in Dutch, *still-leven*) was a *nature reposée*, that is, a depiction of objects resting, or laid to rest.[34] The advantage of these designations is that they emphasize the gravitational pull at work in the image. They draw attention to the force of aggregation, disaggregation, and sedimentation that makes the visible happen the way it does. Thus, Claesz does not paint oysters but their perishability. Adrien van Utrecht does not paint a skull next to a large nautilus shell, a pearl necklace, and a pile of coins but the mineralization of existence in nongeological terms.[35] *Gone*'s busy composition teeming with extinct forms of life puts all its sobering weight on the edge of the table brushed by the feathers of the double-banded argus pheasant in the bottom right-hand corner. On the opposite side, the linear leaves of the mariposa lily point toward the depths beyond the frame of the painting. Three tree snails add to the overall tipping

effect. One peers into the abyss beneath the table, ready to slide off the image and into the world, from which they are now gone. Two smaller specimens straddle the imaginary point of passage between the table, a volumetric realm where things are perceived and consumed, and the tableau, a planar realm where they are represented and offered as image. But also between the promise of mastery over extinction delivered by the naturalism of still-life painting and the one that finds its expression in bioengineering. It is that very threshold between the promise of likeness and the disappointing vagaries of image making that Chapter 6 seeks to occupy.

# Meat

By the end of Perrault's "Puss in Boots" everybody either gets to eat or is eaten. Everybody except the fabulous cat left to play with his food. Now a pet of great means, he chases mice only to entertain himself, not for his sustenance. Mice may still die in the process—for who knows how cruel his pleasures are—but not to become the meat of the meal. What are we to make of this future past moment of dissociation between mice and meat in the Anthropocene present? Is it the beginning of a new cycle of transformations in which the trickster will do with meat what he has done previously with his master, born nothing and reborn marquis with a name, a body, an estate, a castle, and a lineage? The fairy tale baits its readers with the promise of a new, if not final, chapter in the coevolution of life, death, and food.

The object under scrutiny in this final chapter goes under different names: in vitro meat (or IVM), lab-grown meat, artificial meat, cultured meat, nonanimal meat, vegetarian or vegan meat, victimless meat, and even meat without feet. With each term comes a different inflection.[1] It is a delicate exercise in marketing that signals the coming into existence of a new product but also of new relations between life, death, and food. "Clean meat" denotes a purification project, while "victimless meat"

picks up on the sacrificial and often religious dimension of meat. "Artificial meat" seems to imply that *in vivo* meat, by opposition to *in vitro* meat, is not already artificial through and through, from the rearing of the animal and the control over its living and breeding conditions, to the processing and packaging of its parts. It is hard to shake off the faintly repulsive assonance of "meat without feet."

When it comes to artificial meat, the logic is not a logic of substitution—replacing one substance by another that offers the same, if not better, mouthfeel or taste or nutritional properties—but a logic of dissociation—between animal meat and animal death. To a degree, the search for clean meat parallels the search for clean, alternative, unlimited energy and fuels the same logical circuit: Why change a failing system if you can just power it until the next power failure? Like geoengineering proposals and de-extinction scenarios evoked in the previous chapter, the prospect of feeding the future with IVM falls in the technofix category. It is another spectacular instance of a technological leap of faith taken in the face of an ecopolitical situation of impasse, externalizing the problem instead of confronting the architecture of the problem so you can have all the genetic information without the vagaries of conservation, all the animal calories without the environmental or ethical cost of rearing and killing.

The Vanitas hypothesis reinvests this externalizing impetus as one of the sites where it would be possible to rethink the terms of a certain Anthropocenic indifference toward the life and death of images that stay with us but whose relation to the negative futurity we are left to inhabit remains unscripted. Here the objective is not to rob a hungry future of its dreams of making the association between animal and meat a thing of the past. It is not to defuse the media buzz and debunk the promissory structure in which the IVM enterprise is embedded either. Rather, and in the same improvisational spirit that characterizes the rest of the book, it is to understand IVM as a point of reentry into the history of our mimetic relation to the reality in which animals are reared, killed, processed, and consumed. It is to attend to the emergent properties of IVM as an image of meat in order to

re-create a context for the consumption of early modern visual culture and image theory.

## Immortal Meats

IVM is fatless and bloodless and, as such, flavorless. It functions as a blank slate that has the magnetizing power to attract promissory scenarios as well as venture capital. It already employs farmers of the future and feeds expectations that there won't be meat tomorrow, only an image of meat. It exists in the future tense as a point of exit from conditions of mass slaughter and its environmental consequences. In his militant travelogue to the land where a vegan world is not only being imagined but built, Paul Shapiro situates the IVM research enterprise in a startup culture of disruption. What is being disrupted, he explains in *Clean Meat*, are agricultural practices that have become unacceptable and unsustainable. But also, I would contend, although on a terrain biotech does not know it occupies, the relationship between image, animality, and death orchestrated by a book such as *The Art of Spiritual Painting* (1611). IVM represents a development in a history that started a long time ago, well before tissue culture in the early twentieth century.

Published in Lyon but conceived in Rome, where Louis Richeome resided from 1608 to 1615, *The Art of Spiritual Painting* is part of a large corpus of Jesuit image theory that emerged in the Counter-Reformation period to offer lessons in image consumption.[2] It is akin to a manual of visual culture that seeks to ascertain the value of images in the spiritual development of Jesuit novices. It deals with images insofar as they are reproduced, imagined, interpreted, circulated, and materialized in the form of paintings, engravings, verbal descriptions, and even bodies. Its pedagogy is structured around a series of visualization exercises focusing on the impressions images leave and the ways these impressions are solicited and rehearsed to compose new ones. Each section introduces different techniques and practices: how to use an altarpiece as a support for meditation, first with the help of a visual support, and then through the medium of a verbal description.

In the second section of the book, Richeome introduces novices to the refectory, a place dedicated to corporeal sustenance, where tables compose a tableau for the mouth (*Tableau de BOVCHE*) by opposition to a *Tableau de VEVE* hanging on the walls and made for the eyes, and a *Tableau d'OREILLE* painted for the ears by edifying readings. The tableau for the mouth, Richeome explains, is horizontal, and the tables in the refectory are its medium:

> The first coat corresponds to the tablecloths, napkins, spoons, knives, forks, glasses and other tableware. The tableau's main pieces are the viands [*viandes*] that one would put in front of you, not in painting— like the emperor Heliogabalus once did, when he covered the table of his courtiers with partridges, pheasants, capons, and other delicacies that only had their appearance and colors, and that could not sustain life only sight.

To be clear, the *Tableau de BOVCHE* is not a trompe l'oeil painting but a meal. The first lesson doesn't consist in shaking off the deceptive allure of an appetizing image but in seeing meat beyond what the mouth makes of it. In a sudden descriptive move, Richeome turns the table on the tableau painted by food laid on the tables. Although he states that "it is instituted and practiced for the conservation of life," the scene of nourishment also contains a hidden vanitas. The "*Tableau de BOVCHE*," he explains,

> represents death to us naturally [*naisvement*] through the main things that we eat. The meager serving or portion that is at the heart of the meal is made of dead things, either flesh or fish. For who has a piece of mutton or beef in his plate, a lamb or a kid's head, he has a piece of death and a skull [*teste de mort*] in front of him. And who has one or more fish, he has as many dead bodies in front of him, which he is about to bury in the pit of his stomach as if in a grave.[3]

Richeome concludes the exercise by exhorting his brethren to relinquish dead meats—here in the archaic sense that survives in viand—in favor of immortal meats (*viandes immortelles*) served at the celestial ban-

quet.[4] In the context of Tridentine theology, the stakes of this passage are eucharistic by proxy and the following section devoted to the *Tableaux de VEVE* hanging on the walls of the refectory is devoted to the Eucharist. In this initial meditation, novices learn to see differently, but they are also instructed to trust in the power of certain descriptive words to reveal the true nature of a substance and even change its reality without altering its appearance.[5]

Thomas S. P. Strangeways was a pathologist at the University of Cambridge and a pioneer of tissue culture, but he too has a lesson to teach about a case of resurrected flesh. In his last lecture, fatefully titled "Death and Immortality" (1926), he treated his audience to a gruesome thought experiment that would not be out of place in the imagination of a dark fairy tale:

> If we now proceed to pass the theologically dead body through a sausage machine it becomes physiologically dead, i.e. function is abolished. The body, now transformed into one or more string of sausages, does not however become cytologically dead for several days or if kept in cold storage, weeks (unless in the meantime life is abruptly terminated in the frying pan). Assuming that the procedure was carried out under aseptic conditions and that no toxic seasonings have been added it will be found that on cultivating pieces of the mince-meat in vitro, active division and migration of the cell will take place.[6]

Bringing the thought experiment to life, and with an indubitable flair for pedagogical theatrics, legend has it that Strangeways unveiled at the end of his lecture a cell culture he had prepared with sausage links purchased from a local butcher.[7]

Although this episode of meat reverse engineering from the early history of tissue culture brings us considerably closer to the IVM present and its dream of making the association between animal and meat a thing of the past, the unexpected proximity of some elements with Richeome's demonstration is worth highlighting. In its raw state, the sausage link is not what it seems. It is dead. But under the guidance of

the professorial voice, its minced flesh is said to exist in three states: as subject to theological death ("the permanent departure of the soul from the body"), physiological death (permanent organ failure), and cytological death (once the sausage has been cooked or seasoned too aggressively).[8] Minced meat may be a sure sign of death, but it may still be cytologically alive. In the right conditions, with the right medium and proper care, cultivated cells can live forever (the Hayflick limit to cellular division was yet to be discovered at the time of Strangeways's last lecture). In both Richeome's theology and Strangeways's cellular biology there is an insistence on seeing meat and what it stands for differently. It is less about the fact that meat is an image (of death) than about the opacity that comes with its visual presence on the table in the Jesuit refectory and in the Cambridge lecture theater. In both meditative exercises, a desire named IVM stands in retrospect as a missing term between different versions of death (and life), and thus between theology and biology (and even Jesuit iconology), but also between meat as sign of death and the meat still to come that will be a by-product of cellular immortality.

## Trompe bouche

The desire named IVM is the desire for an image that finds its expression at the crossroads of idioms that don't usually translate each other. IVM is the desire for an image that will replace meat like photography was supposed to replace painting in its claim to reality, or even reality itself, in the emphatic words of Oliver Wendell Holmes: "Every conceivable object of Nature and Art will soon scale off its surface for us. Men will hunt all curious, beautiful, grand objects, as they hunt the cattle in South America, for their *skins*, and leave the carcasses as of little worth."[9] Likewise, IVM intends to discard the very notion of animal carcasses, for it is mostly flesh that it is after. Of course, IVM is actual flesh only for a select number of tasters. The others will have to lean in, trust in the hype and the words. For them IVM is only an expensive image whose palatability hides in plain sight.

Although consumers are already chewing on the idea of dissoci-
ation between animal and meat that would offer all the nutritional
benefits and carnivorous pleasure without the killing and the onerous
environmental footprint, at this point in time lab-grown meat is still
a non-offering, and if it is indeed possible to grow minced meat, it re-
mains difficult to engineer a rib-eye steak. This may explain why tasting
scenes are a key element in the constitution of IVM's claims to reality.[10]
The 2013 public unveiling and mediatized degustation of the first burger
grown in vitro is a good example. Before that, in 2003, a bioart in-
stallation in Nantes, France, conceived by Oron Catts and Ionat Zurr,
served a tiny frog steak to guests in the presence of the living frog that
provided the initial cells for the "steak."[11] In this origin story, which
again is redolent with the enchantment of fairy tales, the taste test was
less about taste than it was about redirecting the potential source of
disgust attached to the identity of the meat—frog meat—toward the
provenance of the meat as artificial and semi-living meat. Reportedly,
Catts and Zurr's guests ended up spitting out their bite-size meal._

Paul Shapiro had a more positive experience, although not entirely
free from a certain uneasiness. He describes his first bite of "clean" foie
gras developed by Hampton Creek with duck liver cells cultivated in
a nonanimal-sourced serum, as a semi-transgressive experience fla-
vored with the thought of failing to his commitment to vegetarianism:
"The flavor was impressive. The *pâté* was rich, buttery, savory, and very
decadent, just as one would expect. I'm certainly not the best judge
in this case, but as I closed my eyes and let the fatty liver melt on my
tongue, the Hampton Creek foie gras brought me an amount of plea-
sure I'll confess I was a little embarrassed to admit."[12] I would argue
that these tasting scenes rehearse and disrupt the memory of Zeuxis's
grapes "painted so naturally," Pliny the Elder wrote, "that the birds
flew towards the spot where the picture was exhibited."[13] With IVM,
however, the image yields and becomes chewable. No more tricks. No
more pretenses of the image to life.

Two anecdotal variations on the same conceit retrieved by Louis
Marin in eighteenth-century art criticism go even further in their evo-

cation of the trompe l'oeil setup inspired by the Zeuxis fable. The first anecdote from the Abbé de Monville recounts that Pierre Mignard had painted a cat ambushing a turtle hidden under the foliage "with such truthfulness that on more than one occasion some have witnessed dogs seduced by the image run into it, hurt themselves and leave traces of their blood on it."[14] The other anecdote from Dezallier d'Argenville describes a view in perspective painted by Jacques Rousseau in the gardens of the Château de Reuil that was so lifelike that birds attempting to fly through it would break their head against the wall.

Like trompe l'oeil painting, IVM is a "strange artifact."[15] I am not saying that IVM is a form of trompe l'oeil, but that in order to address the promise of an image (of meat) that is supposed to save us from our carnivorous appetites, as well as to save animals promised death in a world of dwindling resources, we have to consider how trompe l'oeil implicates birds, cats, dogs, and turtles. The bloodstains that the dogs leave on the wall painted by Mignard and the dent that birds make in Rousseau's painting as they lose their lives to the image are both essential to the image and yet incidental to it.[16] Because "a trompe l'oeil insists on the bodily presence of the beholder in order for its deception to be enacted," the illusionistic effect demands its pound of flesh in the form of bleeding animal collaterals.[17] From the perspective of mimesis, that is, from the perspective of what lab-grown meat seeks to imitate so well that it takes over the imitated substance, the problem is not about the difference between original and copy, livestock meat and cultured meat, because lab meat can pass as meat without being really meat. It has to do with the continuum between meat, animality, death, sacrifice, and image making that a desire named IVM seeks to interrupt.[18]

A thought: perhaps IVM enters the history of visual culture as the fantasy of an image that would not be so indifferent to animal life and death. In the anecdotes cited by Marin, examples of trompe l'oeil painting take animal lives, but the medium itself remains indifferent to the difference between life and death. Painting captures life and death and puts them on the same plane. It may give the illusion of life and movement even though visually speaking a painted animal is no different

from a dead one. Another thought: maybe this is what the exuberant juxtaposition of dead and living animals in Frans Snyders's market scenes and game still lifes is all about.

## Tableaus of Meat

Snyders's life-size compositions are not trompe l'oeil, partly—and only partly—because they have fused the telltale animal lured by the painting and the dead animal killed by the impact. No more blood splatter ruining the overall illusionistic effect. In the *Game Market* from the Los Angeles County Museum of Art, the bloodstains are part of the painting, reabsorbed into the frame as telltales of animal death.[19] A single drop of blood on the mouth of one of the two hares hanging from the beam is just about to drip and sully the majestic feathers of the peacock underneath. Captured in its suspended state, in a meantime that lasts forever, it catches a speck of light and glistens. Below the table covered with carcasses, a rapacious cat holds the dead peacock's head with its paws as if to look right into its eyes in an acknowledgment that they belong, alive or not, to the same pictorial reality.

Commentators have observed that while some of the dead animals displayed in Snyders's game still life are clearly marked for consumption, others are destined to become trophies.[20] But doesn't painting always turn meat into trophies regardless? Other have observed that Snyders paints abundance but that it is not clear whether the gesture toward plenty is celebratory or indicts excess. Visually, the abundance on the table allows for gravity to register. Carcasses are either limp, piled up, or hanging. Because of its limpness, the fawn in the bottom right corner belongs to the pile of asparagus, artichokes, and cardoons. From the perspective of early modern art theory these are not so different. Still-life paintings with meat and veggies are bad hanging objects. De Lairesse is very clear on that point: "As for cabbage, carrots and turnips, as likewise codfish, salmon, herring, smelt, and other such things; they are bad and awful decorations, not worthy of hanging in interiors."[21]

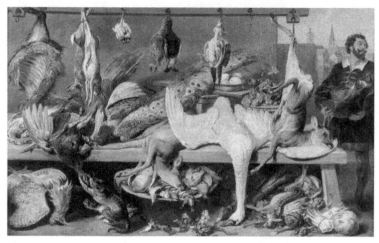

**Figure 16.** Frans Snyders and Cornelis de Vos, *Game Market* (ca. 1630). Oil on canvas, 80 11/16 × 134 1/4 in. Frame: 85 × 139 × 2 1/4 in. Los Angeles County Museum of Art.

**Figure 17.** *Game Market.* Detail 1.

**Figure 18.** *Game Market.* Detail 2.

In Snyders's *Game Market*, animal carcasses hang in different states of preparation—skinned, quartered, dressed, plucked, or still intact—from the same beam running alongside the upper edge of the painting. Two of the eight hooks are still available, as if calling for more carcasses. Unless of course, at a figural level, the empty hooks are already supporting the lifeless carcass of the painting itself. Like the glistening drop of blood beading up on the hare's mouth, the empty hooks remind us that an image of meat can never be just an image of meat. They carve some much-needed depth in what would be otherwise a shallow display of flesh, but not the kind of depth rendered by perspective. The image of meat can be assigned, signed, dated, purchased, copied, and curated on the presumption that it meant something to someone at

**Figure 19.** Peter van Boucle, *Butcher's Meat with Dog and Cat* (1651). Oil on canvas, 44.4 × 58.6 in. Propriété de l'Etat, musée du Louvre département des Peintures, INV 1852; MR 1038. https://collections.louvre.fr/ark:/53355/cl010061438.

some point—at a time when the distance between the wall, the canvas, and the beholder was still assignable. After all, images are artifacts, possessions, consumables, no less than meat. And like meat, the image of meat can also be an offering, a visual event, made to last and outlast whoever wished it into mimetic existence.

It is hard to imagine a more jarring juxtaposition of dead and live animals than in Peter van Boucle's *Butcher's Meat with Dog and Cat* (1651). Perched on the left side of a kitchen table, a cat, either vexed or defiant, engages the dog on the other side of the painting in a staring contest. About a third of the dog and three-quarters of the cat are visible. The rest of their bodies has been cropped out by the frame, as if to leave enough room between them to fit the butchered body of a lamb split in half. Still intact, the head of the lamb is all that's left of its humanimality. Viscera hang from a wheel above the right side of the table, catching light and glistening. On the other side of the

composition, towering above the cat, a flayed animal head rests in a copper colander facing upward. Its dead eye "looks at us" from across the difference and the distance that separate life from death "but does not see us."[22] Like the glistening drop of blood on Snyders's hare, or the shimmering tin can of sardines floating on the water under the sun in Jacques Lacan's childhood memory, the glare in the eye of the skinned head in the colander is not a geometrical point. It is unassigned and does not assign the difference between life and death, human and animal, sacrifice and cooking, meat and trophy. It is but a dent in the wall of painting we are hitting without even registering the impact. A retinal bruise in our mimetic relation to the world. The distance between the painted carcass on Van Boucle's table and the beholder on the other side of his tableau remains unknown and nonmeasurable, forever ambivalent, which is why there might be something Christological in disguise about the visual rhymes between the dramatic marbling of the meat and the gentle folds in the immaculate tablecloth that receives the flayed lamb in a shroud.[23]

By comparison, the knife wedged underneath the lamb's carcass seems stable enough. And yet it too is deeply destabilizing in the visual effect it projects. In a move common to seventeenth-century still lifes, the knife sticks out of the table and trespasses on the picture plane.[24] With its blade facing inward, the knife handle is closer to us than anything else on the table. It is almost within reach, as if looking at the carnage was already taking part in it. And yet this knife is also one of the least legible objects in the composition. Not that there is any doubt on what this thing with a blade and handle is. What makes the knife a knife, the blade, with all its carving potential, the blade that is likely responsible for the flaying of the lamb, disappears inside the carcass. As the iconographic sum of everything that can be said about it—its estimated length for instance, or the fact that the handle is perhaps made of bone or ivory—the "knife" belongs to the table. But the idea of "knife" does not quite cut it. The designation does not do descriptive justice to its angular dimension as the gnomon of a sundial that knows nothing of the sun, or its beckoning properties as a handle that no hand has ever

**Figure 20.** *Butcher's Meat with Dog and Cat*. Detail.

touched, only painted. The painted knife in *Butcher's Meat with Dog and Cat* breaches the invisible limit between meat and its image.

The reference to these still lifes does not explain the desire called IVM any more than the promises of meat without animal death explain meat in a painting—whatever explanation is needed. (Sometimes we simply don't want the real thing. We prefer the ersatz for all sorts of reasons nobody can hold us accountable for. The foodie in us knows best, and yet we can't help preferring clear artificial vanilla extract because it tastes like the birthday cake mix we learned to love before having to want to love the real stuff.) Despite a techno-narrative of likeness made easier and ever more lifelike—from trompe l'oeil painting to photography, from 3-D printing to tissue culture—the future of image making never ends up being a future of least mimetic contrivance. For in the end no image really needs to be.[25] At best—to return to the terms of Panofsky's lecture—IVM "enlivens what otherwise would remain dead."[26] It breathes interest in the still lifes painted by Snyders, Van Boucle, and others. For Panofsky, enlivening means connecting dispersed historical

records in terms of influences and lines of evolution.[27] Knight Powell comments: "By enlivening its objects, [art history] tries to forget that its objects never in fact belonged to their original contexts precisely because they are lifeless things, which neither live nor die along with the people who make them."[28] IVM may enliven still-life painting but not by assigning a stable referent to life and death freed at last from being their own tropes. After all, in the context of tissue culture, cellular life and death are movable targets waiting to be reassigned. It enters, uninvited, the temporality of art history, visual culture, and the discourse on human-made objects in the "age of Man"—the Anthropocene—as the fantasy of an image that lives and dies in the act of its literal consumption as semi-living meat.

## Coda: The Lament of the White Doe

Let's retrace our steps. *Environmental Humanities on the Brink* represents an effort to initiate a dialogue between a present that has little patience for the past and the proposals, projects, and prototypes that same present invests with prospects of continuity in time. For better or worse, it is not the kind of dialogue that lends itself to a linear argument made of concatenated lessons to be learned on the premise that "understanding how past societies responded to social-ecological risks or regime shifts may help us better navigate present and future challenges in an era of accelerated environmental transformation."[29] The past I have in mind is less an enclave in the divisions of historical time than a perceptual field. That is, a capacity to notice, take in, and let go. It is an experiment in affective responsivity and exhausted attention.

Incidentally, it is through the retelling of an experiment in responsivity across perceptual boundaries that Theodor Adorno and Max Horkheimer understand modernity's relation to the past: "Book XII of the *Odyssey*," they explain, "tells how Odysseus sailed past the Sirens. Their allurement is that of losing oneself in the past." But not any past. The Sirens present their victims with a past in its melodic state, unharnessed to a narrative of progress and uncontained by "a fixed order of

time . . . intended to liberate the present moment from the power of the past."[30] Noninstrumental versions of the past are not amenable to precedence or exemplarity. They exist only to haunt us—or to wreck wayward ships. Tied to the mast, Odysseus got a taste of the dangerous song, while his crew kept on rowing, their ears filled with softened wax. Or in Friedrich Kittler's interpretive coup, the ever-unreliable hero did stop by the Sirens' island to replenish his supplies and have sex with them before covering up the escapade with a tall tale of his own invention: the fable of a body capable of receiving the allurement of the past without losing itself into it.[31]

Unlike the Sirens' song in the *Odyssey*, "The Lament of the White Doe" ("La complainte de la blanche biche") does not hold alluring promises of knowledge. It withholds as much as it shares. It tells a story of metamorphosis involving a legendary animal and a concerned mother, a troubled girl and her violent brother, a merciless hunt and a hunting accident. It ends with a grueling feast during which the girl killed by her brother is served to an assembly of guests, for whom she appears to be singing:

> The women going into the woods are a mother and a daughter,
> The mother sings and the daughter sighs.
> "Why this sigh, my fair Marguerite?"
>
> — "I have so much anger in me I dare not say:
> I am a girl during the day and by night a white doe.
> Hunted by barons and princes,
>
> "And my brother Renaud, who is the worst of them.
> Go Mother, go and promptly tell him
> To hold his dogs until tomorrow afternoon."
>
> Renaud, where are your dogs and your princely hunters?
> — "They are in the woods chasing the white doe."
> — "Stop them, Renaud, stop them, I implore you!"

Three times he recalled them with his brass horn
The third time over, the white doe was taken.
"Let's summon the stripper to skin the beast."

The one who skins her says: "I do not know what to say:
She has blond hair and the breasts of a girl."
Drawing his knife, he quartered her.

They served her for dinner to the barons and princes.
"Here we are all seated but my sister Marguerite?
— "Go ahead and eat, I am the first seated;

My head is in the platter and my heart by my ankles,
My blood is splattered all over the kitchen,
And on the black coals, my bones are roasting."[32]

The song exists in a vaporous state made of multiple versions. Georges Doncieux situates its origins in the late sixteenth century but only by virtue of its "moderately archaic colors."[33] In what Benjamin would have called its "chaste compactness," "The Lament of the White Doe" does not explain anything.[34] Instead, it aggregates narrative voices into an operatic sequence of events that never seem to fully register and leaves witnesses at a loss for words ("I dare not speak"; "I don't know what to say"). It is impossible to assign a definite tone to the haunting send-off of the song ("go ahead and eat"). Is it a ghostly rejoinder destined to be heard by the guests? Is it a fabulous disturbance that will surely put an end to the horrible feast and leaving, as one might expect, the plated meat untouched? Or is it a melismatic interlude lodged between the event itself and its narrative aftermath to signal the work of memory? What are we supposed to hear in the strange song of the meat? A revenge in music or an invitation to consume the victim and forget the exact contours of the incident? Whatever really happened to Marguerite, all that is left of her ordeal is now ciphered in a commemorative lament.

The language that surrounds the capture of the doe is suffused with sexual violence—"the white doe was taken"—as if to suggest that the hunting accident was but a placeholder for another ill-fated pursuit that led to Marguerite's demise at the hand of her brother. Moreover, a long tradition in medieval literature going back to Ovid associates chase, hunt, and amorous pursuits.[35] To say something as unconceivable as what really happened between Marguerite and Renaud, one needs an impossible voice that can travel through a concert of bodies: from the initial sigh to the final song, from the concerned mother to her withdrawn daughter, from the princely predators to the puzzled butcher, and from the humanimal body of the victim to the meat itself, whose voice hovers above the dish ("My head is in the platter") in an unsettling vision of breast, hair, head, ankles, heart, blood, and bones heaped in a disjointed state.

By shifting the ground on which meat, death, and animality define each other, IVM may allow us to hear differently the disconcerting terms of Marguerite's lament as a lyric episode in a history of meat and violence that dreams of having the animal and eating it too. I am not suggesting that Marguerite's song is about IVM. In fact, the lament is not about anything that can be assigned in such terms. It is what's left once the possibility to reconstitute and recount a series of events has been forfeited. It is not even a matter of moving on by putting things behind. That kind of directionality is entirely foreign to Marguerite's pared-down tragedy. In this scenario, IVM is not the future of meat but an elegy by different means. In an unclaimed variation on the Siren episode, the IVM project wished into existence a body capable of indulging a long legacy of carnivorous appetites without condoning the killing of nonhuman animals. It seeks to index the difference between past and future on the disjunction between meat and animal death. In Marguerite's lament, the disjunction between animal death and meat is essentially melismatic. It is contained by a singing voice ("Go ahead and eat, I am the first seated") but directionless.

Besides, IVM doesn't exactly spare the animal—say, the pig fated to become sausage. Rather, it creates conditions in which that pig is

not brought into existence. In other words, IVM promises to save the animal as it erases that animal in the sense that the animal does not exist anymore as a creature that can be consumed. In "The Lament of the White Doe," the singing voice is indifferent to the bodies it impersonates. But so is meat in the end: the venison in the plate could just as well be someone—the missing sister or someone's sister. Not unlike the IVM project, Marguerite trades her body for a voice that sings its indifference toward the bodies it impersonates to give us permission to keep on eating, to put aside the violence that both feeds and gathers, and to stomach the perceptual indifference that allows for certain bodies to be turned into meat.

# Light

The Anthropocene hypothesis offers the civilizational equivalent of an out-of-body experience where a few millennia of historical record will have become legible as a symptom of collapse, decline, hubris, or extinction depending on the story we want to tell. It leaves earthlings with the picture of a world that may have never felt more responsive in unpredictable and catastrophic ways and more terraforming in its capacity to blow out the civilizational record to geological proportions. And yet, it is not clear what this hypothesis has to say about the fact that this record means something to some of us in a meantime where fossil deposits, millions of years in the making, are burnt in a matter of centuries, when they are not turned into a one-time-use Styrofoam cup with up to a million-year life span.

It is that experience of a present coming undone that I wanted to reoccupy with the Vanitas hypothesis as the inspiration for an ecocriticism in a minor key. The argument I pursued did not consist in trading facts for representations, or by stabilizing volatile relations, if only for the hard-to-swallow reason that, as Fradenburg put it with such resolve, "knowledge of what happens in time . . . does not 'fix' anything because it is always changing the future."[1] Rather—and this brings us back to

the idea of alternative ethics of history broached in the Prologue—it spoke to the possibility for the past to exist in relation to future loss—as loss of data or loss of sensitivity—and even in light of extinction. While Chapters 1 and 5 playfully engaged with visual proxies of extinction in the guise of vanitas still-life paintings, old and new, in this Epilogue I toy with the word "extinction" itself to ask: How do we stay with the flickering thought of extinction before extinction?

In the lyrical world of Pierre de Ronsard extinction is not quite a thing but not quite an abstraction either. It pertains to light and affects rather than to forms of collective existence on the brink of collapse—be it a species, a language, or a way of life. This photosensitive version of extinction is quiet. It does not find its expression in explosive visions of the end of all things but in an unrequited wish upon a candle:

> *Je voyois me couchant, s'esteindre une chandelle,*
> *Et je disois au lict, basement à-par moy,*
> *Pleust à Dieu que le soin, que la peine & l'esmoy*
> *Qu'Amour m'engrave au cœur, s'esteignissent comme elle.*

> I saw, as I laid me down to rest, a candle extinguishing itself,
> And said in bed silently to myself
> If only the care, the sorrow, and the agitation
> That Love engraves in my heart, could, like this candle, extinguish themselves.[2]

If there was indeed a time when extinction was materialized by faint wisps of smoke warping above snuffed candles in vanitas painting, there is nothing to suggest that the truth of extinction is in Ronsard's crepuscular tableau. After all, "the verb 'to extinguish' [*s'éteindre*] can kill anything, a noise as well as a heart, love as well as anger," even a conceptual entity like "species" as in "species extinction." In a late phenomenological *rêverie*, Gaston Bachelard adds, almost as a corrective: "But who wants the true meaning, the primary meaning, must remember the death of a candle."[3] One must, if only to be reminded of the cre-

puscular prehistory of a word, whose point of anchor in the world could be vacated at any time. It seems oddly comforting that an early modern memory of extinction should be borne by something as labile as the flame of a candle and as codified as a sonnet, or that it would linger in the form of a past whose relation to the present is not anticipatory.

Early modern extinction is neither a paleontological event nor an evolutionary concept. It designates a form of temporal and affective volatility, something in the light of which to grieve for the world that hurts. In a rousing plea for the conservation of biodiversity, Edward O. Wilson says something of that nature, only with much more assurance in the availability of a future tense:

> As habitats shrink, species decline wholesale in range and abundance. They slip down the Red List ratchet and the vast majority depart without special notice. Being distracted and self-absorbed, as is our nature, we have not yet fully understood what we are doing. But future generations, with endless time to reflect, will understand it all, and in painful detail. As awareness grows, so will their sense of loss.[4]

It is as if there were a form of duration and contemplation that only the thought of extinction could grant us in the Anthropocene present. In Wilson's temporal arithmetic, sense of loss and prospects of endless time seem to be able to grow in proportionate measures. Where is this sense of endlessness coming from?

A possible, although unclaimable, source is to be found in the kind of tour de force deployed in another sonnet by Ronsard from the same collection, which also happens to be one of the most anthologized poems of the French Renaissance:

> *Quand vous serez bien vieille, au soir à la chandelle,*
> *Assise aupres du feu, dévidant et filant,*
> *Direz chantant mes vers, en vous émerveillant,*
> *"Ronsard me celebroit du temps que j'estois belle."*[5]
> When you will be quite old, beside the evening candle,

> Sitting by the fire, winding and spinning wool,
> You'll say, singing my verses in wonder,
> "Ronsard celebrated me, when I was beautiful."

A precarious incandescence subtends the poem. The candle that illuminates the scene glows against a future in chiaroscuro where youth and beauty are already things remembered. The sonnet is a temporal trap. Winding and spinning tenses, like she spins and winds the thread of her crepuscular thoughts, Ronsard's verses premeditate the reflexive duration she will have gained with age, but only too late. While the future takes over the scene, the present in which she is still beautiful and worthy of celebration is reduced to almost nothing in the last two verses of the sonnet by the urgency of a flower-plucking imperative:

> *Vivez, si m'en croyez, n'attendez à demain:*
> *Cueillez dés aujourdhuy les roses de la vie.*

> Live, believe me: don't wait for tomorrow,
> Pluck this very day the roses of life.

If *anthos* is Greek for flower, then that particular sonnet stands for the *logos* that both wields tenses around the aperture of Ronsard's resounding ego—"singing my verses"—and rearranges the stems of her temporal existence into a capacious vase filled with regrets.

There is no need to lament the carpe diem cliché at the end. All one needs according to Malcolm Quainton is a modicum of historical sensitivity. He explains that "one of the initial difficulties facing the twentieth-century reader of French Renaissance poetic texts in general (and amatory utterances in particular), is that s/he must divest her/himself of anachronistic (post-Romantic?) hermeneutic models which mechanistically equate sincerity and lived experience with originality, inspiration and creative excellence."[6] It is not unreasonable to expect that some readers will manage to remain sensitive to the metric and intertextual intricacies of early modern poetry, taking upon themselves to constitute

themselves into its living and aging remains. *Seizièmistes* may be endangered, but they are not all gone. That said, Quainton's admonition also offers at the expense of his own reading effort a glimpse at the thought of a lyric tradition stranded in a present that has grown insensitive to its subtleties. What happens to Ronsard's temporal contraptions in a world where the asymmetry of light and life registers as chronic sleep deprivation, or as the profitability of an agricultural model that photo-tricks chickens into laying eggs several times a day? Could this other memory of extinction remind a present of its formalization efforts in matters of synchrony, whether it means finding a rhythm in the annual return of the pumpkin spice latte for those of us longing for sensorial patterns of comfort that off-the-rail seasonality fails to offer?

> . . . *or comme on voit souvent*
> *L'Esté moins bouillonner que l'Automne suivant,*
> *Mon Septembre est plus chaud que mon Juin de fortune.*

> . . . and as often we see
> a summer less boiling than the following autumn,
> My September is hotter than my precarious June.

Time here is the abstract target of normative and regulatory practices that turn it into a substance. It is an object of attention and effort in relation to which codes of conduct are defined and enforced. In an age of mass extinction and quantified loss, Ronsard's lyric attempt at an orchestration of asynchronized desires, hers and his, and durations, things made to last, like poetry and love, and things that embody transience and disposability, like flowers and youth, throws into relief our modes of holding on to affective and temporal expectations in the Anthropocene present.[7]

The problem this book wrestled with is not that the idea of a world after us has stretched historical sensibility to its narrative limits and left us without a script with which to get by, but, as Wendy Chun explains, that "in response to the unimaginable and the undecidable, we

have produced a scientific and technological imaginary that allegedly needs neither imagination nor decision."[8] As if all we needed to survive in a climate of uncertainty were forensics powerful enough to close the gap between past, present, and future by converting biodiversity into retrievable (or irretrievable) genetic information, or by compressing centuries of painting into color ratios on a chart. There is nothing wrong about wanting to police temporal volatility in order to take up a position in a world faced with unimaginable disruptions. Only, forensic fantasies can fail us too. Predictive models, Chun argues, force the present into decisional impasses, at which point all there is left to do is to wait for the future to show up, prove some right, prove others wrong, while everybody else loses. That is why we need to turn to "other forms of reasoning that lie beneath, that are less than reality, but not for that reason less important and scientific."[9] Even though it is not what Chun has in mind when she talks about hypo-real models, it is on these premises that I have turned to vanitas motifs, allegorical engravings, landscape and still-life paintings, chronicles, fairy tales, and fragments from the early modern lyric tradition.

Of course, it does not mean that, handled correctly, historical sources will solve ecopolitical problems, fix tepid policies, or sway unresponsive minds. From the vantage of the Vanitas hypothesis there is no point in wielding early modern *humanitates* as an unqualified good in the face of quantitative reasoning. That said, the book strives to extend invitations to stay with the thought that there are still lessons to be learned from a sustained engagement with a historical record in the process of being made irrelevant by the Anthropocene hypothesis, although they are to be learned on unfamiliar premises: that is, without presuming that the future is available to us, and neither simply on the account of the inherent pastness of the past, nor solely on the basis of its lasting effects. Too often, anthropologist Andrea Ballestero writes, "effects are predetermined by what we can recognize in the present."[10] Environmental humanists need to bother with memories of what seems to be ineffectual and reclaim its ineffectuality before the future shows up. It is not a matter of beating predictive

models and logics of datafication at their own game but of challenging a belief in the disposability of the past in an ecology of knowledge that deals in proposals, policy-oriented memos, and scalable models. It is not a matter of having something left to salvage in the face of the Anthropocene worst-case scenarios, but rather of having something to lose to the thought of extinction.

Lauren Berlant taught us that breaking up with a fantasy is not easy, especially when no claims to the real will do the trick. It is hard because forensic fantasies are all we have by way of a reality check and all we have left by way of assessing what it is that threatens that reality. It also means that in the end, only the future we will have given up on can possibly register what went amiss by not showing up as a future to live by. By the same token, unlearning historicist attachments is never simple, when so much of what it has meant to be responsible and ethical depends on the capacity to tell the story of what gets lost to the present and speaks for the dead and their wishes, and why not, for extinct species. If the Anthropocene hypothesis threatens the historical record with indifference, it is only to the extent that humanistic inquiry can't take the responsivity that the emergence of a planetary archive made of temperature charts, generalized social inequalities, crop monoculture, and sprawling landfills demands from us. The Vanitas hypothesis orchestrates a responsivity to the pressure of facts, data, conjectures, and other "contested points of reference in climate policy debates," like the wedge diagram, without presuming too much about what the environmental knowledge produced in proximity to objects from the past should look like or amount to.[11] It recognizes that the combined forces of artificial intelligence (AI) and datafication are not the only horizon of history, that the totality of the human record does not lend itself so easily to compression into a single file, and that objects from the premodern past also exist as modes of intellection rather than as searchable deposits of information. It is less vested in retrieving ecological information in historical texts and images on the assumption that we always know where the world ends and representation begins than in finding out ways to channel contemporary interests for the unraveling of the

world in objects and texts from the past, not knowing where the past ends and the future begins. It offers for debate a sense of feeling historical in unprecedented times. I cannot promise that non-indifference will taste exactly like precedence. But perhaps that's the point.

# ACKNOWLEDGMENTS

This book lived many lives and went through many cycles of destruction and rebirth before existing in its current body. I'm most grateful to Faith Wilson Stein for taking an early interest in the manuscript and Erica Wetter for taking up the baton before leaving it in the caring hands of Caroline McKusick, whose patience and encouragement have kept the project alive when light was dwindling. I can't thank her enough for believing in the book and carrying it with me through the finish line. Thanks also to Tim Roberts for overseeing the production of the book and Cynthia H. Lindlof for her meticulous copyediting.

The combined wisdom of the anonymous readers contributed to shape the project and then transform it into something that makes sense. The editorial savvy of Daniel Simon came into play just at the right time and was instrumental in nudging the book in the right direction. I'm grateful to the staff of the Wellcome Library; Museum of Fine Arts, Boston; Museum of Fine Arts, Houston; and Strasbourg Museum for making images and documents available to me, and the Dartmouth Library, the Birmingham Museum of Art, Metropolitan Museum of Art, New York; Library of Congress; NASA Ames Re-

search Center; Getty Museum; Städel Museum, Frankfurt am Main; and Los Angeles County Museum of Art for their generous open-access policies. I'm also grateful to Naoya Hatakeyama for letting me use his photograph in Chapter 1 and Karin Yamada from Taka Ishii Gallery for arranging everything.

Parts of Chapters 1 and 2 appear in "Terrestrial Hypotheses: A Slideshow," *Diacritics* 47, no. 3 (2020): 54–71, copyright © 2020 Cornell University. An earlier version of Chapter 5 was written in 2019 for a special issue of *Oxford Literary Review* on extinction. I warmly thank Karen Pinkus, Derek Woods, and Sarah Wood for editing my work on the Anthropocene as it was taking shape.

I am indebted to the collegiality of my colleagues at Emory and other institutions: Valérie Loichot and Elissa Marder as chair of the department of French and Italian; Lynne Huffer for the always engaging ways she has to think about extinction, writing, and the work of fragmentation; Liran Razinsky for graciously offering to read every line of an earlier version of the manuscript and sitting with me over a cup of coffee to go over his insightful marginalia; Chad Cordova and Pauline Goul, two dedicated early modernists filled with ecocritical energy; Subha Xavier for the impromptu debriefings; the students in my *natures mortes* seminar for humoring and questioning my weird hypotheses, and Hannah Freed-Thall for a stimulating discussion about the aquatic intersections of visual and textual culture; Anne-Lise François and Dora Zhang for the conversational space their ACLA seminars opened up for the project; Jon Abel and Allan Stoekl for more than a decade of indulging and fueling my thought experiments; Cassidy Puckett for driving a fully packed car to a writing camp in North Georgia and the conversation along the way (and to the Provost's Office for making it possible); and last but not least, Alexander Mendes and Kyle Bladow for all the rosé and cheer in Paris.

I have the deepest gratitude for my family on both sides of the Atlantic, for retreats at the lake and retreats in the hills. Thank you, Margaux, for going to the museum with me. Thank you, Amandine and

Ben, for your friendship during confinement. Sumter has slept through most of the writing, bringing calm to the room from underneath the desk. Aaron has been by my side through the entire process, one more time, unwavering when everything else wavers. He brings peace to my world. This book is for him.

# NOTES

## Prologue

1. Corcoran, Moore, and Jazvac, "An Anthropogenic Marker Horizon," 4–8.

2. LeMenager, "Humanities after the Anthropocene," 473.

3. Steven Mentz lists and explains twenty-four neologisms in a chapter of *Break Up the Anthropocene* appropriately titled "The Neologismcene."

4. Rosalie Colie, "Still Life: Paradoxes of Being," in *Paradoxia Epidemica*, 274.

5. Stoichita, *The Self-Aware Image*, 21.

6. See objects from the Pierre Berger collection in Tapié, *Vanité*, 89–91.

7. DeSilvey, *Curated Decay*, 28.

8. Benjamin, *Origin of the German Trauerspiel*, 174.

9. Gould, "The Median Isn't the Message," 40–42.

10. Erwin Panofsky, "The History of Art as a Humanistic Discipline," in *Meaning in the Visual Arts*, 25.

11. Panofsky, "History of Art as a Humanistic Discipline," 23–24.

12. Panofsky relays a Kantian understanding of the humanities as a relationship to traces. In the appendix of *The Critique of Judgment*, "On the Methodical Doctrine of Taste," Kant explains that the Humanities (*Humaniora*) are called humanities "presumably because *humanity* signifies on the one hand the universal feeling of taking part (*Teilnehmungsgefühl*), and on the other, the power of being able to *impart oneself* (*mitteilen*) in the most inward and universal manner; which properties in combination comprise the

*sociability* of human beings, by which they distinguish themselves from the limited character of animality." Cited in Weber, *Institution and Interpretation*, 143. Panofsky chimes in with the beaver example: They "build dams. But they are unable, so far as we know, to separate the very complicated actions involved from a premeditated *plan* which might be laid down in a drawing instead of being materialized in logs and stones." "History of Art as a Humanistic Discipline," 5.

13. Colebrook, *Extinction*.

14. Stacy Alaimo, "Your Shell on Acid: Material Immersion, Anthropocene Dissolves," in *Exposed*, 166.

15. Bryson, "Abundance," 96–135.

16. Bryson, "Chardin and the Text of Still Life," 228. In *Still Life and Trade in the Dutch Golden Age*, Julie Hochstrasser puts a different spin on the vanitas effect by reconstituting the hidden human cost extolled by the valuables represented in still-life painting.

17. Focusing less on the admission of pointlessness and more on the stark visualization of transience it affords, vanitas painting is for Victoria Herrmann—president of the Arctic Institute in Washington, D.C.—the "unconventional aesthetic intersection" between two visual memories of September 2007, *The Age of Rembrandt* exhibit at the Metropolitan Museum of Art and renderings of a dramatic loss of Arctic sea-ice loss seen from space. Herrmann, "Arctic Vanitas."

18. Here I adopt Lauren Berlant's central claim in *Cruel Optimism* that "the present is perceived, first, affectively: the present is what makes itself present to us before it becomes anything else, such as an orchestrated collective event or an epoch on which we can look back" (4). In *Learning How to Die in the Anthropocene*, Roy Scranton offers a theologico-political variation on the vanitas hypothesis: "The greatest challenge the Anthropocene poses isn't how the Department of Defense should plan for resource wars. . . . It won't be addressed by buying a Prius, turning off the air conditioning, or signing a treaty. The greatest challenge we face is a philosophical one: understanding that this civilization is already dead" (23).

19. Cohen, Colebrook, and Miller, *Twilight of the Anthropocene Idols*, 94.

20. Colebrook, *Extinction*.

21. See Paulson, *The Noise of Culture*, ix: "The study of literature can . . . be seen as a survivor of an earlier intellectual mode in which all study was essentially the study of texts, in which the written word was unquestionably taken to be a reservoir of knowledge. The discussion of literature's status as object or reservoir of knowledge, the attempt to bring insights from scientific disciplines to bear on cultural questions—these cannot be understood without reference to the history of literature's place in an increasingly divided world

of knowledge." On the critical trading between representations and facts in ecocriticism, see Nersessian, "Literary Agnotology," 355.

22. Freed-Thall, "Thinking Small," 229. For other compelling examples of ecocriticism in a minor key, see Anne-Lise François, "Chastity Belt for Trees," in *Open Secrets*, 34–38; Ronda, *Remainders*; and Nersessian, *The Calamity Form*.

23. Bergstrom, *Dutch Still-Life Painting*, 15.

24. On the whorled shell as image of the world in the baroque tradition, see Leonhard, "Shell Collecting," 1:182.

25. Alpers, *The Art of Describing*, 95.

26. *Corbeilles de verres et pâté* (ca. 1630–1640), oil on canvas, 50 × 64 cm, Strasbourg: Musée de l'Oeuvre Notre-Dame; *Corbeilles de verres* (1644), oil on canvas, 52 × 63 cm, Strasbourg: Musée de l'Oeuvre Notre-Dame; *Corbeille de verres* (1644), oil on wood, 49 × 60.3 cm, private collection; *Corbeille de verres et pièces d'orfévrerie* (ca. 1650), oil on canvas, Karlsruhe: Staatliche Kunsthalle; *Nature morte à la corbeille de verres et aux bouteilles* (after 1640), oil on canvas, 122 × 99 cm, Berlin: Staatliche Museen Preussischer Kulturbesitz. See *Sébastien Stoskopff 1597–1657*.

27. Alpers, *The Art of Describing*, 103.

28. Ronsard, "Elegie du verre," 165–171.

29. Barthes, "The World as Object," 3–4.

30. Descartes, *Discours de la méthode*, 192. On the Cartesianism of still-life Dutch painting and the Dutchness of Cartesianism, see Martin, "Bubbles and Skulls," 559–584.

31. On the enigmatic interiority of seashells in "shell-life" painting, see Bass, "Shell Life," 87–93.

32. Adriaen van Utrecht, *Still Life with Bouquet and Skull* (ca. 1642), oil on canvas, 26.3 × 33.8 in., private collection.

33. Barthes, "The World as Object," 3–4. On the absence of horizon in still life, see Grootenboer, *The Rhetoric of Perspective*, 76–80. Barthes's later work on non-appropriative forms of knowledge has recently been the object of an ecocritical reassessment—by Freed-Thall, for instance. It is worth noting in that regard the concerns for appropriative aesthetics in "The World as Object." *Environmental Humanities on the Brink* extends this reassessment to the work of other literary and cultural critics from Barthes's generation such as Louis Marin, Jean-François Lyotard, Michel de Certeau, Michel Foucault, and Jacques Derrida.

34. For another reading of Donovan's plastic cup installations, see Morton, *Hyperobjects*, 114.

35. Fradenburg, "So That We May Speak of Them," 215–216. See also Fradenburg and Freccero, "The Pleasure of History," 371–384. Another source of

inspiration for the dialogue between modern and early modern visual culture is Knight Powell, *Depositions*.

## Chapter 1

1. The extinction symbol was created in 2011 by London-based street artist ESP. See www.extinctionsymbol.info.

2. Stoichita, *The Self-Aware Image*, 291. The same canvas peeling effect can be found in a number of vanitases painted by Gijsbrechts: *Trompe l'oeil with Studio Wall and Vanitas Still Life* (National Gallery of Denmark), *Trompe l'oeil Studio Wall with a Vanitas Still Life* (Ferens Art Gallery, Hulls Museum), *Trompe L'oeil with Studio Wall and Vanitas Still Life* (Musée des Beaux-Arts de Valencienne), *Trompe l'oeil Still Life with a Painting of Fruit upon a Ledge with a Palette and Brushes and a Self-Portrait* (Rychnov Castle).

3. "Templum," in Smith, Wayte, and Marindin, *A Dictionary of Greek and Roman Antiquities*. See https://www.perseus.tufts.edu/hopper/text?doc=Perseus:text:1999.04.0063:entry=templum-cn.

4. Chakrabarty, "The Climate of History," 197, 201.

5. Krauss, *Originality of the Avant-Garde*, 161.

6. There is another recent example in Halliday, *Otherlands*, xii: "If all 4.5 billion years of Earth's history were to be condensed into a single day and played out, more than three million years of footage would go by every minute. *We would see* ecosystems rapidly rise and fall as the species that constitute their living parts appear and become extinct. We would see continent drift, climatic conditions change in a blink and sudden, dramatic events overturn long-lived communities with devastating consequences" (emphasis added).

7. Kolbert, *The Sixth Extinction*, 105.

8. Bryson, *Looking at the Overlooked*, 116.

9. Weisman, *The World without Us*, 4–5.

10. Nersessian, *The Calamity Form*, 49.

11. Weisman, *The World without Us*, 4.

12. Grootenboer, *The Rhetoric of Perspective*, 164.

13. Introducing the idea of a Humanist Anthropocene, Phillip John Usher has recently tasked an early modern archive dealing with subterranean matters to redraw the extractive contours of the Anthropocene present. "The founding intuition of the Humanist Anthropocene," Usher explains, "is that early modern humanists read and wrote with a sense of what [Bruno] Latour calls 'analytic continuity' . . . which the project of modernity largely dismantled to the point that 'the representation of nonhumans' came to

belong 'to science' while science came to be no longer 'allowed to have any relation to the nonhumans produced and mobilized by science and technology.' The beforeness of early modern humanists—they read and wrote *before* modern science, *before* modern geology, *before* Descartes and Bacon, etc.—is what make[s] them so urgently *not modern* and thus so potentially helpful in thinking the Anthropocene." *Exterranean*, 10 (emphasis in original). I understand the Humanist Anthropocene as a memory of the world nestled at the intersection between the "beforeness of early modern humanists" and the world after Descartes and Bacon that some of us have come to think of in Anthropocenic terms.

14. Petryna, "Horizoning," 247.

15. On the one hand, "the most recent report of the Intergovernmental Panel on Climate Change states that humanity has twelve years to stem climate change catastrophe." On the other, as Adriana Petryna stresses, "around the same time that this report came out, a yellow-vest protester in France stated that, with respect to Emmanuel Macron's proposed fuel tax hike, 'we are sick of the government pitting the French people worried about the end of the world with people like us, who are just worried about the end of the month.'" Delaporte and Grant, "Searches for Livability."

16. Pacala and Socolow, "Stabilization Wedges," 968–972; Socolow, "Wedges Reaffirmed"; J. Davis et al., "Rethinking Wedges."

17. Petryna, "What Is a Horizon?," 159.

18. Chakrabarty, "The Climate of History," 197.

19. De Certeau, *The Writing of History*, 3.

20. See Nevle and Bird, "Effects of Syn-pandemic Fire Reduction and Reforestation," 25–38.

21. The counterpart to the historical identification of variations in the concentration of atmospheric $CO_2$ is the non-identification of bones, dust, shoes, and other debris that define mass graves as unminable geological strata rather than as burial grounds. See Steyerl, "Missing People."

22. In *The Uninhabitable Earth*, David Wallace-Wells contends that allegories of climate change are at an impasse if we understand them as forms of containment. Allegory may be good at capturing abstractions but remains ill-suited to represent a situation that knows no outside from which it would be possible to narrate the world at a safe distance (150–151). For a more positive critical reassessment of allegory in the Anthropocene, see DeLoughrey, *Allegories of the Anthropocene*.

23. Gaudio, *Engraving the Savage*, xv–xvii.

24. Lewis and Maslin, "Defining the Anthropocene," 171–180.

25. Matt Hooley, "Reading Vulnerably: Indigeneity and the Scale of Harm," in Menely and Taylor, *Anthropocene Reading*, 187. Alessandro Anton-

ello and Mark Carey write in a similar vein: "When non-Western societies are brought into the ice core discussion, such as with the Maya, it is often to show societal collapse, civilizations that could not withstand climatic changes and that offer lessons for the present day." "Ice Cores," 194.

26. Hamilton, "Getting the Anthropocene So Wrong," 3. For a similar criticism, see also Members of the Anthropocene Working Group, "Colonization of the Americas," 117–127. Furthermore, for Hamilton, "traditional stratigraphy is unsuited to making a judgement about the Anthropocene. Finding new species (or other signs) in rock strata is not the same as identifying a change in the functioning of the Earth System" (6).

27. Brébeuf, *Relation de ce qui s'est passé aux Hurons*, 120.

28. Léry, *History of a Voyage*, 79.

29. Meadows et al., *The Limits to Growth*, 19.

30. Meadows et al., *The Limits to Growth*, 20.

31. Meadows et al., *The Limits to Growth*, 18.

32. Scott, "Earthlike," 10.

33. Scott, "Earthlike," 15.

34. Lyotard, *The Inhuman*, 183.

35. Stoichita, *The Self-Aware Image*, 59.

## Chapter 2

1. Hartman et al., "Medieval Iceland, Greenland, and the New Human Condition," 135. In contrast, literary critic Lawrence Buell mobilizes the concept of environmental memory against environmental amnesia. See "Uses and Abuses of Environmental Memory," 95–116.

2. Braider, *Refiguring the Real*, 11.

3. Hanski, "The World That Became Ruined," S36.

4. Wood, *Tambora*, 8.

5. Danowski and Viveiros de Castro, *The Ends of the World*, 18.

6. Neuberger, "Climate in Art," 46.

7. Damisch, *A Theory of /Cloud/*, 123.

8. Damisch, *A Theory of /Cloud/*, 132.

9. I borrow the atmospheric image of the blizzard from Siegfried Kracauer's essay "Photography," 432.

10. Neuberger, "Climate in Art," 54.

11. Hulme, "Review."

12. Cruikshank, *Do Glaciers Listen?*, 140, 177.

13. Vince, "What We Lose When We Lose Our Glaciers."

14. Jasanoff, "A New Climate for Society," 237.

15. In 2004, a team of astronomers linked the red sky in Edvard Munch's *The Scream* to the eruption of Krakatoa in 1883. Doescher, Olson, and Olson, "When the Sky Ran Red," 28–35. See also Zerefos et al., "Further Evidence of Important Environmental Information Content," 2987–3015.

16. Serres, "Science and the Humanities," 6–21.

17. Damisch, *A Theory of /Cloud/*, 123–124.

18. Van den Bosch, "Nature's Trespassing."

19. Granger, Gottlieb, and Nordhaus, "Needed," 38.

20. On the apostrophic nature of clouds, see Nersessian, *The Calamity Form*, 129–168.

21. Crary, "Climate Control," 80.

22. Cited in Marin, "Depositing Time in Painted Representations." 285–308. See also Félibien, *Entretiens*, 3:49.

23. Marin, "Depositing Time in Painted Representations," 305.

24. Clark, *The Sight of Death*, 24.

25. Clark, *The Sight of Death*, 85.

26. Clark, *The Sight of Death*, 12.

27. Clark, *The Sight of Death*, 79.

28. Marin, "Depositing Time in Painted Representations," 301–302.

29. Clark, *The Sight of Death*, 4.

30. Smailbegović, "Cloud Writing," 95.

31. Neuberger, "Climate in Art," 56.

32. Rockström et al., "A Safe Operating Space for Humanity," 472–475.

33. Marin, "Depositing Time in Painted Representations," 301.

34. Cited from the 1552 Latin edition in Le Roy Ladurie, *Times of Feast, Times of Famine*, 130.

35. Serres, "Science and the Humanities," 11.

36. Davies, "Cosmogenic Nuclide Dating."

37. I borrow the notion of nonhuman photography from Joanna Zylinska.

38. Le Roy Ladurie, *Times of Feast, Time of Famine*, 104 (modified translation).

39. Paré, *On Monsters and Marvels*, 159.

40. Thomas Ellis, *A True Report of the Third and Last Voyage into Meta Incognita: Achieved by the Worthie Capteine, M. Martine Frobisher Esquire* (1578), cited in Heuer, *Into the White*, 10.

41. Archives communales de Chamonix, CC3, no. 84, 1632, cited in Le Roy Ladurie, *Times of Feast, Times of Famine*, 148.

42. Agassiz, *Etudes sur les glaciers*, 178–179.

43. Le Roy Ladurie, *Histoire du climat*, 11.

44. Le Roy Ladurie, *Histoire du climat*, 11.

45. See Cruikshank, *Do Glaciers Listen?*, 48–49: "Performers that eve-

ning in the Alaska Native Brotherhood Hall were Tlingit residents, and observers were visiting scientists. The following morning at the high school auditorium, the scientists performed (also using elaborate visual displays in PowerPoint presentations) and Tlingit residents politely observed from the audience. Boundaries distinguishing 'science' from 'culture' were maintained by familiar strategies of location, technology, and styles of formality that clearly differentiated them."

46. Clifford Geertz, "The Impact of the Concept of Culture on the Concept of Man," in Geertz, *The Interpretation of Cultures*, 49.

47. Crutzen, "The Geology of Mankind," 23.

48. Stephanie LeMenager, "Climate Change and the Struggle for Genre," in Menely and Taylor, *Anthropocene Reading*, 225.

49. Camuffo and Sturaro, "Sixty-cm Submersion of Venice Discovered," 333–343.

50. See Wood, "Constable, Clouds, Climate Change," 25–33; and Nerses-sian's response to the article in *The Calamity Form*, highlighting the need to return to what she calls the "documentary ignorance" of Constable's cloud studies (160).

## Chapter 3

1. Adeney Thomas, "History and Biology in the Anthropocene," 1601: "We have yet to grasp the challenge to our discipline posed by humanity's unprecedentedly rapid biochemical transformation and by its uneven effects on individuals and communities."

2. Adeney Thomas, "History and Biology in the Anthropocene," 1597.

3. Schoonover, "Documentaries without Documents," 483–507.

4. See Nixon, *Slow Violence*.

5. Agard-Jones, "Detox." J. B. Greenough's *Allen and Greenough's New Latin Grammar* explains that the verb "*Memini* takes the accusative [*memento toxicum*] when it has the literal sense of retaining in the mind what one has seen, heard, or learned. Hence the accusative is used of persons whom one remembers as acquaintances, or of things which one has experienced. . . . *Memini* takes the genitive [*memento toxici*] when it means to be mindful or regardful of a person or thing, to think of somebody or something (often with special interest or warmth of feeling)" (350).

6. Perhaps it bears mentioning in the context of a chapter probing colonial memory that, in French, the adjective *vernaculaire* derives from the Latin *vernaculus*: "which pertains to slaves born in the house." See *Le trésor de la langue française informatisé*.

7. Agard-Jones, "Bodies in the System," 191.

8. Duden, "A Historian's 'Biology,'" 3:89.

9. Foucault, "The Life of Infamous Men," 89.

10. Foucault, "The Life of Infamous Men," 90.

11. Foucault, "The Life of Infamous Men," 90.

12. On the multiple chemical sensitivity memoir, see Alaimo, *Bodily Natures*, 113–140. Heather Houser talks about ecosickness fiction as "when artists abandon quests for etiology as the driving force of their narratives" and instead focus on the affective dimension of environmental distress. See *Ecosickness in Contemporary U.S. Fiction*, 2. See also Shapiro and Kirksey, "Chemo-Ethnography," 481–493.

13. Williams, *Marxism and Literature*, 132.

14. Montel, *Le père Labat viendra te prendre*, 178–179.

15. Labat, *Nouveau voyage*, 1:158–159.

16. Labat, *Nouveau voyage*, 2:66–67.

17. On the Caribbean plantation as the cradle of our modern sense of visuality, see Mirzoeff, *The Right to Look*, 48–76.

18. Labat, *Nouveau voyage*, 2:69.

19. See Garraway, *The Libertine Colony*.

20. Bougerol, "Medical Practices in the French West Indies," 125–143; Pluchon, *Vaudou, sorciers, empoisonneurs de St. Domingue*. The toxicophobia described in Mel Chen's work on multiple chemical sensitivity (MCS) and the history of race relations in the United States brings bodies into contact across color lines. It is about lead-tainted toys being the wrong kind of transitional objects that put the well-to-do class at risk of developmental delay. It is about the scandal of having invited toxicity into your home—even paying good money for it—when, precisely, money was supposed to be the key to overcoming environmental toxicity. For Chen, toxicity is more than a chemical state or property. It is a reflexive structure in which to negotiate categorical distinctions between what is alive and what is not, what lives are worthy of protection and love and what lives fall between the cracks, lives that are alive but with a life that is not biological or alive only by virtue of leaving traces in someone's biography in the form of a gut reaction, allergies, and chemical intolerance. Chen, *Animacies*, 159–222.

21. For an in-depth study, see Gibbs, *Poison, Medicine, and Disease*.

22. Labat, *Nouveau voyage*, 1:166–167.

23. Labat, *Nouveau voyage*, 1:75.

24. On August 13, 1793, the Marquise de Rouvray, in exile from Le Cap in Saint-Domingue, wrote to her daughter from New York about the future being birthed in Haiti: "Everyone has their mulâtresse that they have brought up or just found, and with whom they are going to produce a new genera-

tion of mulattoes and quarterons destined to butcher our children." Cited in Dayan, *Haiti, History, and the Gods*, 187. Gruesome examples of obstetric horror abound in Patrick Chamoiseau's 2002 novel *Biblique des derniers gestes*: "According to the science of these matrons, the babies were once and for all swallowing the inside of the lady. They were devouring her ovaries, unhooking her Fallopian tubes, drinking her waters, nibbling on her rectal walls, gnawing her bowels, sucking up her blood through the membranes, in short they were engaging in cannibalistic and thus unholy agapes" (356–357).

25. Confiant and Boutrin, *Chronique d'un empoisonnement annoncé*, 143–148.

26. LeJeune, *Relation*, 9:207 (modified translation).

27. Goldberg, "The History That Will Be," 13.

28. The toxicity of the written medium could be compared to that of nitrate celluloid in Fay's account: "That nitrate [celluloid] is also highly flammable, that its combustion has destroyed buildings and small towns and ended flesh-and-blood lives, suggests that in recording and archiving the living world, we not only destroy the image but also threaten to erase the very world captured in it." *Inhospitable World*, 204.

29. Grévin, *Deux livres des venins*, 33–34. On the relation between poison and witchcraft, see Gibbs, *Poison, Medicine, and Disease*, 167–173.

30. Barthes, *The Pleasure of the Text*, 16.

31. Brennan, *The Transmission of Affect*.

32. "The 'I'm Tired' Project," Facebook, August 7, 2015, https://www.facebook.com/theimtiredproject/. The project "frontispiece" was featured on the cover of a special issue of the *American Journal of Public Health* in October 2015 (no. 105) devoted to guns, domestic violence, and racial discrimination.

33. Deleuze, "The Exhausted," 3–28.

34. Christine Marran writes in "Contamination" that, half a century after Chisso Corporation's dumping of methylmercury in Minamata Bay, "time is running out for [the] victims to receive the official recognition they deserve, as their bodies are growing increasingly frail."

35. Sue, "Microaggression and 'Evidence,'" 170–172. For a critical synthesis of the debate, see Lilienfeld, "Microaggressions," 138–169.

## Chapter 4

1. Conley, *An Errant Eye*, viii.

2. In *Last Things*, Jacques Khalip considers the "near-term extinction of romantic studies" not simply as the end of romanticists but as the endangerment of a collective effort to teach the unteachable (9). It is not just the loss of a form of expertise on a historically defined period that is at stake but also

the loss of a form of expertise about what feels, and hurts, like the present, if indeed "pleasures around extinction, apocalypse, and ecological disaster are not foreign to what we call romanticism" (7).

3. Panofsky, "History of Art as a Humanistic Discipline," 23–24.

4. Panofsky, "History of Art as a Humanistic Discipline," 4n3: "Just as it was impossible for the Middle Ages to elaborate a system of perspective based on the realization of a fixed distance between the eye and the object, so it was equally impossible for this period to evolve an idea of historical disciplines based on the realization of a fixed distance between the present and the classical past." On the notion of historical distance in Panofsky, see also Moxey, "Impossible Distance," 139–172.

5. Fradenburg, *Sacrifice Your Love*, 63–64.

6. François Rabelais, *Pantagruel* (1532), in *The Complete Works of François Rabelais*, 133 (modified translation).

7. Chrulew, "Freezing the Ark," 293 (emphasis in original).

8. On the investment of the Renaissance in repetition, reproductive futurism, and education, see Greene, *The Light in Troy*; Quinones, *The Renaissance Discovery of Time*; and Freccero, *Father Figures*.

9. DeSilvey, *Curated Decay*, 153.

10. DeSilvey, *Curated Decay*, 152.

11. Chakrabarty, "The Climate of History," 201.

12. DeSilvey, *Curated Decay*, 17.

13. Malm and Hornborg, "The Geology of Mankind?," 67.

14. Malm and Hornborg, "The Geology of Mankind?, 66: "Realising that climate change is 'anthropogenic' is really to appreciate that it is *sociogenic*."

15. Léry, *History of a Voyage*, 199.

16. Léry, *History of a Voyage*, 212.

17. Léry, *History of a Voyage*, 101 (modified translation).

18. Léry, *History of a Voyage*, xlv.

19. Colebrook, "The Twilight of the Anthropocene," 126.

20. Léry, *History of a Voyage*, 8.

21. Lévi-Strauss, "Entretien avec Dominique-Antoine Grisoni," 13.

22. For another example of a relic with informational value, see Nagel and Wood on the Titulus Crucis, a fragment of the tablet (with a message) mounted on Christ's cross rediscovered in Rome in 1492. Nagel and Wood, *Anachronic Renaissance*, 216–239.

23. Léry, *Histoire mémorable*, 137–138.

24. Léry, *Histoire mémorable*, 129–139.

25. Léry, *Histoire mémorable*, 138.

26. Léry, *History of a Voyage*, 67.

27. De Certeau, "Writing vs. Time," 40.

28. Duchet, "Le texte gravé de Théodore de Bry," 45.

29. Léry, *History of a Voyage*, 217.

30. Léry, *History of a Voyage*, 77.

31. Lévi-Strauss, "The Scope of Anthropology," 31.

32. Derrida, "Biodegradables," 815.

33. Greene, *The Vulnerable Text*, 223. Alexander Nagel and Christopher Wood in *Anachronic Renaissance* have linked the emergence of the notion of anachronism as a category of incipient historical consciousness in the fifteenth and sixteenth centuries to the formation of a mode of relating to "what it is that artworks do" (9).

34. Conley, *The Self-Made Map*, 3.

35. Conley, *The Self-Made Map*, 4.

## Chapter 5

1. Panofsky, "History of Art as a Humanistic Discipline," 5 (emphasis in original).

2. Appleton, "The First Successful Cloning of a Gaur."

3. Friese, *Cloning Wild Life*, 86.

4. Christine A. Jones, "The Master Cat; or Cat-in-the-Boots," in Jones, *Mother Goose Refigured*, 127 (modified translation).

5. Tsing, "A Threat to Holocene Resurgence," 54.

6. Rousseau, *Emile, or Education* (modified translation).

7. In another passage of *Emile*, Rousseau explains: "Of all our different senses, we are usually most affected by taste. Thus it concerns us more nearly to judge aright of what will actually become part of ourselves, than of that which will merely form part of our environment. Many things are matters of indifference to touch, hearing, and sight; but taste is affected by almost everything."

8. Anupam Mishra, cited in Anne-Lise François, "Ungiving Time: Reading Lyric by the Light of the Anthropocene," in Menely and Taylor, *Anthropocene Reading*, 241.

9. Jones, "The Master Cat," 127.

10. Jones, "The Master Cat," 127.

11. See Thom Van Dooren, "Breeding Cranes: The Violent-Care of Captive Life," in Van Dooren, *Flight Ways*, 87–122.

12. Jones, "The Master Cat," 130.

13. Jones, "The Master Cat," 131 (modified translation).

14. Perrault, "Peau d'Âne," 58.

15. Marin, "Peau d'Ane ou la ré-écriture de l'oral," 590.

16. Bluebeard, one of Mother Goose's most frightening creatures, inhabits a metabolic paradox of his own design, blurring the distinction between storage and burial. See Bruyere, *Perishability Fatigue*, 32–35.

17. See, for instance, Jérémie Benoît, "Le chat botté: Initiation royale et prise de possession du sol," in Benoît, *Le paganisme indo-européen*, 72–80.

18. See Zimov, "Wild Field Manifesto." See also Zimov, "Pleistocene Park," 796–798.

19. In "The Storyteller," Benjamin explains that "death is the sanction of everything that the storyteller can tell. He has borrowed his authority from death. In other words, it is natural history [*Naturgeschichte*] to which his stories refer back" (93–94). In Benjamin's text the difference between *Naturgeschichte* and *Historie* does not hinge on a distinction of agency (i.e., the idea that nature, rocks, season have no agency) but on the opposition between modes of writing [*Geschichtsschreibung*]. While the historian [*Historiker*] explains a concatenation of events, chronicling, like storytelling, is the art of embedding events "in the great inscrutable course of the world" (96). *Einbettung*, "embedding" in English, is also a geological term describing the fossilization process.

20. See Szerszynski, "Reading and Writing the Weather Climate Technics," 15: "While hunter-gatherer societies engaged in passive solar energy utilization by utilizing the resource density of existing ecosystems, agrarian societies actively maximized useful solar energy by monopolizing land area, clearing forests and raising high-utility organisms, and were thereby able to progressively support increased population and non-agricultural economic activity." By extrapolation, it would be possible to say that, with its emphasis on narrative traps, "Puss in Boots" reflects a moment in the history of the equilibrium between animal density and the energy needs if, indeed, a trap is a marker of the relation between the territory and the energy need that also happens to warp surfaces and disrupt spatial continuities. See Marin, *Le récit est un piège*.

21. Fradenburg, *Sacrifice Your Love*, 61.

22. Andersen, "Welcome to Pleistocene Park," 77–78.

23. Jones, "The Master Cat."

24. Andersen, "Welcome to Pleistocene Park," 82.

25. See LeGuin, "The Carrier Bag Theory of Fiction."

26. Clark and Gunaratnam, "Exorbitant Responsibility," 73–81.

27. On the notion of counterworld, see Zipes, *The Irresistible Fairy Tale*, 14.

28. Latour, *Facing Gaia*, 8.

29. Charles T. Rubin in "The Rhetoric of Extinction" puts it differently: "The rhetoric of extinction would have us believe that the restraints

and controls of the past are of no value in relation to the post-human future" (64–73).

30. De Lairesse, *Le grand livre des peintres*, 2:474–475.

31. De Lairesse, *Groot schilderboek*, 268. Translation by Henriette Rahusen: "Even though we just stated that the famous [Willem] Kalf was the very best still-life painter, he nevertheless, just as his predecessors and followers never explained the reason for his compositions, why he depicted this or that; but only painted that which fancied him . . . without ever having considered whether to create something important that had a significant meaning, or that could refer to something." See also "Willem Kalf: *Still Life*, c. 1660," National Gallery of Art, 2023, https://www.nga.gov/collection/art-object-page.12206.html.

32. See *Gone* by Isabella Kirkland, 2004, https://www.isabellakirkland.com/gone.

33. See *Gone* by Isabella Kirkland, Revive and Restore, 2023, https://reviverestore.org/gone-by-isabella-kirkland/. *Gone* was also featured on a poster for TEDxDeExtinction (March 15, 2013). The Long Now Foundation is a think tank based in California, established in 1996 by Stewart Brand and Danny Hillis with the mission "to foster long-term thinking and responsibility in the framework of the next 10,000 years." See https://longnow.org.

34. Sterling, *Still Life Painting*, 63–64.

35. See Deleuze, *Francis Bacon*, 56–57: "The task of painting is defined as the attempt to render visible forces that are not themselves visible. . . . This is a problem of which painters are very conscious. When pious critics criticized Millet for painting peasants who were carrying an offertory like a sack of potatoes, Millet responded by saying that the weight common to the two objects was more profound than their figurative distinction. As a painter, he was striving to paint the force of that weight, and not the offertory *or* the sack of potatoes."

## Chapter 6

1. Jonathan Keats, "In Vitro Meat," in Keats, *Virtual Words*, 33. The existence of a specific Dutch lexicon— *kweekvlees* (cultured meat), *kunstvlees* (artificial meat), or *puurvlees* (pure meat)—reflects the early investment of the Netherlands in the concept.

2. See Fabre, "Le pacte précaire," 289–317.

3. Richeome, *La peinture spirituelle*, 66–68.

4. Richeome, *La peinture spirituelle*, 69.

5. See Fabre, "La lecture comme problème dans le catholicisme moderne," 199–225.

6. Strangeways, "Lecture VI," 2.

7. Squier, *Liminal Lives*, 63.

8. Strangeways, "Lecture VI," 1.

9. Holmes, "The Stereoscope and the Stereograph." Along the same lines, Benjamin W. Kilburn patented in 1883 a gun camera that claimed to "bag" the animal without maiming it. See Traisnel, *Capture*, 1–3. I have Elissa Marder to thank for the reference to the Holmes essay.

10. See Stephens and Ruivenkamp, "Promise and Ontological Ambiguity," 327–355.

11. Catts and Zurr, "Disembodied Livestock," 101–113.

12. Shapiro, *Clean Meat*, 180.

13. Pliny the Elder, *The Natural History*, Book XXXV, chap. 36, https://www.perseus.tufts.edu/hopper/text?doc=Perseus%3Atext%3A1999.02.0137%3Abook%3D35%3Achapter%3D36.

14. Abbé de Monville, *Vie de Mignard* (1730), cited in Marin, "Le trompe l'œil," 77.

15. Marin, "Le trompe l'œil," 75.

16. It is this uncertainty in the relation between event and accident, between animality and early humanity, that John Onians's prehistory of mimesis is seeking to stabilize by assigning the origin of lifelike representation to cognitive mechanisms: "Once [paleolithic artists] had begun to add their own marks and colours, their pleasure in the imagined shape would have been increased, prompting further enhancement. In each case the continued activity is likely to have been fuelled by the brain's chemistry, with each enhancement of the correspondence causing the release in the brain of one of the neurotransmitters that drive all the actions that are vital for our survival. . . . The release would have prompted the repetition of the activity, so eliciting a further release and this process of continuous positive chemical feedback from the manual interaction would have been liable to continue as long as the constant increase in the resemblance intensified the chemical reaction." Onians, "Neuroarchaeology and the Origins of Representation in the Grotte de Chauvet," 314.

17. Grootenboer, *The Rhetoric of Perspective*, 45.

18. By the same token, Gilles Deleuze explained that meat in the pictorial world of Francis Bacon has only loose visual connections to the muscular reality of meat. Rather, what we have is a meat effect that consists of a field of colors where animality and humanity congeal at the risk of defacement. Deleuze, *Francis Bacon*, 22.

19. Another version of the painting exists in the collections of the Musée

des Beaux-Arts de Lyon. Frans Snyder, *Table de cuisine avec gibier et légumes* (ca. 1600/1700), oil on wood, 272 × 337 cm.

20. Palmeri, "A Profusion of Dead Animals," 50–77.

21. De Lairesse, *Groot Schilderboek*, cited in Grootenboer, *The Rhetoric of Perspective*, 27.

22. Lacan, *Le séminaire livre III*, 96.

23. On hidden Christological motifs in still-life painting, see Robert N. Watson, "The Retreat of God, the Passions of Nature, and the Objects of Dutch Painting," in Watson, *Back to Nature*, 166–225.

24. Marin discusses a similar visual effect with the protruding pewter plate in Lubin Baugin, *Dessert de gaufrettes*. "Le trompe l'œil," 89–90.

25. Knight Powell, *Depositions*, 41: "The modern painter experiences his task as impossible because industry does it better—but it is, in fact, merely superfluous. The task of the late-medieval makers of images of God (and perhaps all image-makers) was just as possible yet superfluous—possible as demonstrated by the long history of such images, superfluous because God did it better when he created Adam in his own image and again when he descended into the flesh."

26. Panofsky, "History of Art as a Humanistic Discipline," 24.

27. Panofsky, "History of Art as a Humanistic Discipline," 24n9.

28. Knight Powell, *Depositions*, 261.

29. Hartman, "Revealing Environmental Memory."

30. Horkheimer and Adorno, *Dialectic of Enlightenment*, 25.

31. Positively allured by the Sirens' song, Kittler launched a research expedition in 2004 to the Italian archipelago where Sirens were believed to have dwelled in search of perceptual foundations that would anchor the episode in an archaeology of media. See Winthrop-Young, *Kittler and the Media*.

32. Doncieux, *Le romancéro populaire de la France*.

33. Doncieux, *Le romancéro populaire de la France*, 237.

34. Benjamin, "The Storyteller," 35.

35. See Thiébaux, *The Stag of Love*.

## Epilogue

1. Fradenburg, *Sacrifice Your Love*, 62.

2. Ronsard, *Œuvres complètes I*, 388.

3. Bachelard, *La flamme d'une chandelle*, 25–26.

4. Wilson, *The Future of Life*, 5.

5. Ronsard, *Œuvres complètes I*, 400.

6. Quainton, "Creative Choreography," 155.

7. The photosensitivity of Ronsard's poetry offers a variation on the idea developed by Tobias Menely in *Climate and the Making of Worlds* that "any poem can be understood, in its world making and time shaping, to offer a meditation on the enigmatic yet omnipresent nature of energy, in its planetary and social manifestations" (14). The formalism of Menely's project recasts the volatility that characterizes two centuries of poetic language in the British Isles in planetary terms as allegorical evidence of the transition from a world organized by a finite, seasonally distributed, amount of energy, to a world powered by energy derived from fossil fuels. It opens up the literary record to the environmental record but not necessarily for the sake of environmental history. It is an experiment in literary history where the shifts between periods and forms of expression are indexed on shifts in a planetary history of energy but not attributed to them.

8. Chun, "On Hypo-real Models or Global Climate Change," 686.

9. Chun, "On Hypo-real Models or Global Climate Change," 693.

10. Ballestero, *A Future History of Water*, 29.

11. Houser, "Climate Visualizations," 360.

# BIBLIOGRAPHY

Adeney Thomas, Julia. "History and Biology in the Anthropocene: Problems of Scale, Problems of Value." *American Historical Review* 119, no. 5 (2014): 1587–1607.

Agard-Jones, Vanessa. "Bodies in the System." *Small Axe* 17, no. 3 (2013): 182–192.

———. "Detox: An Analytic for the Anthropocene." Paper presented at William Paterson University 8th Annual Contexts Conference, Wayne, NJ, November 2019.

Agassiz, Louis. *Etudes sur les glaciers.* Neuchâtel, Switzerland: Jent et Glassmann, 1840.

Alaimo, Stacy. *Bodily Natures: Science, Environment, and the Material Self.* Bloomington: Indiana University Press, 2010.

———. *Exposed: Environmental Politics and Pleasures in Posthuman Times.* Minneapolis: University of Minnesota Press, 2016.

Alpers, Svetlana. *The Art of Describing: Dutch Art in the Seventeenth Century.* Chicago: University of Chicago Press, 1983.

Andersen, Ross. "Welcome to Pleistocene Park." *The Atlantic*, April 2017. https://www.theatlantic.com/magazine/archive/2017/04/pleistocene-park/517779/.

Antonello, Alessandro, and Mark Carey. "Ice Cores and the Temporalities of the Global Environment." *Environmental Humanities* 9, no. 2 (2017): 181–203.

Appleton, Caroline. "The First Successful Cloning of a Gaur (2000), by Advanced

Cell Technology." *The Embryo Project Encyclopedia*, July 26, 2013. https://embryo. asu.edu/pages/first-successful-cloning-gaur-2000-advanced-cell-technology.

Bachelard, Gaston. *La flamme d'une chandelle*. Paris: Presses universitaires de France, 1961.

Ballestero, Andrea. *A Future History of Water*. Durham, NC: Duke University Press, 2019.

Barthes, Roland. *The Pleasure of the Text*. Translated by Richard Miller. New York: Hill and Wang, 1975.

———. "The World as Object." In *Critical Essays*, translated by Richard Howard, 3–12. Evanston, IL: Northwestern University Press, 2000.

Bass, Marisa Anne. "Shell Life, or the Unstill Life of Shells." In *Conchophilia: Shells, Art, and Curiosity in Early Modern Europe*, edited by Marisa Anne Bass, Anne Goldgar, Hanneke Grootenboer, and Claudia Swan, 75–101. Princeton, NJ: Princeton University Press, 2021.

Behringer, Wolfgang. *A Cultural History of Climate*. Translated by Patrick Camiller. Cambridge, UK: Polity, 2010.

Benjamin, Walter. *Origin of the German Trauerspiel*. Translated by Howard Eiland. Cambridge, MA: Harvard University Press, 2019.

———. "The Storyteller: Reflections on the Works of Nikolai Leskov." In *Illuminations: Essays and Reflections*, edited by Hannah Arendt, translated by Harry Zohn, 83–110. New York: Schocken Books, 2007.

Benoît, Jérémie. *Le paganisme indo-européen: Pérennité et métamorphose*. Lausanne: L'âge d'homme, 2001.

Bergstrom, Ingvar. *Dutch Still-Life Painting in the Seventeenth Century*. Translated by Christina Hedström and Gerald Taylor. New York: Thomas Yoseloff, 1956.

Berlant, Lauren. *Cruel Optimism*. Durham, NC: Duke University Press, 2011.

Bougerol, Christine. "Medical Practices in the French West Indies: Master and Slave in the 17th and 18th Centuries." *History and Anthropology* 2 (1985): 125–143.

Braider, Christopher. *Refiguring the Real: Picture and Modernity in Word and Image, 1400–1700*. Princeton, NJ: Princeton University Press, 1993.

Brébeuf, Jean de. *Relation de ce qui s'est passé aux Hurons, en l'année 1635, envoyée à Kébec au Père Le Jeune, par le Père Brébeuf*. In *The Jesuit Relations and Allied Documents: Travels*, vol. VIII, *Québec, Hurons, and Cape Breton, 1634–1635*, edited by Reuben Gold Thwaites, 7–196. Cleveland, OH: Burrows Bros, 1896–1901.

Brennan, Teresa. *The Transmission of Affect*. Ithaca, NY: Cornell University Press, 2004.

Bruyere, Vincent. *Perishability Fatigue: Forays in Environmental Loss and Decay*. New York: Columbia University Press, 2018.

Bryson, Norman. "Chardin and the Text of Still Life." *Critical Inquiry* 15, no. 2 (Winter 1989): 227–252.

———. *Looking at the Overlooked: Four Essays on Still Life Painting*. London: Reaktion Books, 1990.

Buell, Lawrence. "Uses and Abuses of Environmental Memory." In *Contesting Environmental Imaginaries: Nature and Counternature in a Time of Global Change*, edited by Steven Hartman, 95–116. Leiden, Netherlands: Brill, 2017.

Camuffo, Dario, and Giovanni Sturaro. "Sixty-cm Submersion of Venice Discovered Thanks to Canaletto's Paintings." *Climatic Change* 58 (2003): 333–343.

Catts, Oron, and Ionat Zurr. "Disembodied Livestock: The Promise of a Semi-living Utopia." *Parallax* 19, no. 1 (2013): 101–113.

Chakrabarty, Dipesh. "The Climate of History: Four Theses." *Critical Inquiry* 35, no. 2 (2009): 197–222.

Chamoiseau, Patrick. *Biblique des derniers gestes*. Paris: Gallimard, 2002.

Chen, Mel. *Animacies: Biopolitics, Racial Mattering, and Queer Affect*. Durham, NC: Duke University Press, 2012.

Chrulew, Matthew. "Freezing the Ark: The Cryopolitics of Endangered Species Preservation." In *Cryopolitics: Frozen Life in a Melting World*, edited by Joanna Radin and Emma Kowal, 283–305. Cambridge, MA: MIT Press, 2017.

Chun, Wendy Hui Kyong. "On Hypo-real Models or Global Climate Change: A Challenge for the Humanities." *Critical Inquiry* 41, no. 3 (Spring 2015): 675–703.

Clark, Nigel, and Yasmin Gunaratnam. "Exorbitant Responsibility: Geographies of Climate Justice." In *Climate Futures: Re-imagining Global Climate Justice*, edited by Kum-Kum Bhavnani, John Foran, Priya A. Kurian, and Debashish Munshi, 73–81. London: Bloomsbury, 2019.

Clark, T. J. *The Sight of Death: An Experiment in Art Writing*. New Haven, CT: Yale University Press, 2006.

Cohen, Tom, Claire Colebrook, and J. Hillis Miller. *Twilight of the Anthropocene Idols*. London: Open Humanities Press, 2016.

Colebrook, Claire. *Extinction*. Living Books about Life. Ann Arbor, MI: Open Humanities Press, 2012. http://www.livingbooksaboutlife.org/books/Extinction.

———. "Framing the End of the Species: Images without Bodies." *Symploke* 21, no. 1–2 (2013): 51–63.

———. "The Twilight of the Anthropocene: Sustaining Literature." In *Literature and Sustainability: Concept, Text and Culture*, edited by Adeline

Johns-Putra, John Parham, and Louise Squire, 115–136. Manchester, UK: Manchester University Press, 2017.

Colie, Rosalie. *Paradoxia Epidemica: The Renaissance Tradition of Paradox.* Princeton, NJ: Princeton University Press, 1966.

Confiant, Raphael, and Louis Boutrin. *Chronique d'un empoisonnement annoncé: Le scandale du Chlordécone aux Antilles françaises 1972–2002.* Paris: L'Harmattan, 2007.

Conley, Tom. *An Errant Eye: Poetry and Topography in Early Modern France.* Minneapolis: University of Minnesota Press, 2010.

———. *The Self-Made Map: Cartographic Writing in Early Modern France.* Minneapolis: University of Minnesota Press, 2010.

Corcoran, Patricia L., Charles J. Moore, and Kelly Jazvac. "An Anthropogenic Marker Horizon in the Future Rock Record." *GSA Today* 24, no. 6 (June 2014): 4–8.

Crary, Jonathan. "Climate Control." *October* 168 (Spring 2019): 79–82.

Cruikshank, Julie. *Do Glaciers Listen? Local Knowledge, Colonial Encounters, and Social Imagination.* Vancouver: UBC Press, 2006.

Crutzen, Paul J. "The Geology of Mankind." *Nature* 415 (2002): 23.

Damisch, Hubert. *A Theory of /Cloud/: Toward a History of Painting.* Translated by Janet Lloyd. Stanford, CA: Stanford University Press, 2002.

Danowski, Déborah, and Eduardo Viveiros de Castro. *The Ends of the World.* Translated by Rodrigo Nunes. Cambridge, UK: Polity Press, 2017.

Davies, Bethan. "Cosmogenic Nuclide Dating." *AntarcticGlaciers.org*, November 24, 2014. http://www.antarcticglaciers.org/glacial-geology/dating-glacial-sediments-2/cosmogenic_nuclide_datin/.

Davis, Steven J., Long Cao, Ken Caldeira, and Martin I Hoffert. "Rethinking Wedges." *Environmental Research Letters* 8, no. 1 (2013). https://iopscience.iop.org/article/10.1088/1748-9326/8/1/011001/meta.

Dayan, Joan. *Haiti, History, and the Gods.* Berkeley: University of California Press, 1988.

De Certeau, Michel. *The Writing of History.* Translated by Tom Conley. New York: Columbia University Press, 1992.

———. "Writing vs. Time: History and Anthropology in the Works of Lafitau." Translated by James Hovde. *Yale French Studies* 59 (1980): 37–64.

De Lairesse, Gérard. *Le grand livre des peintres.* Vol. 2. Paris: À l'Hôtel de Thou, 1787.

———. *Groot schilderboek.* 1740. Reprint, Haarlem: Soest, 1969.

Deleuze, Gilles. "The Exhausted." Translated by Anthony Uhlmann. *SubStance* 24, no. 3, issue 78 (1995): 3–28.

———. *Francis Bacon: The Logic of Sensation.* Translated by Daniel W. Smith. London: Continuum, 2003.

DeLoughrey, Elizabeth M. *Allegories of the Anthropocene*. Durham, NC: Duke University Press, 2019.

Derrida, Jacques. "Biodegradables: Seven Diary Fragments." Translated by Peggy Kamuf. *Critical Inquiry* 15, no. 4 (1989): 812–873.

Descartes, René. *Discours de la méthode*. Edited by Victor Cousin. Paris: Levrault, 1824.

DeSilvey, Caitlin. *Curated Decay: Heritage beyond Saving*. Minneapolis: University of Minnesota Press, 2017.

Doescher, Russell L., Donald W. Olson, and Marilynn S. Olson. "When the Sky Ran Red: The Story behind *The Scream*." *Sky & Telescope* 107, no. 2 (2004): 28–35.

Doncieux, Georges. *Le romancéro populaire de la France: Choix de chansons populaires françaises*. Paris: Emile Bouillon, 1904.

Duchet, Michèle. *L'Amérique de Théodore de Bry: Une collection de voyage protestante du XVIe siècle. Quatre études d'iconographie*. Paris: CNRS, 1985.

Duden, Barbara. "A Historian's 'Biology': On the Traces of the Body in a Technogenic World." *Historein* 3 (2001): 89–102.

Fabre, Pierre Antoine. "La lecture comme problème dans le catholicisme moderne: Sur le *Pèlerin de Lorette* (1603) de Louis Richeome et quelques autres sources du premier XVIIe siècle." In *Textes et pratiques religieuses dans l'espace urbain de l'Europe moderne*, edited by Élise Boillet and Gaël Rideau, 199–225. Paris: Honoré Champion éditeur, 2020.

———. "Le pacte précaire de l'image et de l'écrit dans le livre illustré d'époque moderne: Le cas de *La peinture spirituelle* (1611) de Louis Richeome." In *Jesuit Image Theory*, edited by Wietse de Boer, Karl A. E. Enenkel, and Walter Melion, 289–317. Leiden, Netherlands: Brill, 2016.

Fay, Jennifer. *Inhospitable World: Cinema in the Time of the Anthropocene*. New York: Oxford University Press, 2018.

Foucault, Michel. "The Life of Infamous Men." In *Michel Foucault: Power, Truth, Strategy*, edited by Meaghan Morris and Paul Patton, 76–91. Sydney: Feral Publications, 1979.

Fradenburg, L. O. Aranye. *Sacrifice Your Love: Psychoanalysis, Historicism, Chaucer*. Minneapolis: University of Minnesota Press, 2002.

———. "'So That We May Speak of Them': Enjoying the Middle Ages." *New Literary History* 28, no. 2 (Spring 1997): 205–230.

Fradenburg, Louise O., and Carla Freccero. "The Pleasure of History." *GLQ* 1, no. 4 (1995): 371–384.

François, Anne-Lise. *Open Secrets: The Literature of Uncounted Experience*. Stanford, CA: Stanford University Press, 2008.

Freccero, Carla. *Father Figures: Genealogy and Narrative Structure in Rabelais*. Ithaca, NY: Cornell University Press, 1991.

Freed-Thall, Hannah. "Thinking Small: Ecologies of Close Reading." In *Modernism and Close Reading*, edited by David James, 228–242. New York: Oxford University Press, 2020.

Freud, Sigmund. *Writings on Art and Literature*. Stanford, CA: Stanford University Press, 1997.

Friese, Carrie. *Cloning Wild Life: Zoos, Captivity, and the Future of Endangered Animals*. New York: New York University Press, 2013.

Garraway, Doris. *The Libertine Colony: Creolization in the Early French Caribbean*. Durham, NC: Duke University Press, 2005.

Gaudio, Michael. *Engraving the Savage: The New World and Techniques of Civilization*. Minneapolis: University of Minnesota Press, 2008.

Geertz, Clifford. *The Interpretation of Cultures*. New York: Basic Books, 1973.

Gibbs, Frederick W. *Poison, Medicine, and Disease in Late Medieval and Early Modern Europe*. New York: Routledge, 2018.

Goldberg, Jonathan. "The History That Will Be." In *Premodern Sexualities*, edited by Louise O. Aranye Fradenburg and Carla Freccero, 1–22. New York: Routledge, 1996.

Gosh, Amitav. *The Great Derangement: Climate Change and the Unthinkable*. Chicago: University of Chicago Press, 2016.

Gould, Stephen Jay. "The Median Isn't the Message." *Discover*, June 1985, 40–42.

Granger, Morgan M., Paul Gottlieb, and Robert R. Nordhaus. "Needed: Research Guidelines for Solar Radiation Management." *Issues in Science and Technology* 29, no. 3 (2013). https://issues.org/morgan-3/.

Greene, Thomas M. *The Light in Troy: Imitation and Discovery in Renaissance Poetry*. New Haven, CT: Yale University Press, 1982.

———. *The Vulnerable Text: Essays on Renaissance Literature*. New York: Columbia University Press, 1986.

Greenough, James Bradstreet, George Lyman Kittredge, Albert Andrew Howard, and Benjamin L. D'Ooge. *Allen and Greenough's New Latin Grammar for Schools and Colleges*. Boston: Ginn, 1903.

Grévin, Jacques. *Devx livres des venins, ausquels il est amplement discouru des bestes venimeuses, theriaques, poisons & contrepoisons*. Anvers, Belgium: Christofle Plantin, 1568.

Grootenboer, Hanneke. *The Rhetoric of Perspective: Realism and Illusionism in Seventeenth-Century Dutch Still-Life Painting*. Chicago: University of Chicago Press, 2006.

Halliday, Thomas. *Otherlands: A Journey through Earth's Extinct Worlds*. New York: Random House, 2022.

Hamilton, Clive. "Getting the Anthropocene So Wrong." *Anthropocene Review* 2, no. 2 (2015): 102–107.

Hanski, Ikka. "The World That Became Ruined." *EMBO Reports* 9 (2008): S34–S36.

Hartman, Steven. "Revealing Environmental Memory: What the Study of Medieval Literature Can Tell Us about Long-Term Environmental Change." *Biodiverse* 2 (2016). http://www.biodiverse.se/articles/revealing-environmental-memory-what-the-study-of-medieval-literature-can-tell-us-about-long-term-environmental-change/.

Hartman, Steven, A. E. J. Ogilvie, Jón Haukur Ingimundarson, A. J. Dugmore, George Hambrecht, and T. H. McGovern. "Medieval Iceland, Greenland, and the New Human Condition: A Case Study in Integrated Environmental Humanities." *Global and Planetary Change* 156 (September 2017): 123–139.

Herrmann, Victoria. "Arctic Vanitas: Temporal Tensions of Imaging the Anthropocene." *Anchorage Museum*. Accessed January 21, 2023. https://www.anchoragemuseum.org/major-projects/projects/chatter-marks-podcast-plus-journal/articles/arctic-vanitas/.

Heuer, Christopher. *Into the White: The Renaissance Arctic and the End of the Image*. Brooklyn: Zone Books, 2019.

Hird, Myra, and Alexander Zahara. "The Arctic Wastes." In *Anthropocene Feminism*, edited by Richard Grusin, 121–146. Minneapolis: University of Minnesota Press, 2017.

Hochstrasser, Julie Berger. *Still Life and Trade in the Dutch Golden Age*. New Haven, CT: Yale University Press, 2007.

Holmes, Oliver Wendell. "The Stereoscope and the Stereograph." *The Atlantic*, June 1859. https://www.theatlantic.com/magazine/archive/1859/06/the-stereoscope-and-the-stereograph/303361/.

Horkheimer, Max, and Theodor Adorno. *Dialectic of Enlightenment*. Translated by Edmund Jephcott. Stanford, CA: Stanford University Press, 2002.

Houser, Heather. "Climate Visualizations: Making Data Experiential." In *The Routledge Companion to the Environmental Humanities*, edited by Ursula K. Heise, Jon Christensen, and Michelle Niemann, 358–368. New York: Routledge, 2017.

———. *Ecosickness in Contemporary U.S. Fiction: Environment and Affect*. New York: Columbia University Press, 2014.

Hulme, Mike. "Review of *A Cultural History of Climate*, by Wolfgang Behringer." *Reviews in History* 925 (July 2010). https://reviews.history.ac.uk/review/925.

Jain, S. Lochlann. *Malignant: How Cancer Becomes Us*. Berkeley: University of California Press, 2013.

Jasanoff, Sheila. "A New Climate for Society." *Theory, Culture & Society* 27, no. 2–3 (2010): 233–253.

Jones, Christine A. *Mother Goose Refigured: A Critical Translation of Charles Perrault's Fairy Tales.* Detroit, MI: Wayne State University Press, 2016.

Keats, Jonathan. *Virtual Words: Language on the Edge of Science and Technology.* Oxford: Oxford University Press, 2011.

Khalip, Jacques. *Last Things: Disastrous Form from Kant to Hujar.* New York: Fordham University Press, 2018.

Knight Powell, Amy. *Depositions: Scenes from the Late Medieval Church and the Modern Museum.* New York: Zone Books, 2012.

Kolbert, Elizabeth. *The Sixth Extinction: An Unnatural History.* New York: Henry Holt, 2014.

Krauss, Rosalind E. *The Originality of the Avant Garde and Other Modernist Myths.* Cambridge, MA: MIT Press, 1985.

Labat, Jean Baptiste. *Nouveau voyage aux isles de l'Amérique.* 2 vols. La Haye, Netherlands: Husson, 1724.

Lacan, Jacques. *Le séminaire: Livre III—Les psychoses, 1955–1956.* Paris: Seuil, 1981.

Latour, Bruno. *Down to Earth: Politics in the New Climatic Regime.* Cambridge, UK: Polity Press, 2018.

———. *Facing Gaia: Eight Lectures on the New Climatic Regime.* Translated by Catherine Porter. Cambridge, UK: Polity Press, 2017.

Le Roy Ladurie, Emmanuel. *Histoire du climat depuis l'an mil.* Paris: Flammarion, 1967. Translated by Barbara Bray as *Times of Feast, Times of Famine: A History of Climate since the Year 1000.* Garden City, NY: Doubleday, 1971.

LeGuin, Ursula K. "The Carrier Bag Theory of Fiction." The Anarchist Library, 1986. https://theanarchistlibrary.org/library/ursula-k-le-guin-the-carrier-bag-theory-of-fiction.

LeJeune, Paul. *Relation de ce qui s'est passé en la Nouvelle France, en l'année 1636.* In *The Jesuit Relations and Allied Documents, vol. IX,* edited by Reuben Gold Thwaites, 5–315. Cleveland, OH: Burrows Brothers, 1896–1901.

LeMenager, Stephanie. "The Humanities after the Anthropocene." In *Routledge Companion to the Environmental Humanities,* edited by Ursula K. Heise, Jon Christensen, and Michelle Niemann, 473–481. New York: Routledge, 2017.

Leonhard, Karin. "Shell Collecting: On 17th-Century Conchology, Curiosity Cabinets and Still Life Painting." In *Early Modern Zoology: The Construction of Animals in Science, Literature and the Visual Arts,* vol. 1, edited by Karl A. Enenkel and Mark S. Smith, 177–214. Leiden, Netherlands: Brill, 2007.

Léry, Jean de. *Histoire mémorable de la ville de Sancerre*. Geneva: n.p., 1574.

———. *History of a Voyage to the Land of Brazil*. Translated by Janet Whatley. Berkeley: University of California Press, 1997.

Lévi-Strauss, Claude. "Entretien avec Dominique-Antoine Grisoni." In *Histoire d'un voyage faict en la terre du Bresil*, by Jean de Léry, edited by Frank Lestringant. Paris: L.G.F. Le Livre de Poche, "Bibliothèque classique," 1994.

———. "The Scope of Anthropology." In *Structural Anthropology, Volume 2*, translated by Monique Layton, 3–32. Chicago: University of Chicago Press, 1983.

Lewis, Simon, and Mark Maslin. "Defining the Anthropocene." *Nature* 519 (2015): 171–180.

Lilienfeld, Scott O. "Microaggressions: Strong Claims, Inadequate Evidence." *Perspectives on Psychological Science* 12, no. 1 (2017): 138–169.

Liu, Alan. *Local Transcendence: Essays on Postmodern Historicism and the Database*. Chicago: University of Chicago Press, 2008.

Luciano, Dana. "The Inhuman Anthropocene." *Los Angeles Review of Books*, March 22, 2015.

Lyotard, Jean-François. *L'inhumain: Causeries sur le temps*. Paris: Galilée, 1988.

———. *The Inhuman: Reflections on Time*. Translated by Geoffrey Bennington and Rachel Bowlby. Stanford, CA: Stanford University Press, 1992.

Malm, Andreas, and Alf Hornborg. "The Geology of Mankind? A Critique of the Anthropocene Narrative." *Anthropocene Review* 1, no. 1 (2014): 62–69.

Marran, Christine. "Contamination: From Minamata to Fukushima." *Asia-Pacific Journal* 9, no. 1, issue 19 (2011). http://www.japanfocus.org/-Christine-Marran/3526.

Marin, Louis. "Depositing Time in Painted Representations." In *On Representation*, translated by Catherine Porter, 285–308. Stanford, CA: Stanford University Press, 2002.

———. "Peau d'Ane ou la ré-écriture de l'oral." In *Oralità: Cultura, letteratura, discorso*, edited by Bruno Gentili and Giuseppe Paioni, 579–595. Rome: Edizioni dell'Ateneo, 1985.

———. *Le récit est un piège*. Paris: Minuit, 1978.

———. "Le trompe l'œil, un comble de la peinture." In *L'effet trompe-l'œil dans l'art et la psychanalyse*, 75–92. Paris: Dunod, 1988.

Martin, Wayne M. "Bubbles and Skulls: The Phenomenology of Self-Consciousness in Dutch Still Life Painting." In *A Companion to Phenomenology and Existentialism*, edited by Hubert L. Dreyfus and Mark A. Wrathall, 559–584. Malden, MA: Wiley, 2011.

McGuire, Richard. *Here*. New York: Pantheon Books, 2014.

Meadows, Donella H., Jorgen Randers, Dennis L. Meadows, and William W. Behrens. *The Limits to Growth: A Report for the Club of Rome's Project on the Predicament of Mankind*. Washington, DC: Potomac Associates Books, 1972.

Members of the Anthropocene Working Group. "Colonization of the Americas, 'Little Ice Age' Climate, and Bomb-Produced Carbon: Their Role in Defining the Anthropocene." *Anthropocene Review* 2, no. 2 (2015): 117–127.

Menely, Tobias. *Climate and the Making of Worlds: Toward a Geohistorical Poetics*. Chicago: University of Chicago Press, 2021.

Menely, Tobias, and Jesse Oak Taylor, eds. *Anthropocene Reading: Literary History in Geologic Times*. University Park: Pennsylvania State University Press, 2017.

Mirzoeff, Nicholas. *The Right to Look: A Counterhistory of Visuality*. Durham, NC: Duke University Press, 2011.

Montel, Aurelia. *Le père Labat viendra te prendre . . .* Paris: Maisonneuve Larose, 1996.

Morton, Timothy. *Hyperobjects: Philosophy and Ecology after the End of the World*. Minneapolis: University of Minnesota Press, 2013.

Moxey, Keith. *Visual Time: The Image in History*. Durham, NC: Duke University Press, 2013.

Nagel, Alexander, and Christopher S. Wood. *Anachronic Renaissance*. New York: Zone Books, 2010.

Nersessian, Anahid. *The Calamity Form: On Poetry and Social Life*. Chicago: University of Chicago Press, 2020.

———. "Literary Agnotology." *ELH* 84, no. 2 (2017): 339–360.

Neuberger, Hans. "Climate in Art." *Weather* 25, no. 2 (1970): 46–56.

Nevle, Richard J., and Dennis K. Bird. "Effects of Syn-pandemic Fire Reduction and Reforestation in the Tropical Americas on Atmospheric $CO_2$ during European Conquest." *Palaeogeography, Palaeoclimatology, Palaeoecology* 264, no. 1–2 (2008): 25–38.

Nixon, Rob. *Slow Violence and the Environmentalism of the Poor*. Cambridge, MA: Harvard University Press, 2011.

Onians, John. "Neuroarchaeology and the Origins of Representation in the Grotte de Chauvet: A Neural Approach to Archaeology." In *Image and Imagination: A Global Prehistory of Figurative Representation*, edited by Colin Renfrew and Iain Morley, 307–320. Cambridge, UK: McDonald Institute for Archaeological Research, 2007.

Orlowski, Jeff. *Chasing Ice*. Sausalito, CA: Ro*co Films, 2012.

Pacala, Steven, and Robert Socolow. "Stabilization Wedges: Solving the

Climate Problem for the Next 50 Years with Current Technologies." *Science* 305, no. 5686 (August 2004): 968–972.

Palmeri, Frank. "A Profusion of Dead Animals: Autocritique in Seventeenth-Century Flemish Gamepieces." *Journal for Early Modern Cultural Studies* 16, no. 1 (Winter 2016): 50–77.

Panofsky, Erwin. *Meaning in the Visual Arts: Papers in and on Art History.* Garden City, NY: Anchor Books, 1955.

Paré, Ambroise. *On Monsters and Marvels.* Translated by Janis L. Pallister. Chicago: University of Chicago Press, 1983.

Paulson, William. *The Noise of Culture: Literary Texts in a World of Information.* Ithaca, NY: Cornell University Press, 1988.

Perrault, Charles. "Peau d'Âne." In *Contes*, 56–75. Paris: Garnier, 1967.

Petryna, Adriana. "Horizoning: The Work of Projection in Abrupt Climate Change." In *Unfinished: The Anthropology of Becoming*, edited by João Biehl and Peter Locke, 243–268. Durham, NC: Duke University Press, 2017.

———. "What Is a Horizon? Navigating Thresholds in Climate Change Uncertainty." In *Modes of Uncertainty: Anthropological Cases*, edited by Paul Rabinow and Limor Samimian-Darash, 147–164. Chicago: University of Chicago Press. 2015.

———. "Wildfires at the Edges of Science: Horizoning Work amid Runaway Change." *Cultural Anthropology* 33, no. 4 (2018): 570–595.

Pliny the Elder. *The Natural History.* London: Taylor and Francis, 1855. http://www.perseus.tufts.edu/hopper/text?doc=Plin.+Nat.+toc.

Pluchon, Pierre. *Vaudou, sorciers, empoisonneurs de St. Domingue.* Paris: Karthala, 1987.

Povinelli, Elizabeth. *Geontologies: A Requiem to Late Liberalism.* Durham, NC: Duke University Press, 2016.

Quainton, Malcolm. "Creative Choreography: Intertextual Dancing in Ronsard's *Sonnets pour Hélène*: II, 30." In *Distant Voices Still Heard: Contemporary Readings of French Renaissance*, edited by John O'Brien and Malcolm Quainton, 155–170. Liverpool: Liverpool University Press, 2000.

Quinones, Ricardo J. *The Renaissance Discovery of Time.* Cambridge, MA: Harvard University Press, 1972.

Rabelais, François. *The Complete Works of François Rabelais.* Translated by Donald N. Frame. Berkeley: University of California Press, 1991.

Richeome. Louis. *La peinture spirituelle ou l'art d'Admirer et louer Dieu en toutes ses œuvres.* Lyon: Pierre Rigaud, 1611.

Rockström, Johan, Will Steffen, Kevin Noone, Åsa Persson, F. Stuart

Chapin III, Eric F. Lambin, Timothy M. Lenton, et al. "A Safe Operating Space for Humanity." *Nature* 461, no. 24 (September 2009): 472–475.

Ronda, Margaret. *Remainders: American Poetry at Nature's End.* Stanford, CA: Stanford University Press, 2018.

Ronsard, Pierre de. "Elegie du verre." In *Œuvres complètes VI*, edited by Paul Laumonier, 165–171. Paris: Hachette, 1930.

———. *Œuvres complètes I.* Edited by Jean Céard, Daniel Ménager, and Michel Simonin. Bibliothèque de la Pléiade, vol. 46. Paris: Gallimard, 1993.

Rousseau, Jean-Jacques. *Emile, or Education.* Translated by Barbara Foxley. New York: E. P. Dutton, 1921. https://oll.libertyfund.org/title/rousseau-emile-or-education.

Rubin, Charles T. "The Rhetoric of Extinction." *New Atlantis* 11 (Winter 2006): 64–73. https://www.thenewatlantis.com/publications/the-rhetoric-of-extinction.

Ruddiman, William F. "The Anthropogenic Greenhouse Era Began Thousands of Years Ago." *Climatic Change* 61 (2003): 261–293.

Schoonover, Karl. "Documentaries without Documents: Ecocinema and Toxins." *NECSUS* 4 (Autumn 2013): 483–507.

Scott, Felicity D. "Earthlike." *Grey Room* 65 (2016): 6–35.

Scranton, Roy. *Learning to Die in the Anthropocene: Reflections on the End of a Civilization.* San Francisco: City Light Publishing, 2015.

*Sébastien Stoskopff 1597–1657: Un maitre de la nature morte.* Paris: Editions de la Réunion des musées nationaux, 1997.

Serres, Michel. "Science and the Humanities: The Case of Turner." Translated by Catherine Brown, with William Paulson. *SubStance* 26, no. 2 (1997): 6–21.

Seward Delaporte, Pablo, and Sonia A. P. Grant. "Searches for Livability: An Interview with Adriana Petryna." *Society for Cultural Anthropology Supplementals* (February 6 2019). https://culanth.org/fieldsights/searches-for-livability-an-interview-with-adriana-petryna.

Shapiro, Nicholas, and Eben Kirksey. "Chemo-Ethnography: An Introduction." *Cultural Anthropology* 32, no. 4 (2017): 481–493.

Shapiro, Paul. *Clean Meat: How Growing Meat without Animals Will Revolutionize Dinner and the World.* New York: Gallery Books, 2018.

Smailbegović, Ada. "Cloud Writing: Describing Soft Architectures of Change in the Anthropocene." In *Art in the Anthropocene: Encounters among Politics, Aesthetics, Environments and Epistemologies*, edited by Heather Davis and Etienne Turpin, 93–107. Ann Arbor, MI: Open Humanities Press, 2015.

Smith, William, William Wayte, and G. E. Marindin, eds. *A Dictionary of*

*Greek and Roman Antiquities*. London: John Murray, 1890. http://www. perseus.tufts.edu/hopper/text?doc=Perseus:text:1999.04.0063.

Socolow, Robert. "Wedges Reaffirmed." *Bulletin of the Atomic Scientists*, September 27, 2011. https://thebulletin.org/2011/09/wedges-reaffirmed/.

Squier, Susan. *Liminal Lives: Imagining the Human at the Frontiers of Biomedicine*. Durham, NC: Duke University Press, 2004.

Stephens, Neil, and Martin Ruivenkamp. "Promise and Ontological Ambiguity in the *In vitro* Meat Imagescape: From Laboratory Myotubes to the Cultured Burger." *Science as Culture* 25, no. 3 (2016): 327–355.

Sterling, Charles. *Still Life Painting: From Antiquity to the Twentieth Century*. Translated by James Emmons. 2nd rev. ed. New York: Harper and Row, 1981.

Steyerl, Hito. "Missing People: Entanglement, Superposition, and Exhumation as Sites of Indeterminacy." *e-flux* 38 (2012). https://www.e-flux.com/journal/38/61209/missing-people-entanglement-superposition-and-exhumation-as-sites-of-indeterminacy/.

Stoichita, Victor. *The Self-Aware Image: An Insight into Early Modern Meta-painting*. New York: Cambridge University Press, 1997.

Strangeways, Thomas S. P. "Lecture VI" (1926). Wellcome Library, London, ref. no. SA/SRL/A.27. MS and typescript, with manuscript note (1973) by Dorothy Strangeways.

Sue, Derald W. "Microaggression and 'Evidence': Empirical or Experiential Reality?" *Perspectives on Psychological Science* 12, no. 1 (2017): 170–172.

Szerszynski, Bronislaw. "Reading and Writing the Weather Climate Technics and the Moment of Responsibility." *Theory, Culture & Society* 27, no. 2–3 (2010): 9–30.

Tapié, Alain. *Vanité: Mort, que me veux-tu?* Paris: Editions de la Martinière, 2010.

Thiébaux, Marcelle. *The Stag of Love: The Chase in Medieval Literature*. Ithaca, NY: Cornell University Press, 2014.

Traisnel, Antoine. *Capture: American Pursuits and the Making of a New Animal Condition*. Minneapolis: University of Minnesota Press, 2020.

*Le trésor de la langue française informatisé*. ATILF. Accessed January 21, 2023. http://atilf.atilf.fr.

Tsing, Anna Lowenhaupt. "A Threat to Holocene Resurgence Is a Threat to Livability." In *The Anthropology of Sustainability: Beyond Development and Progress*, edited by Marc Brightman and Jerome Lewis, 51–65. New York: Palgrave, 2017.

Turcot DiFruscia, Kim. "Shapes of Freedom: A Conversation with Elizabeth A. Povinelli." *e-flux* 53 (March 2014). https://www.e-flux.com/journal/53/59889/shapes-of-freedom-a-conversation-with-elizabeth-a-povinelli/.

Usher, Phillip John. *Exterranean: Extraction in the Humanist Anthropocene.* New York: Fordham University Press, 2019.

Van den Bosch, Paula. "Nature's Trespassing." Accessed October 10, 2022. http://www.berndnaut.nl/text/paula-van-den-bosch/.

Van Dooren, Thom. *Flight Ways: Life and Loss at the Edge of Extinction.* New York: Columbia University Press, 2014.

Vince, Gaia. "What We Lose When We Lose Our Glaciers." *The Guardian*, April 28, 2021. https://www.theguardian.com/environment/2021/apr/28/what-we-lose-when-we-lose-our-glaciers.

Wallace-Wells, David. *The Uninhabitable Earth: Life after Warming.* New York: Tim Duggan, 2019.

Watson, Robert N. *Back to Nature: The Green and the Real in the Late Renaissance.* Philadelphia: University of Pennsylvania Press, 2011.

Weber, Samuel. *Institution and Interpretation.* Exp. ed. Stanford, CA: Stanford University Press, 2002.

Weisman, Alan. *The World without Us.* New York: St. Martin's Thomas Dunne Books, 2007.

Williams, Raymond. *Marxism and Literature.* New York: Oxford University Press, 1977.

Wilson, Edward O. *The Future of Life.* New York: Knopf, 2002.

Winthrop-Young, Geoffrey. *Kittler and the Media.* Cambridge, UK: Polity Press, 2011.

Wood, Gillen D'Arcy. "Constable, Clouds, Climate Change." *Wordsworth Circle* 38, no. 1–2 (2007): 25–33.

———. *Tambora: The Eruption That Changed the World.* Princeton, NJ: Princeton University Press, 2014.

Zalasiewicz, Jan, Mark Williams, Colin N. Waters, Anthony D. Barnosky, and Peter Haff. "The Technofossil Record of Humans." *Anthropocene Review* 1, no. 1 (2014): 34–43.

Zerefos, C. S., P. Tetsis, A. Kazantzidis, V. Amiridis, S. C. Zerefos, J. Luterbacher, J., K. Eleftheratos, E. Gerasopoulos, S. Kazadzis, and A. Papayannis. "Further Evidence of Important Environmental Information Content in Red-to-Green Ratios as Depicted in Paintings by Great Masters." *Atmospheric Chemistry and Physics* 14 (2014): 2987–3015.

Zimov, Sergey A. "Pleistocene Park: Return of the Mammoth's Ecosystem." *Science* 308 (May 2005): 796–798.

———. "Wild Field Manifesto." Accessed January 21, 2023. https://reviverestore.org/projects/woolly-mammoth/sergey-zimovs-manifesto/.

Zipes, Jack. *The Irresistible Fairy Tale: The Cultural and Social History of a Genre.* Princeton, NJ: Princeton University Press, 2012.

Zylinska, Joanna. *Nonhuman Photography.* Cambridge, MA: MIT Press, 2017.

# INDEX

Page numbers in italics indicate figures.

165

CPSIA information can be obtained
at www.ICGtesting.com
Printed in the USA
JSHW080004270723
45479JS00005B/7